ABCs of Morocco

أبجديات المغرب

Timeless Tea Traditions of Morocco

تقاليد الشاي الخالدة في المغرب

Coffee Table Photobook

Mosaic Tree Press

ISBN 978-1-916524-85-9

Copyright © 2024 Mosaic Tree Press
All rights reserved. No part of this book may be reproduced, stored
in a retrieval system, or transmitted in any form or by any means,
electronic, mechanical, photocopying, recording, or otherwise,
without the prior written permission of the author.

All artwork was designed and licensed by Freepik.com

First printing, 2024

Published by Mosaic Tree Press
Browse our complete catalogue of publications at MosaicTree.org

In the name of God, the Most Gracious, the Most Merciful

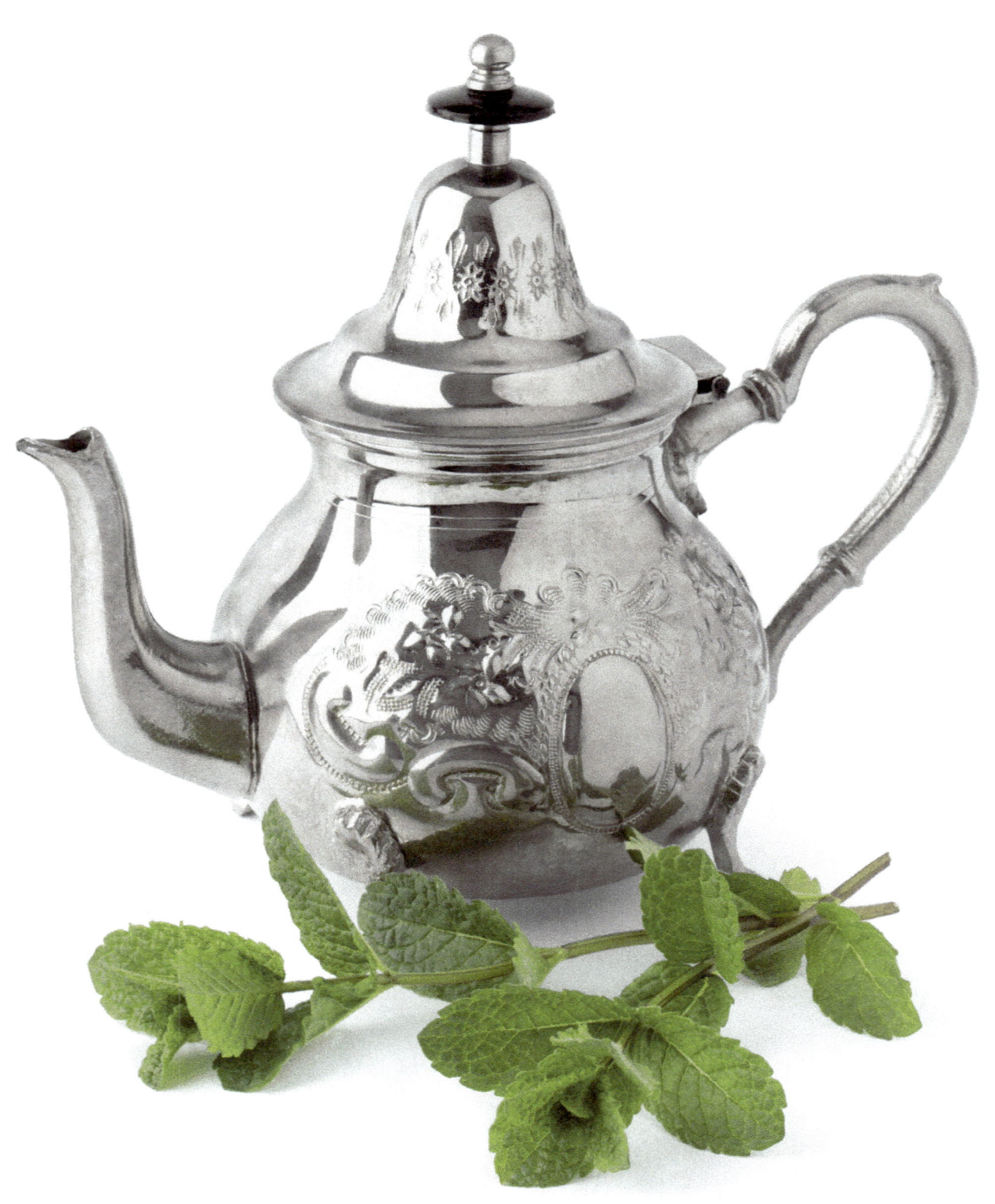

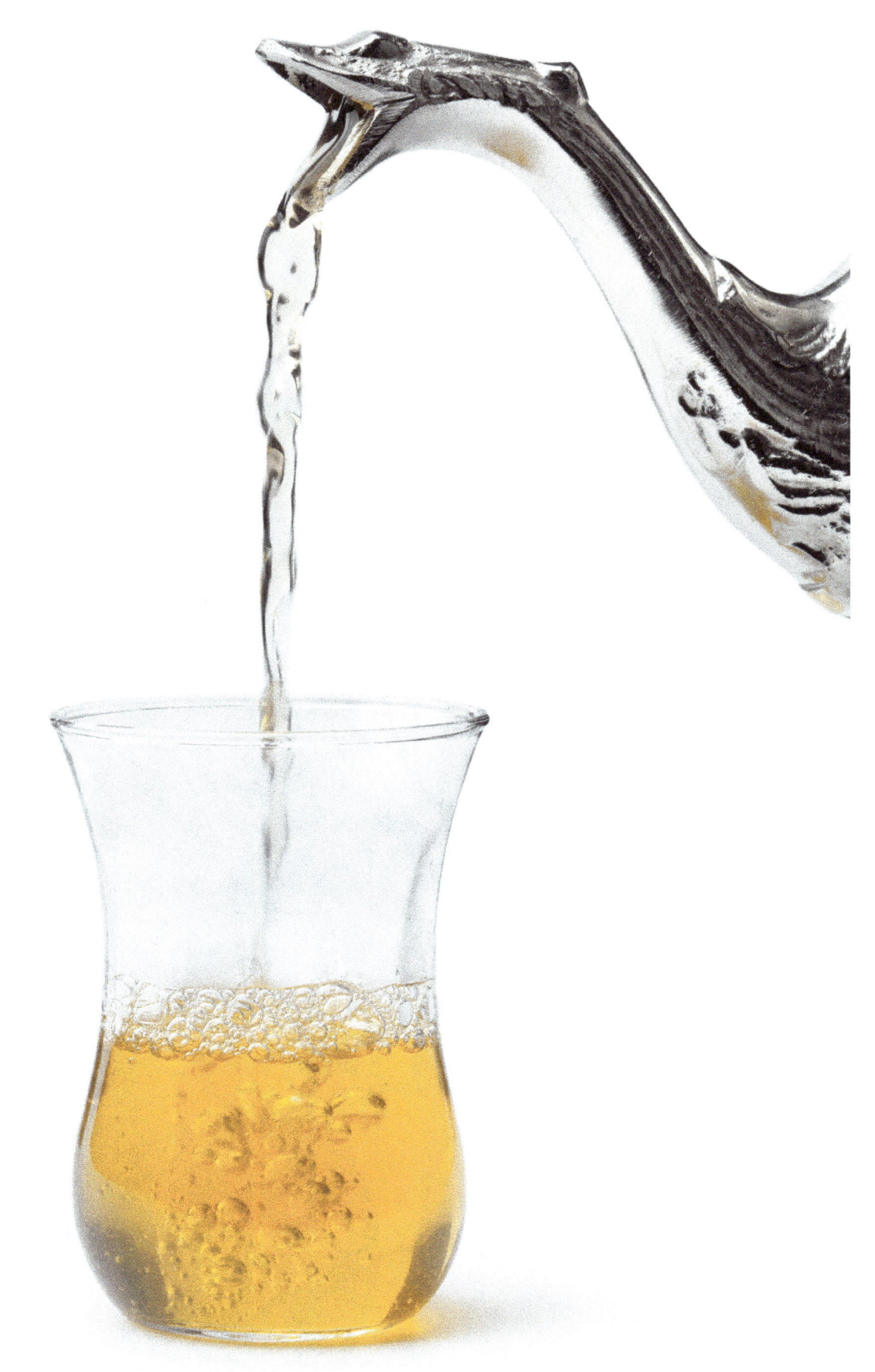

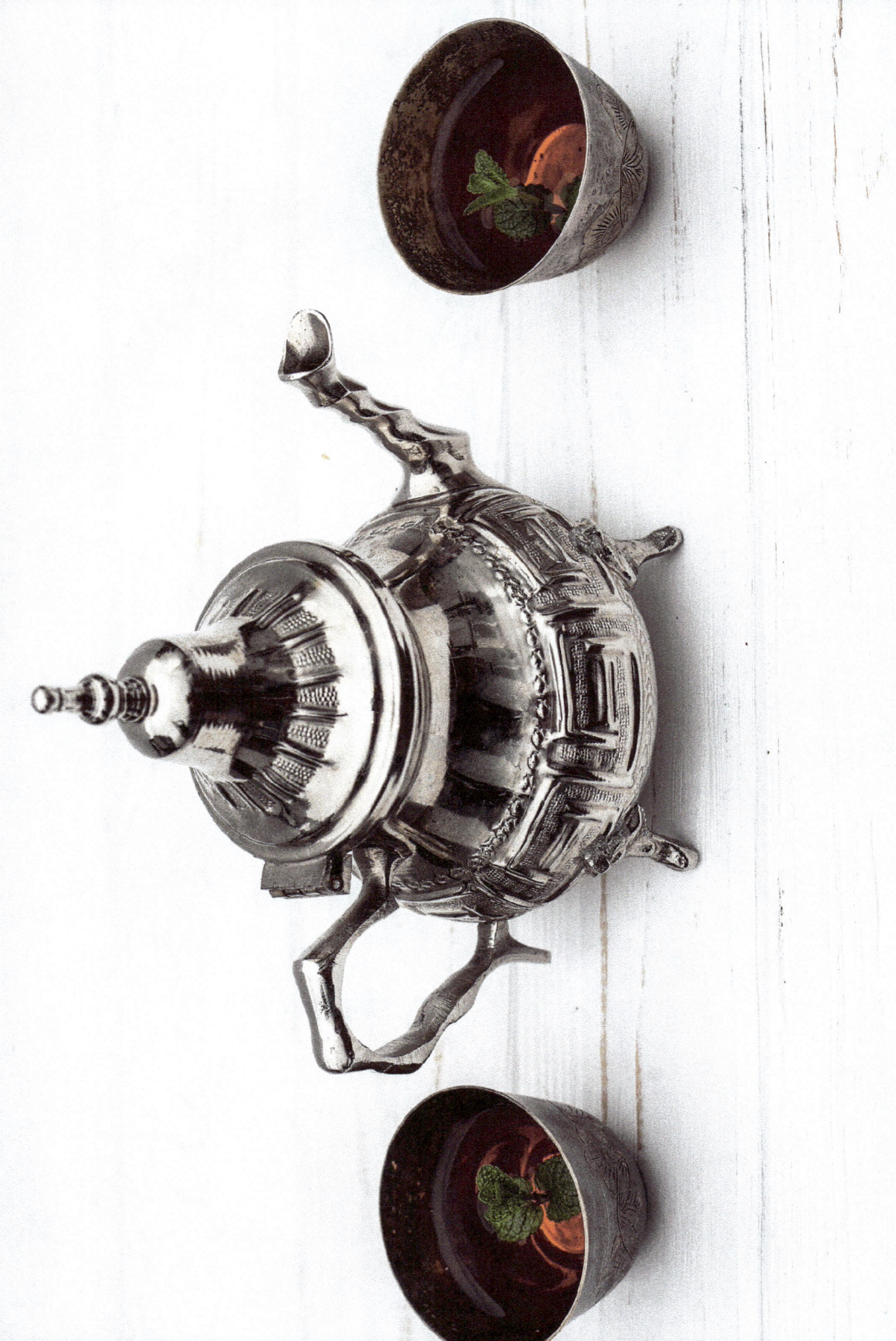

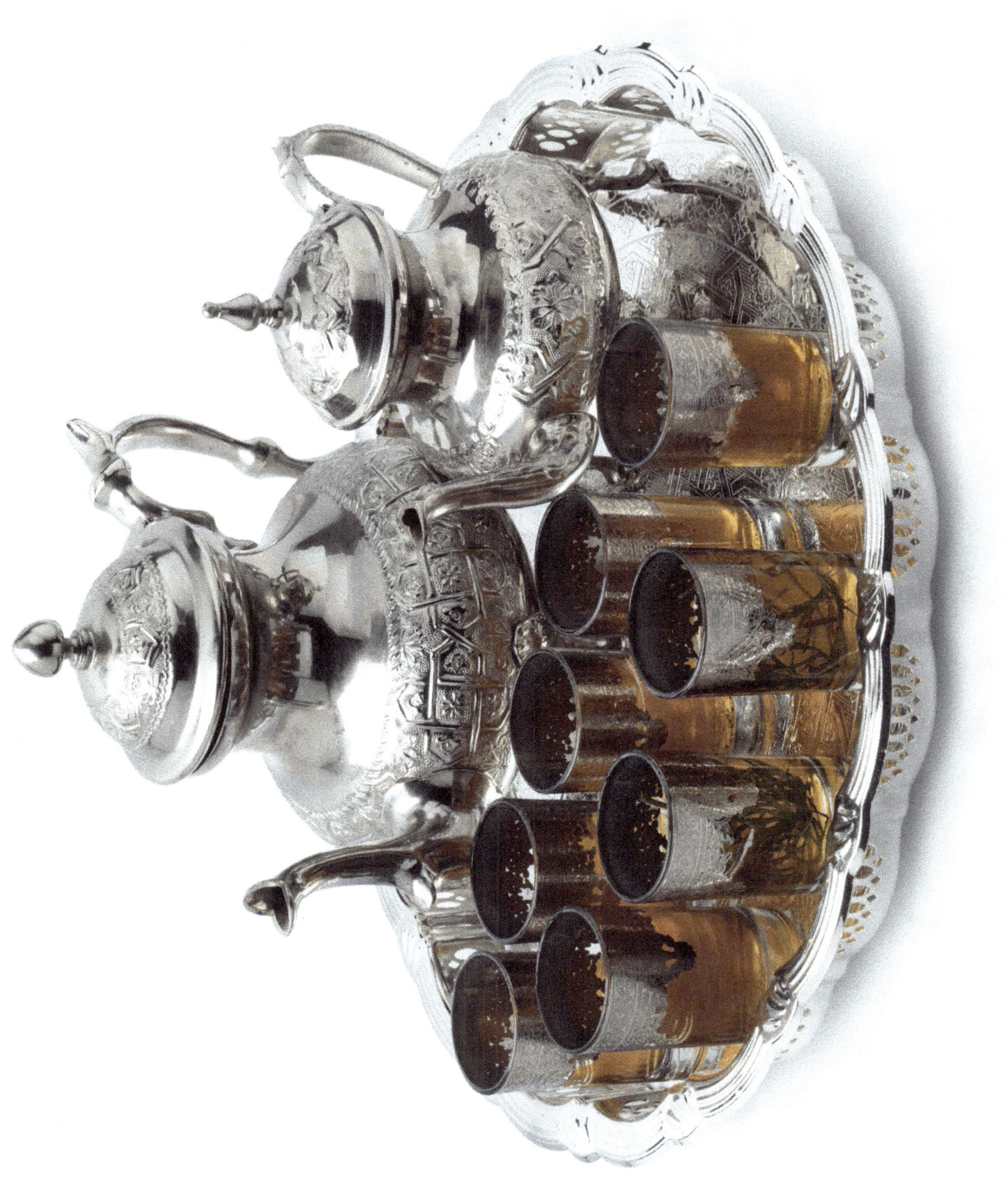

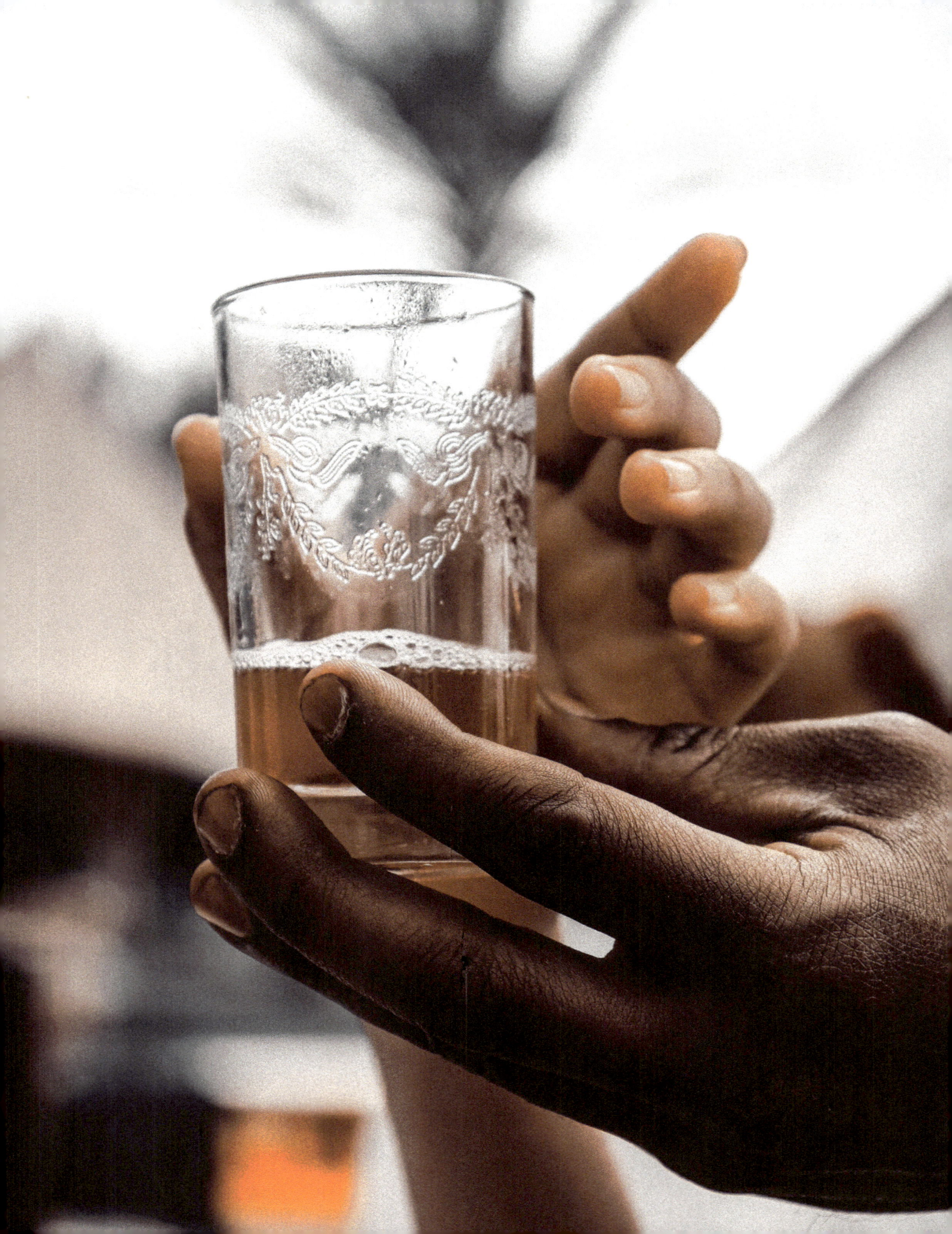

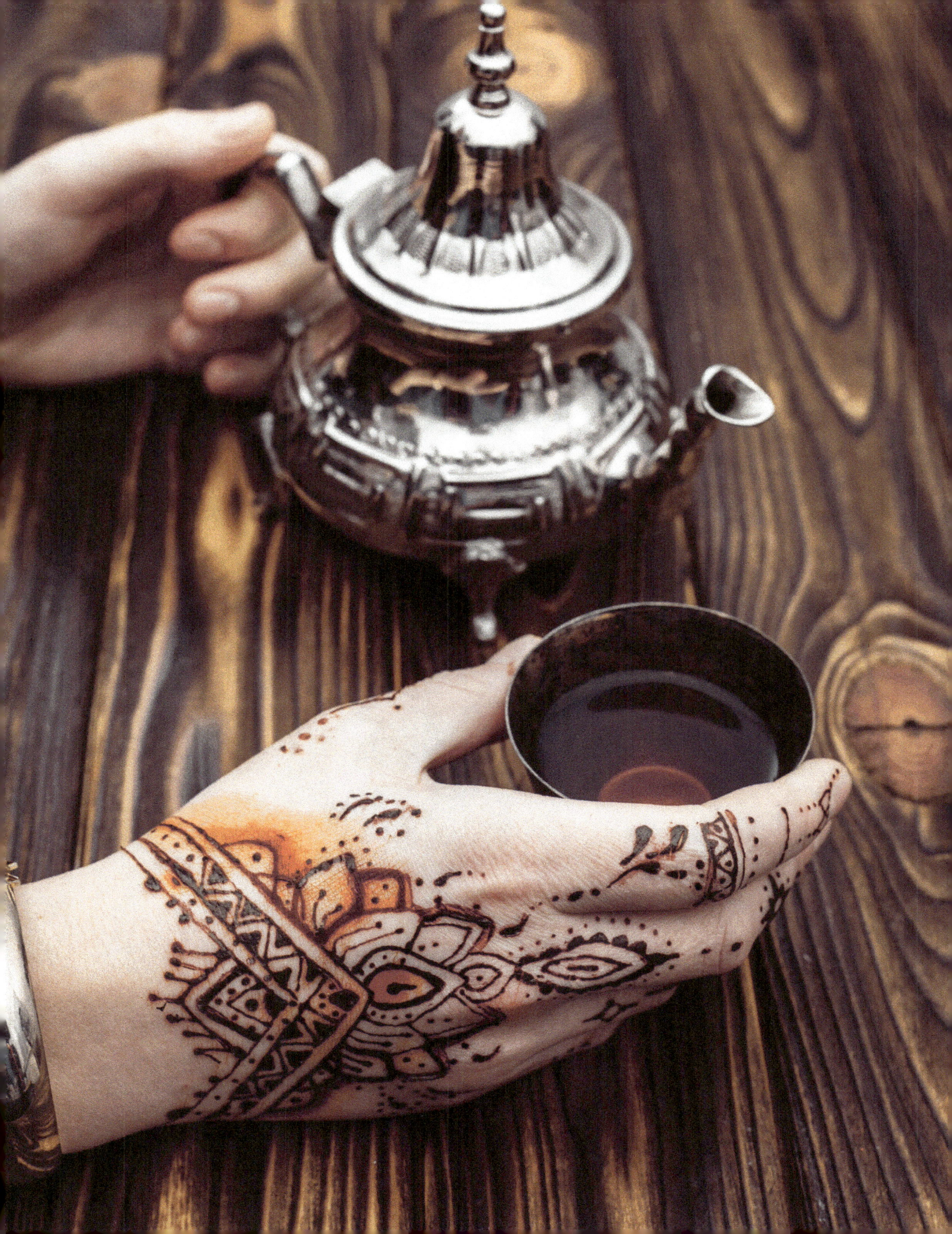

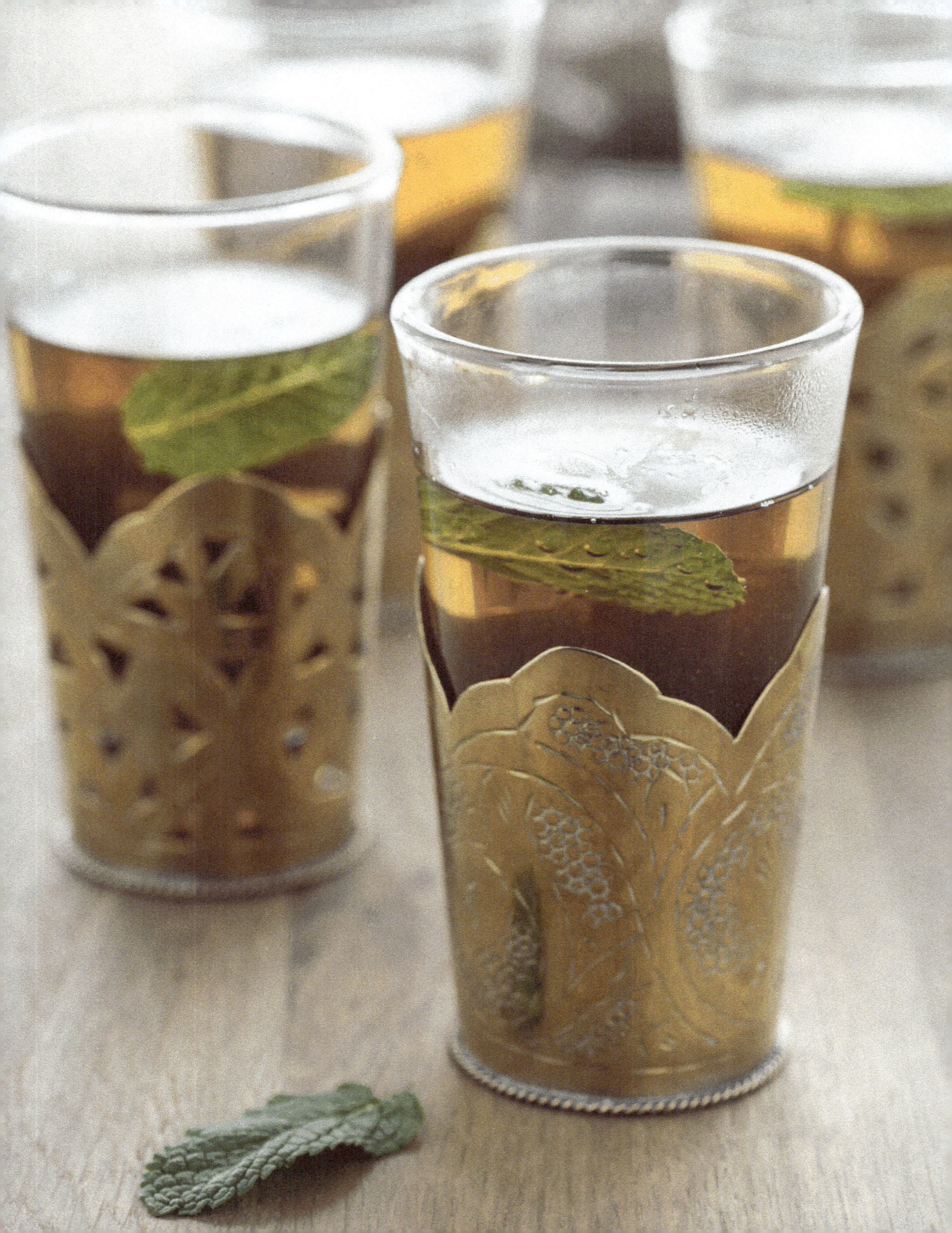

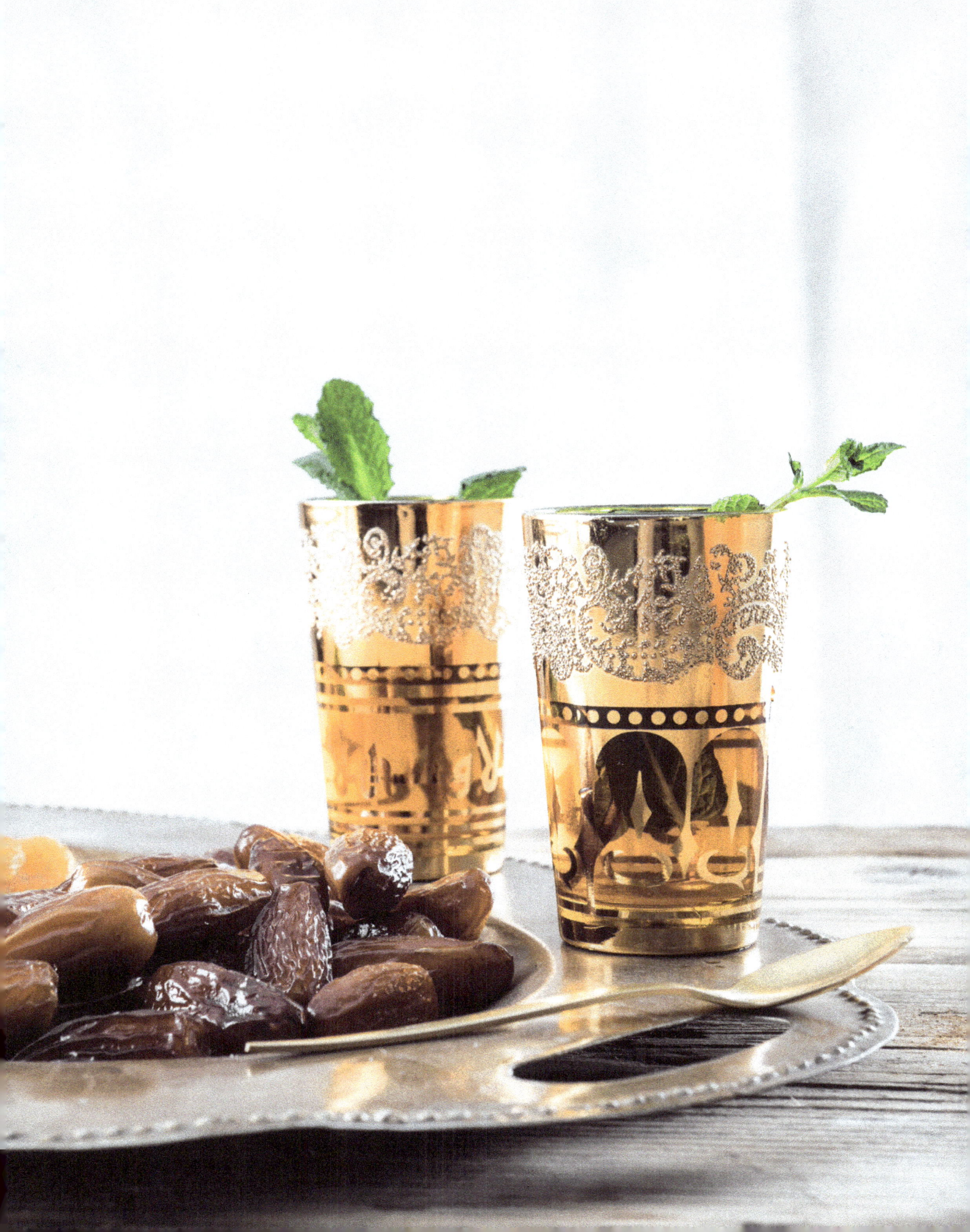

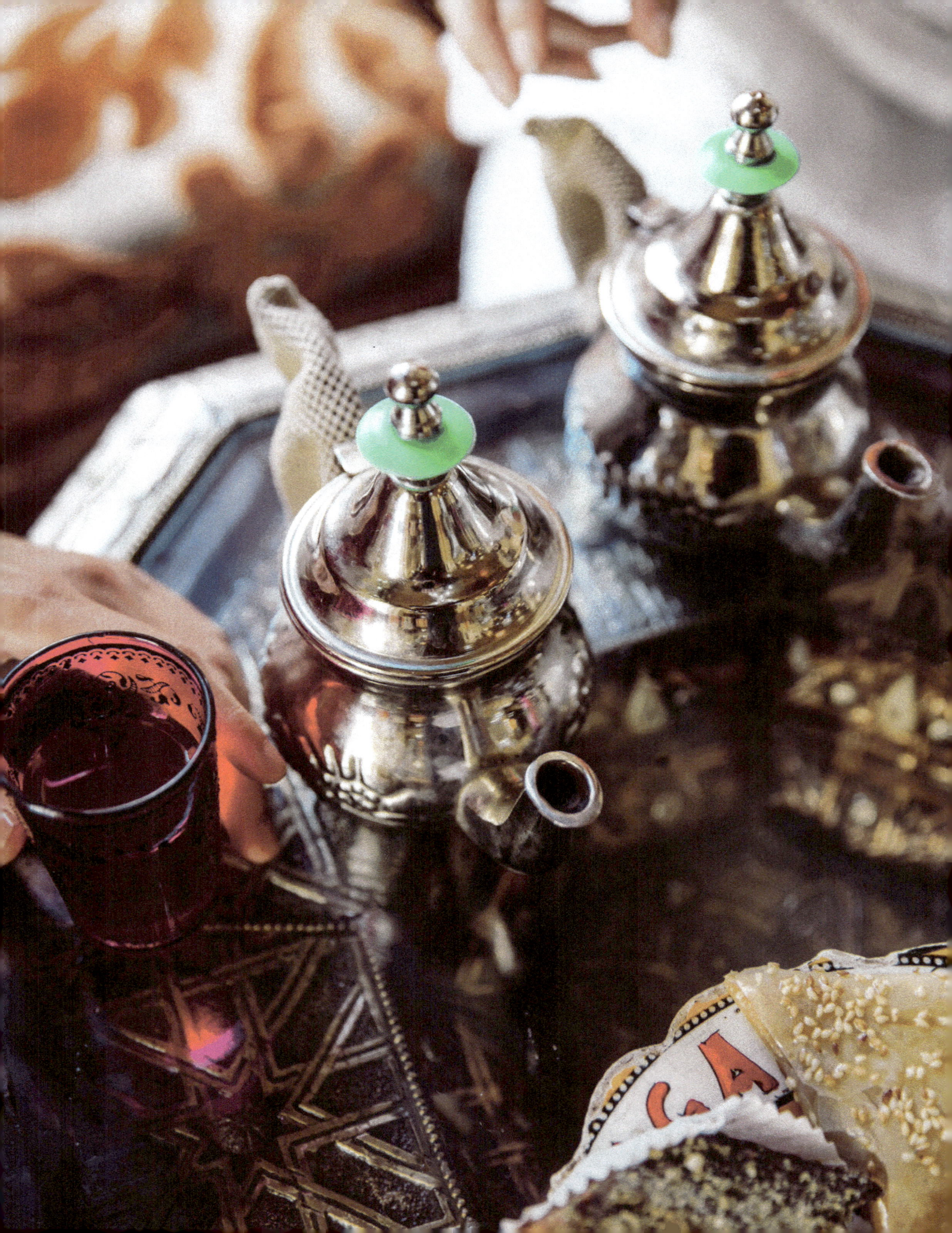

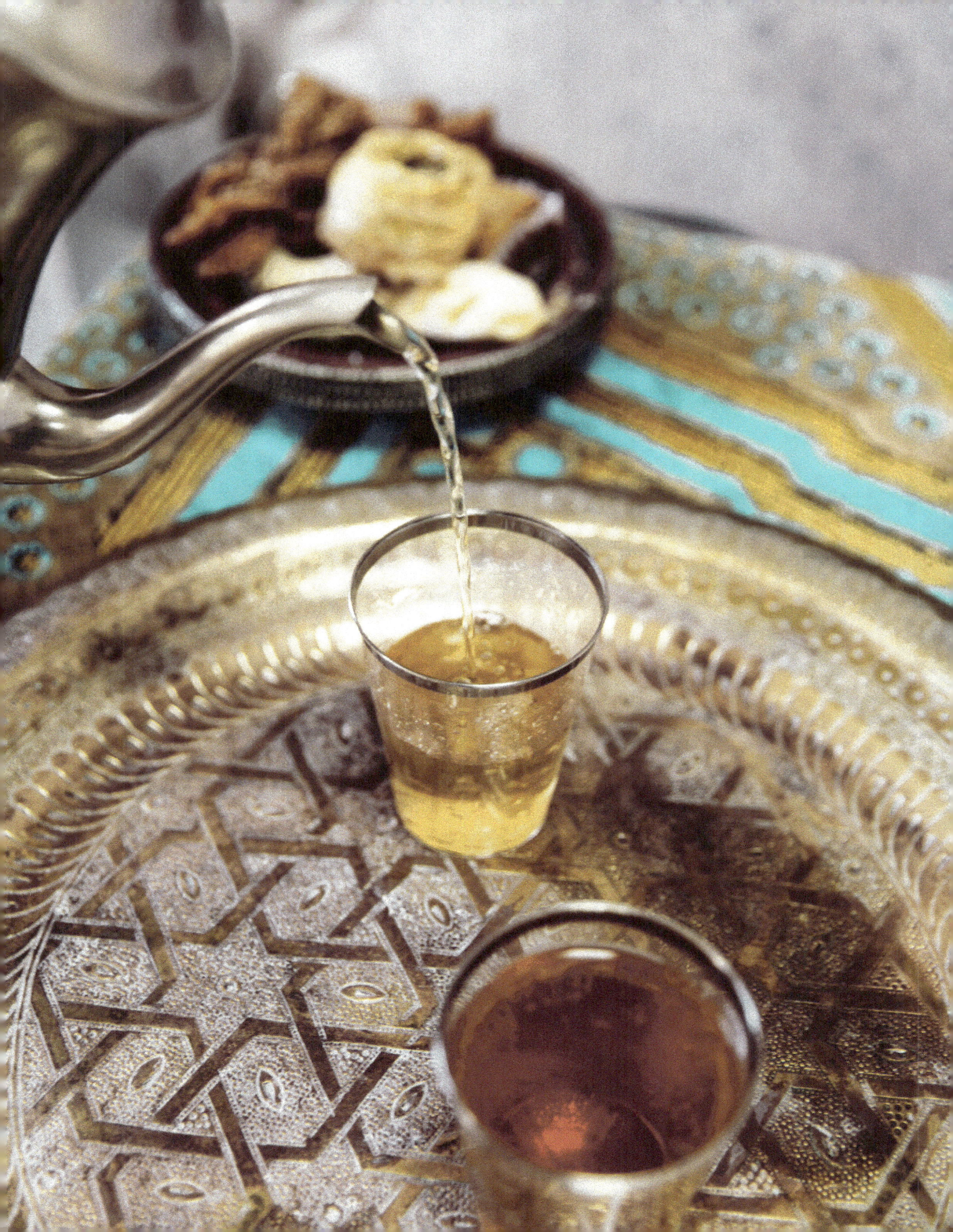

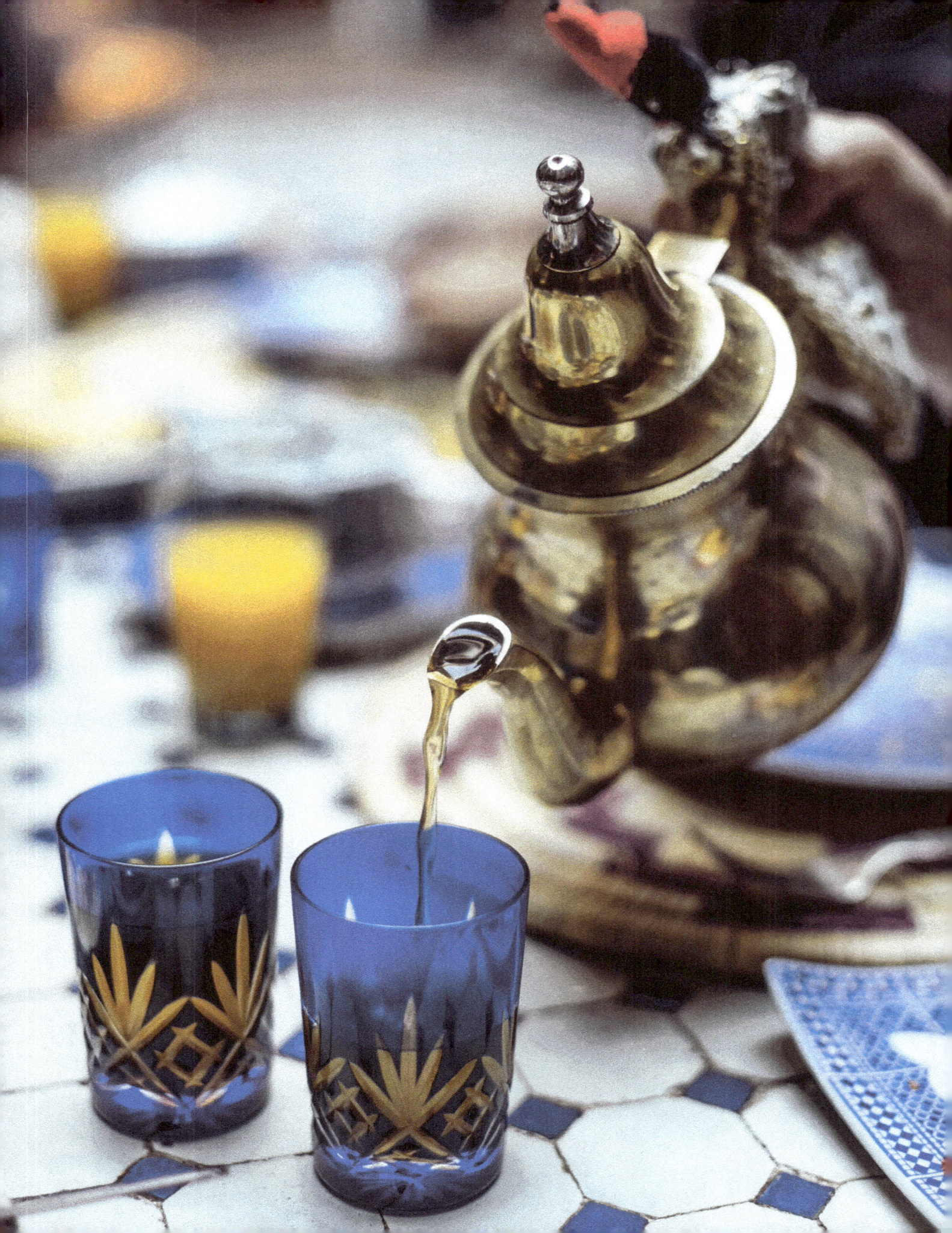

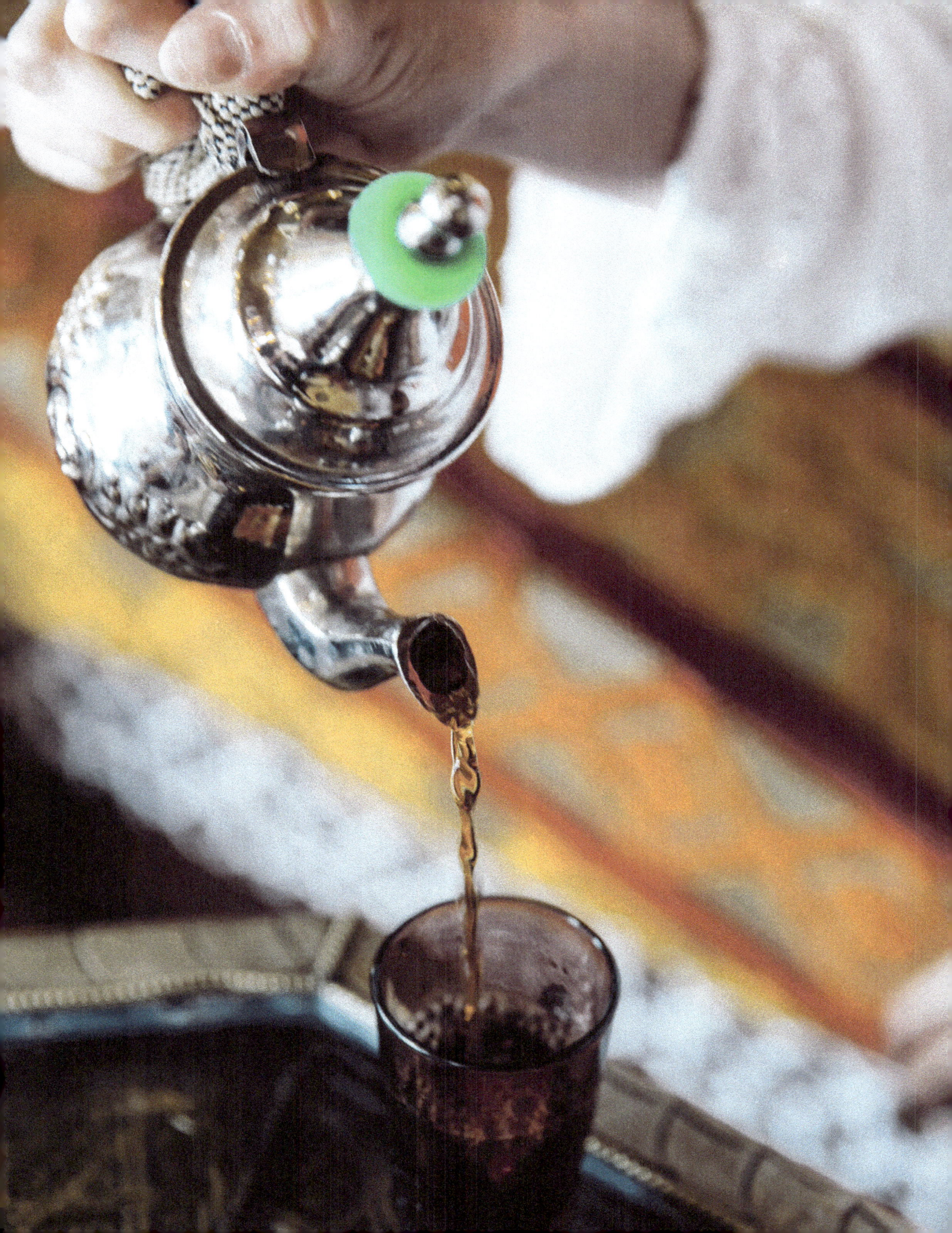

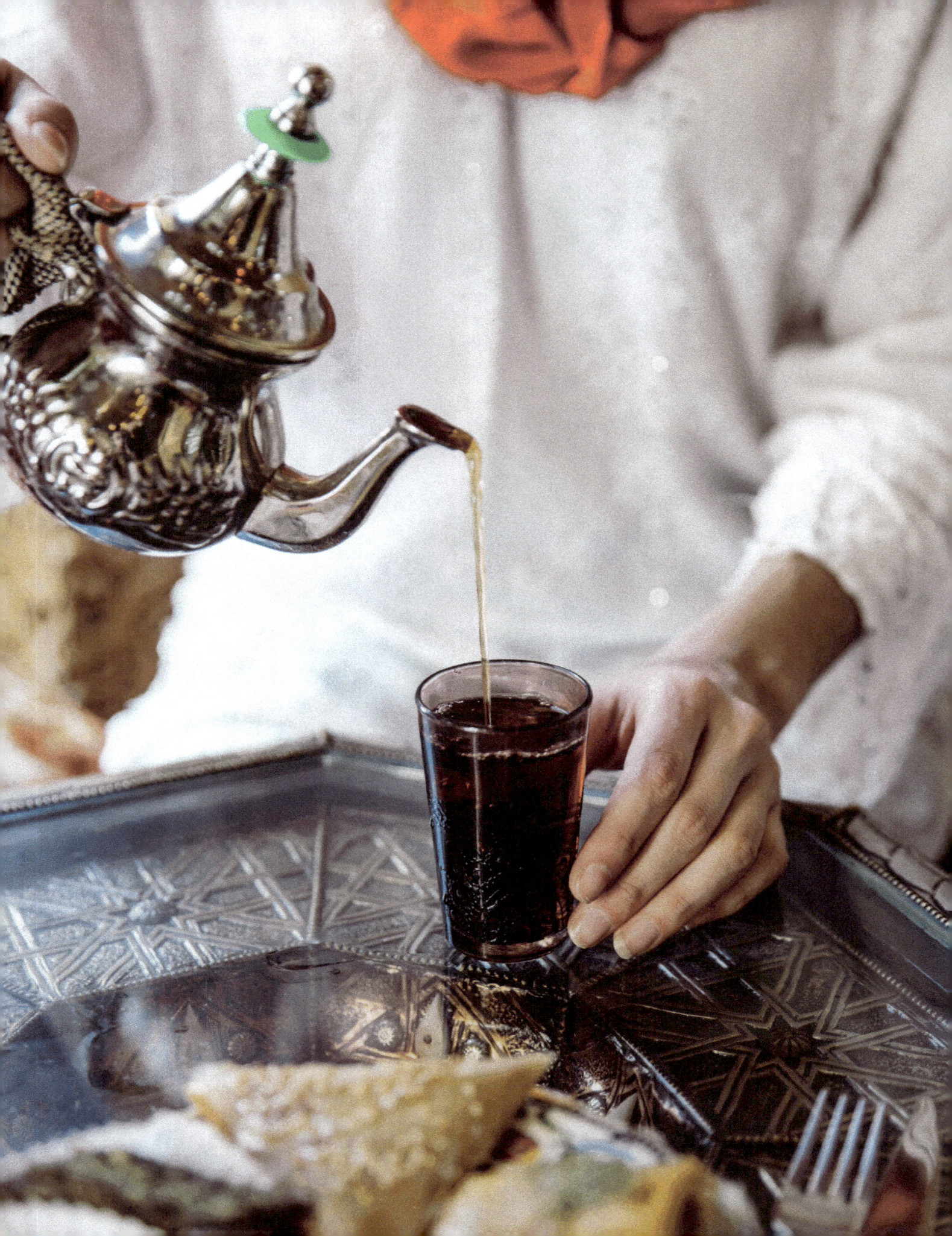

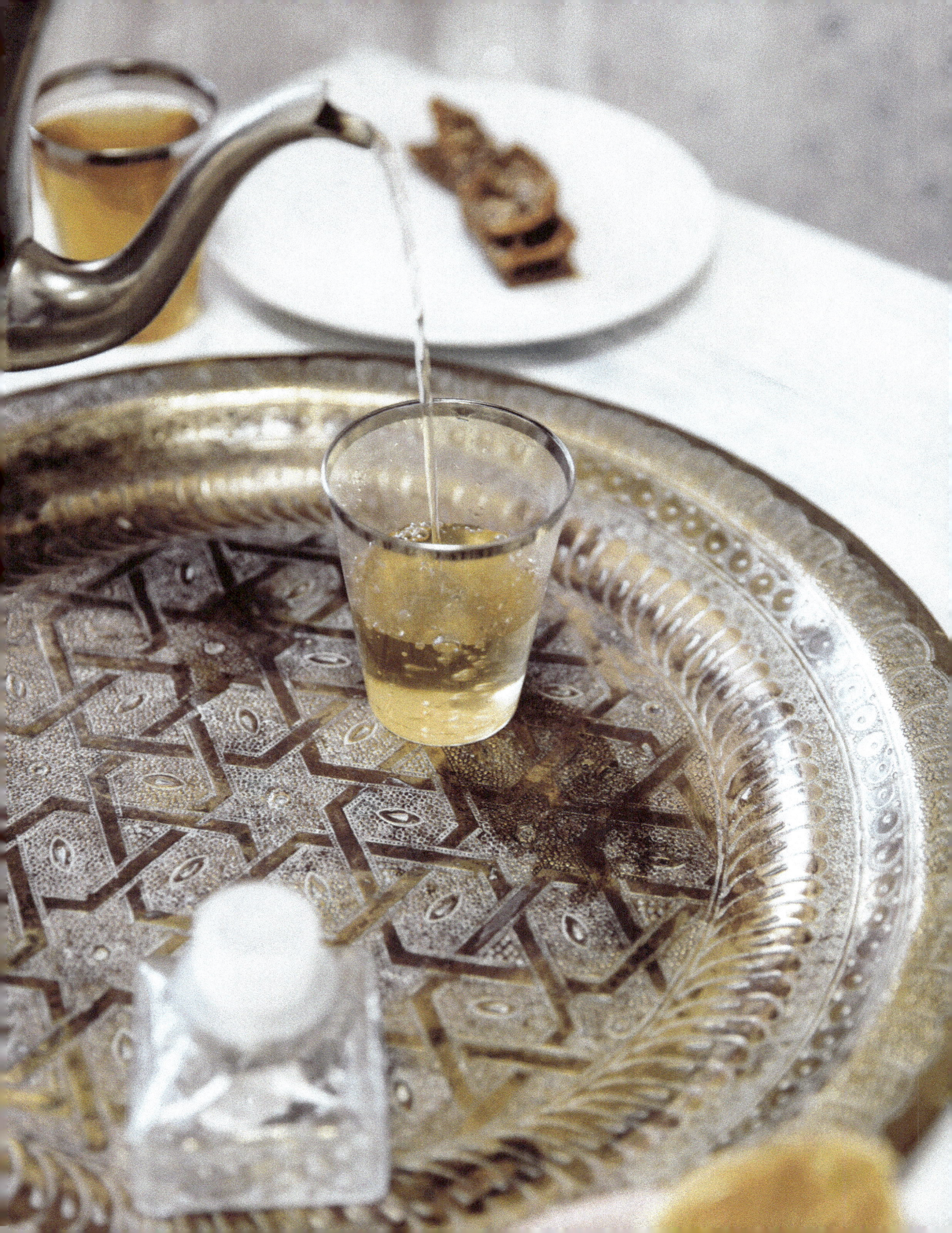

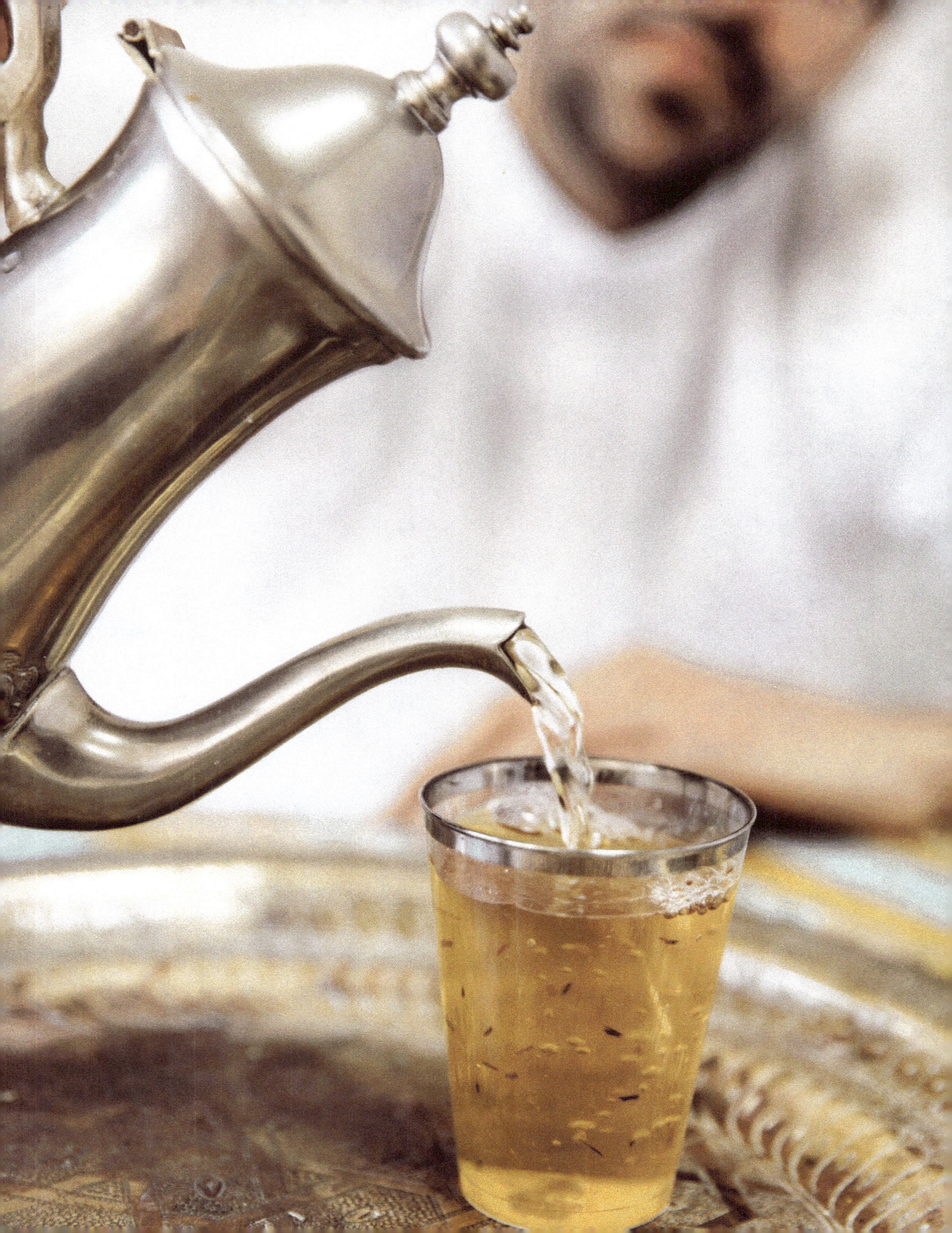

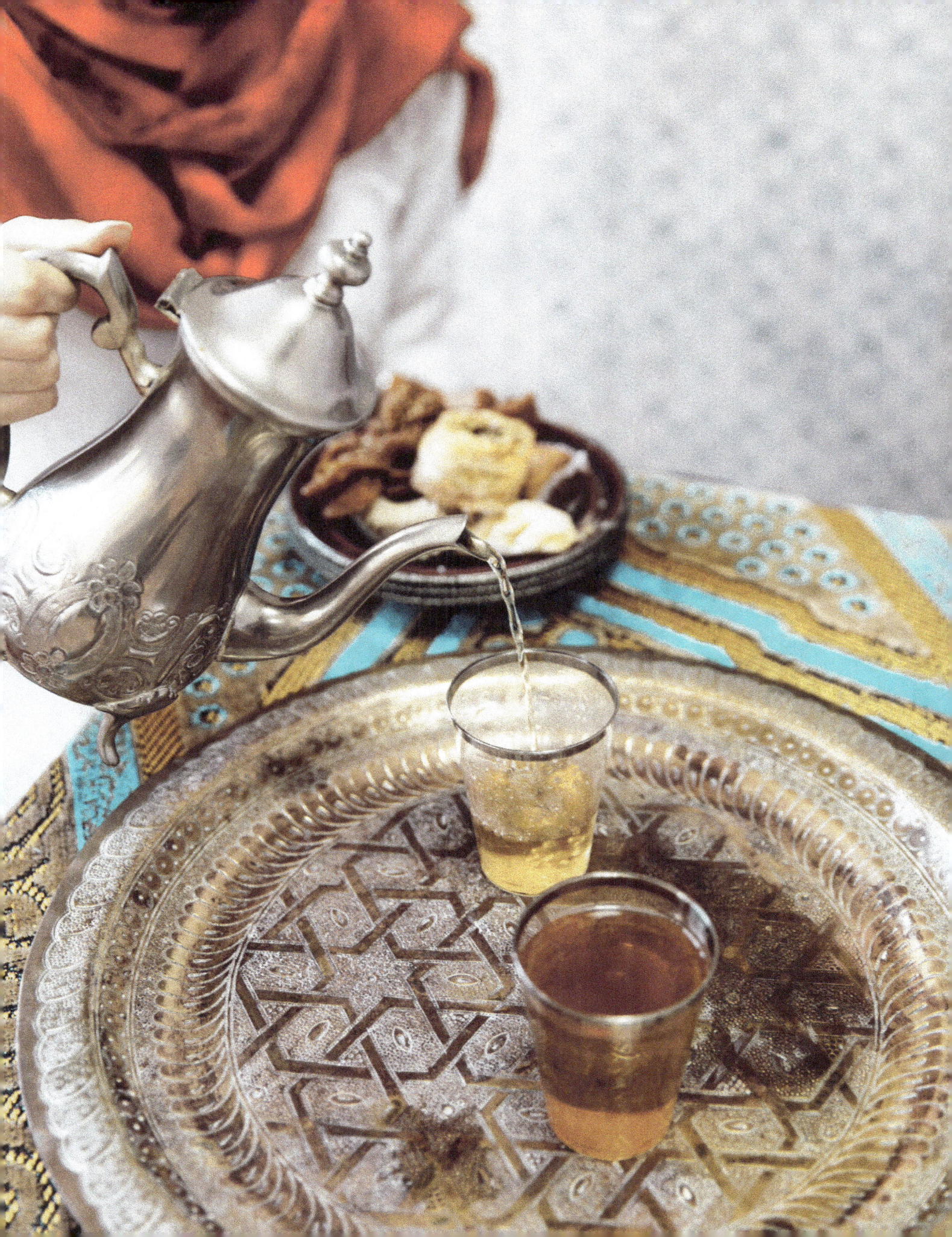

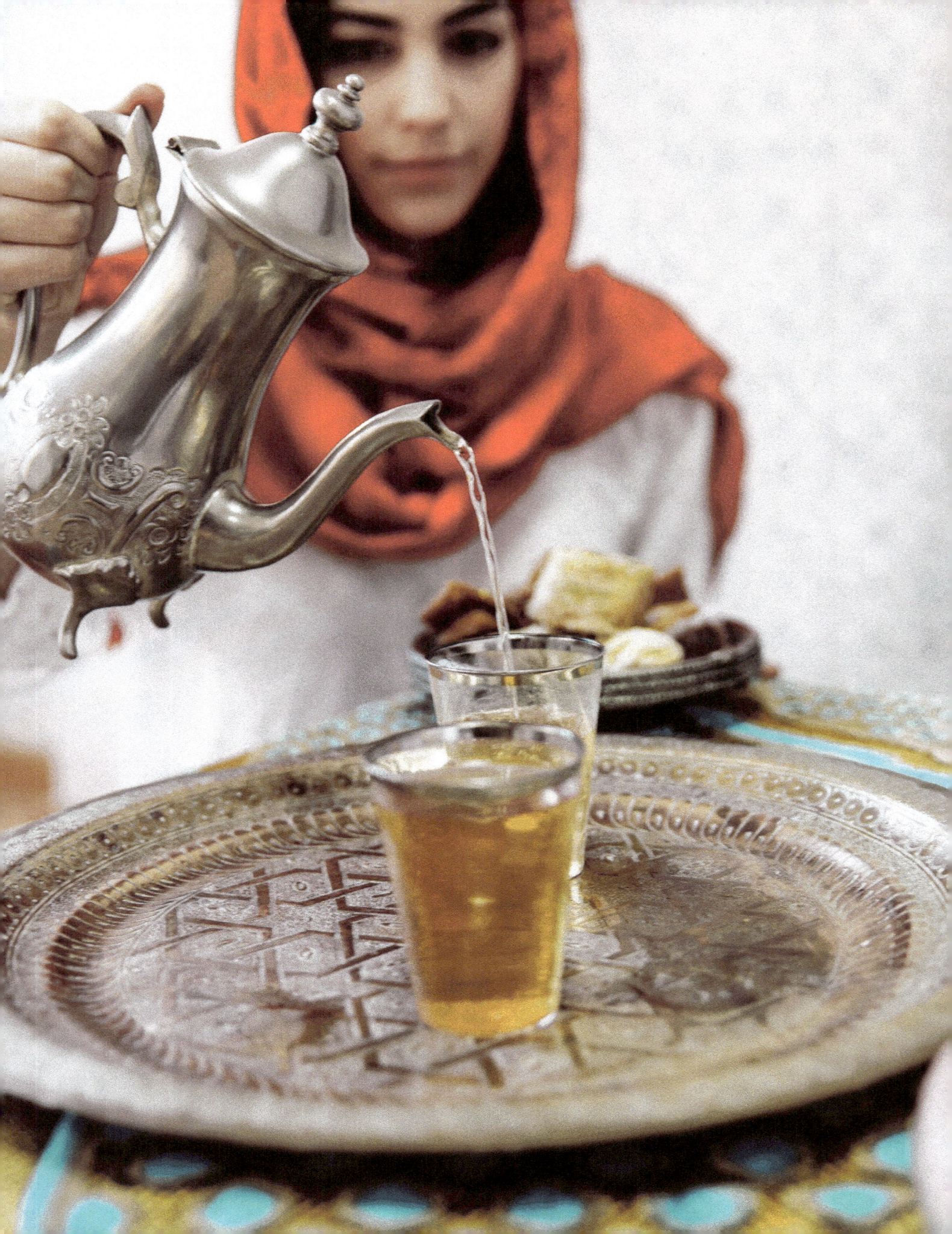

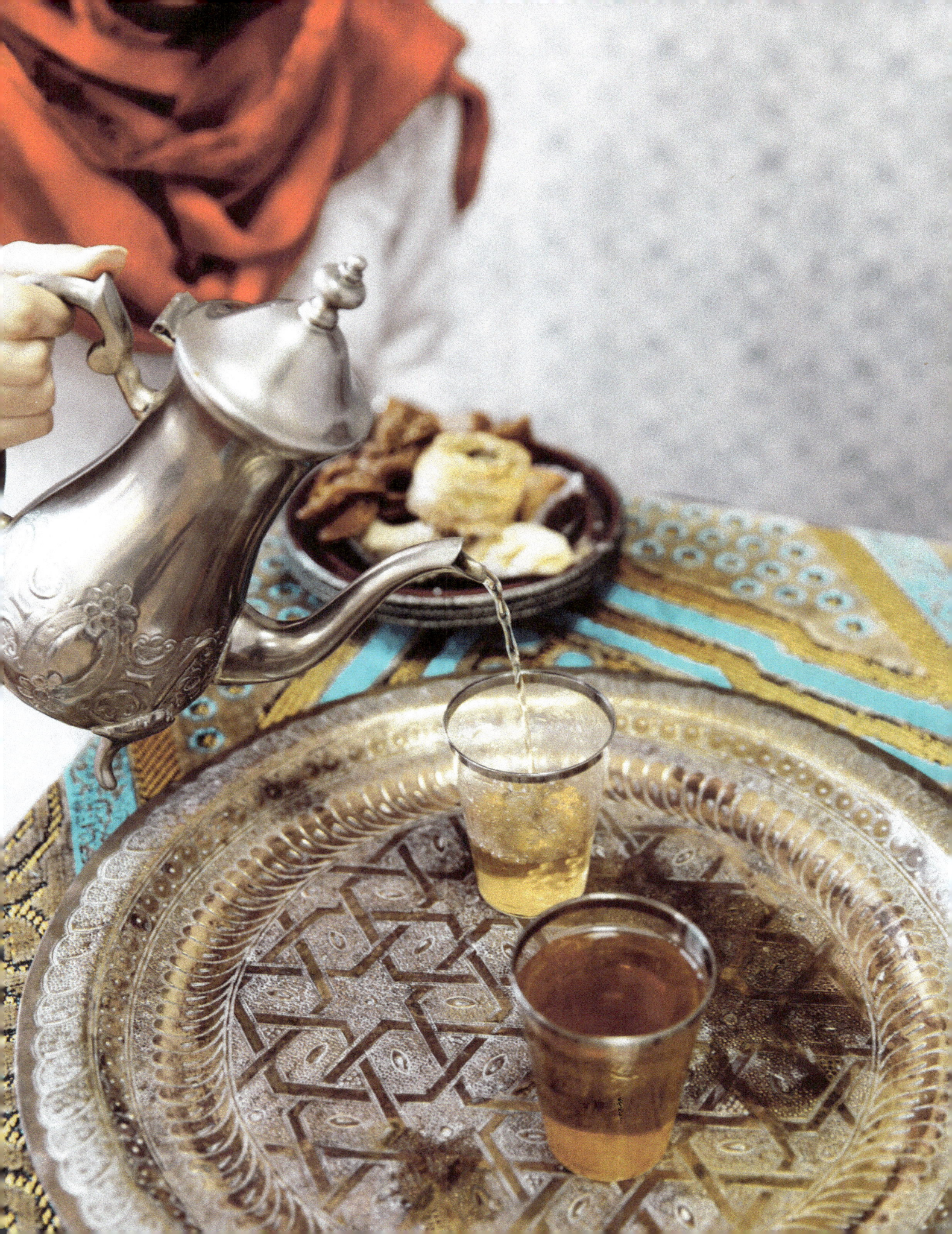

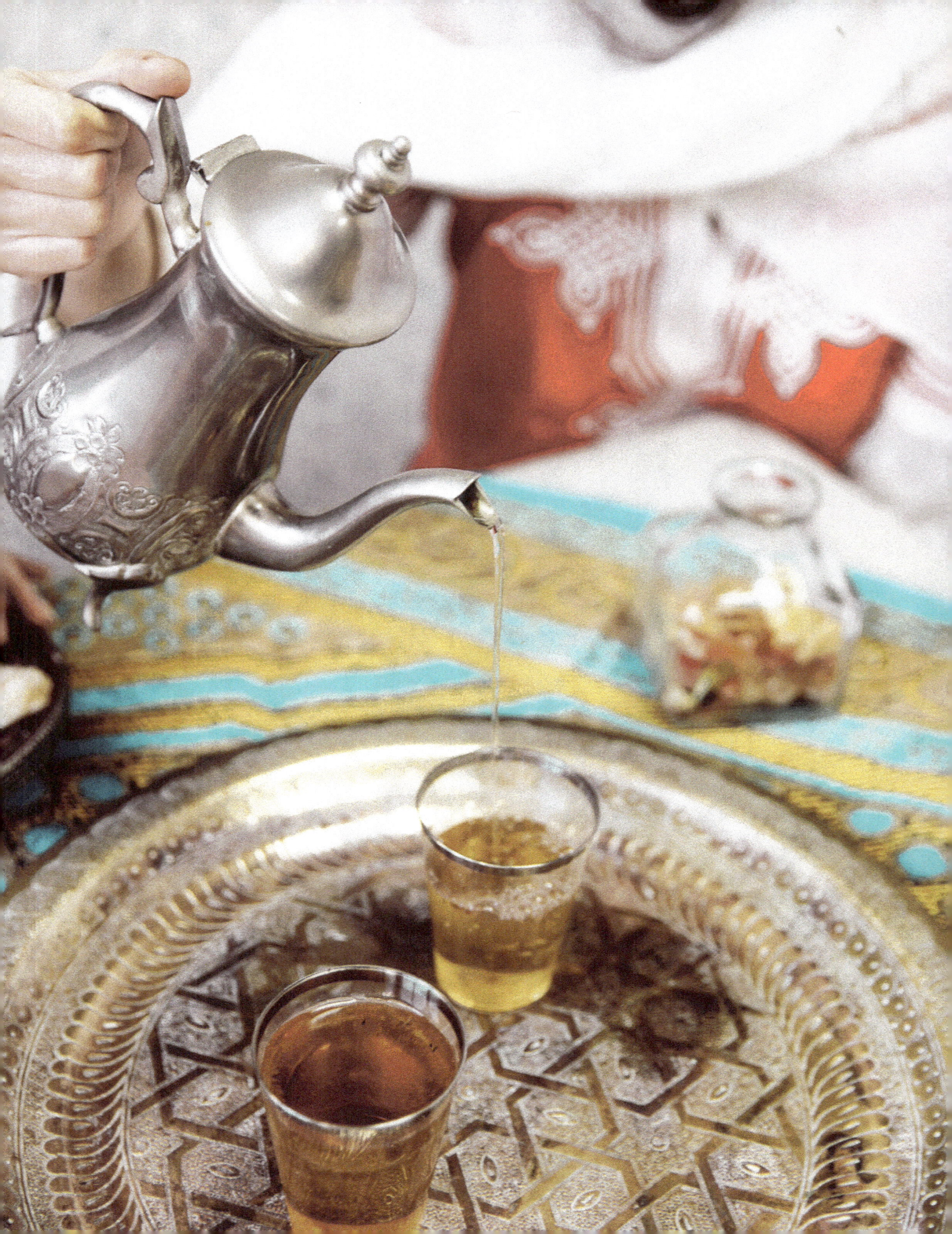

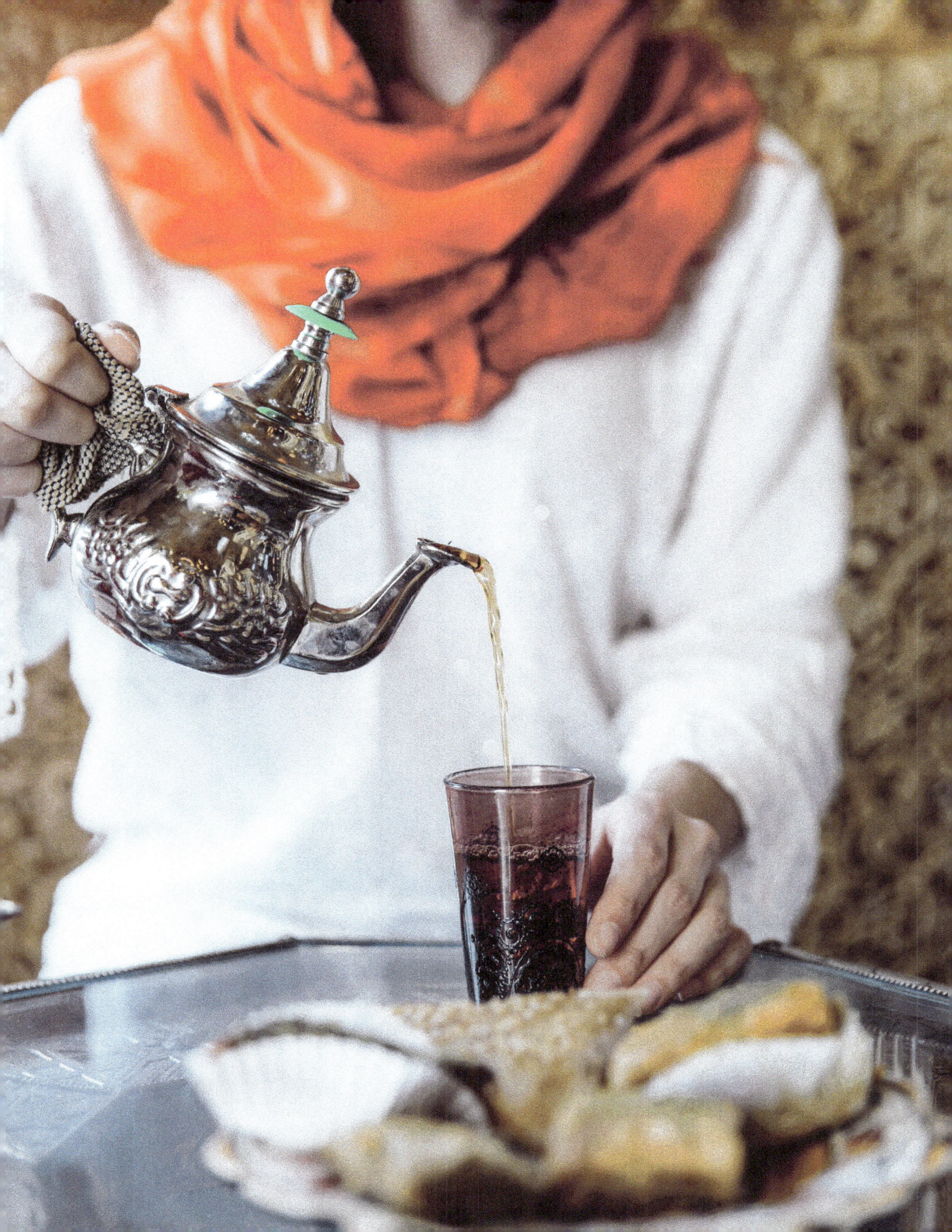

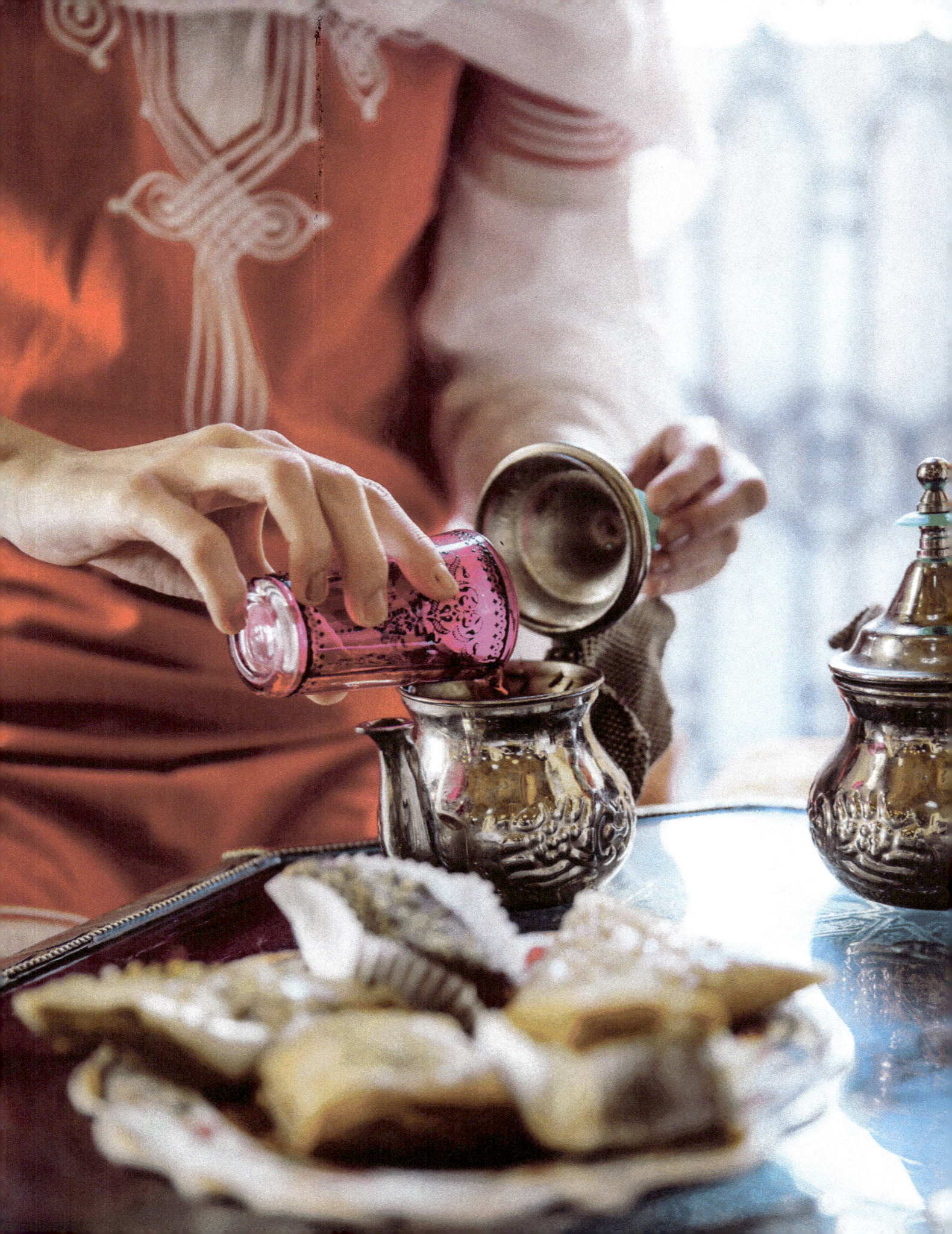

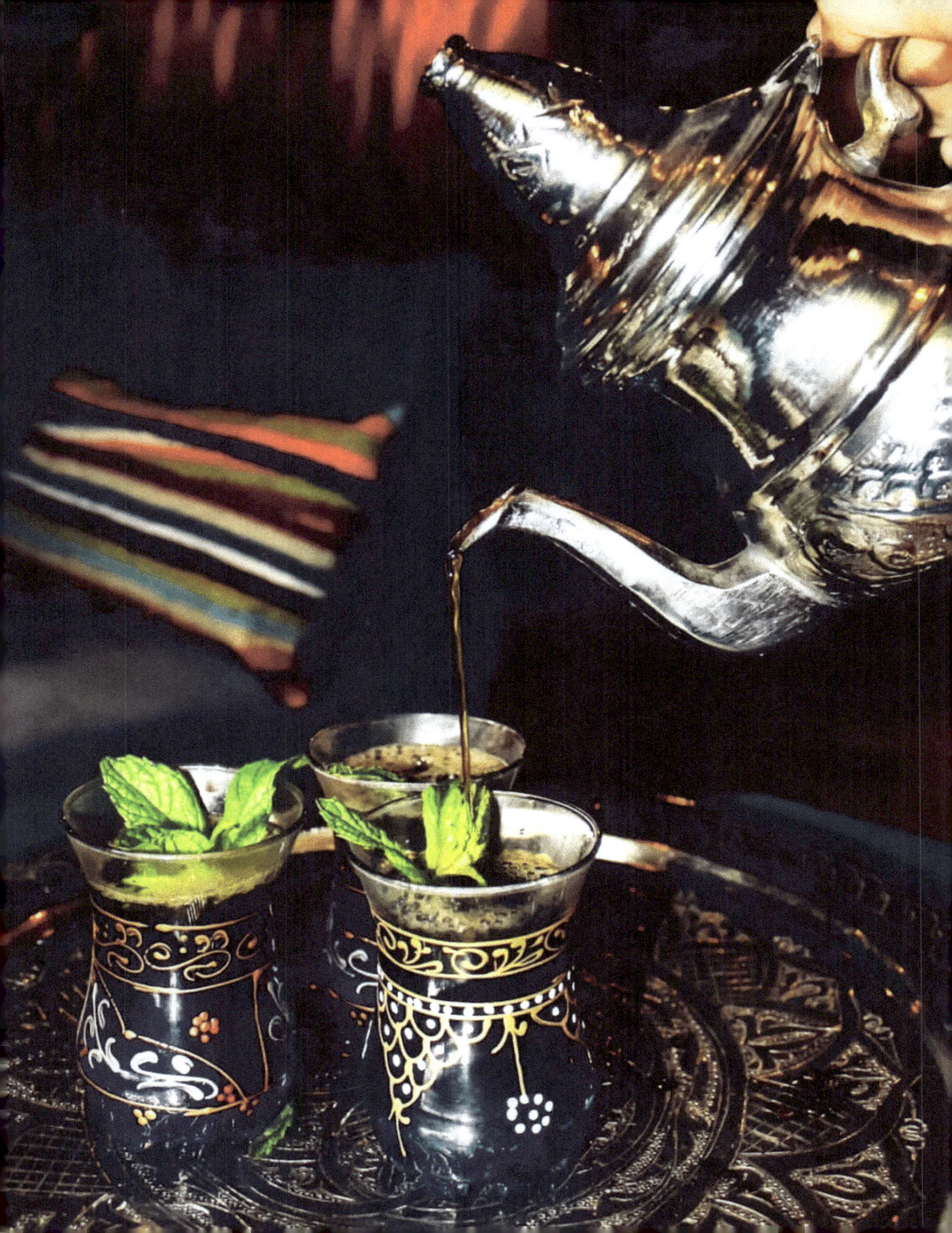

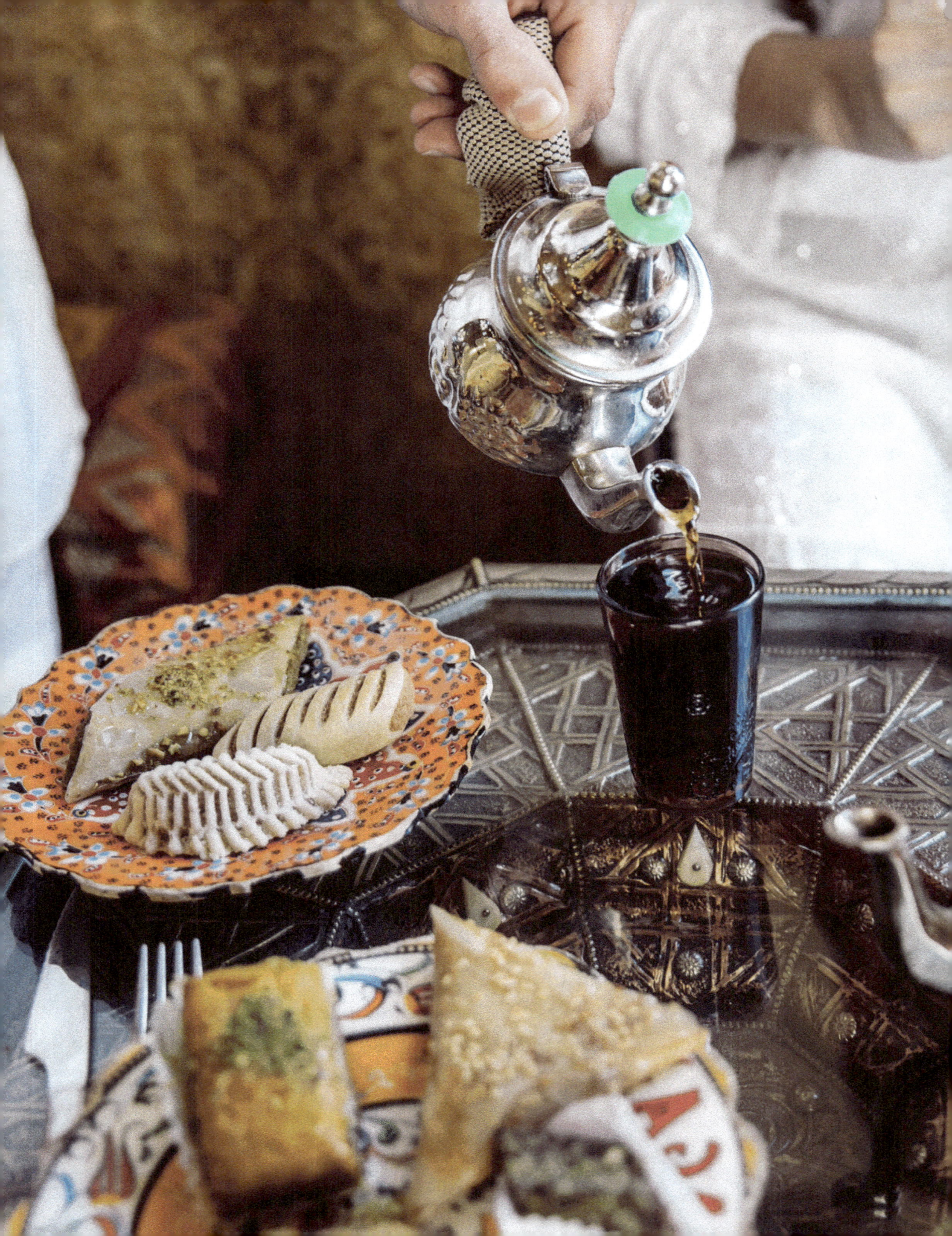

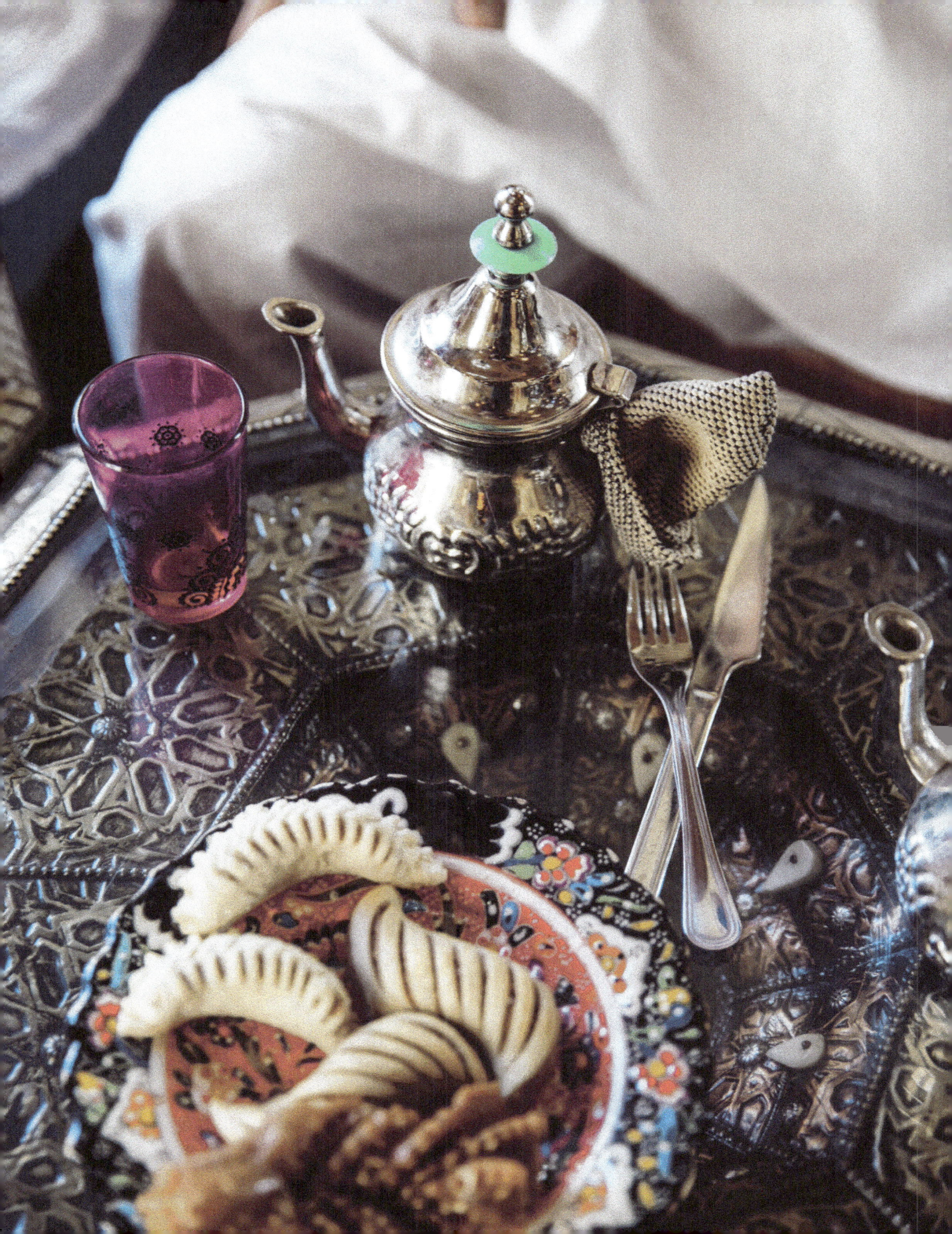

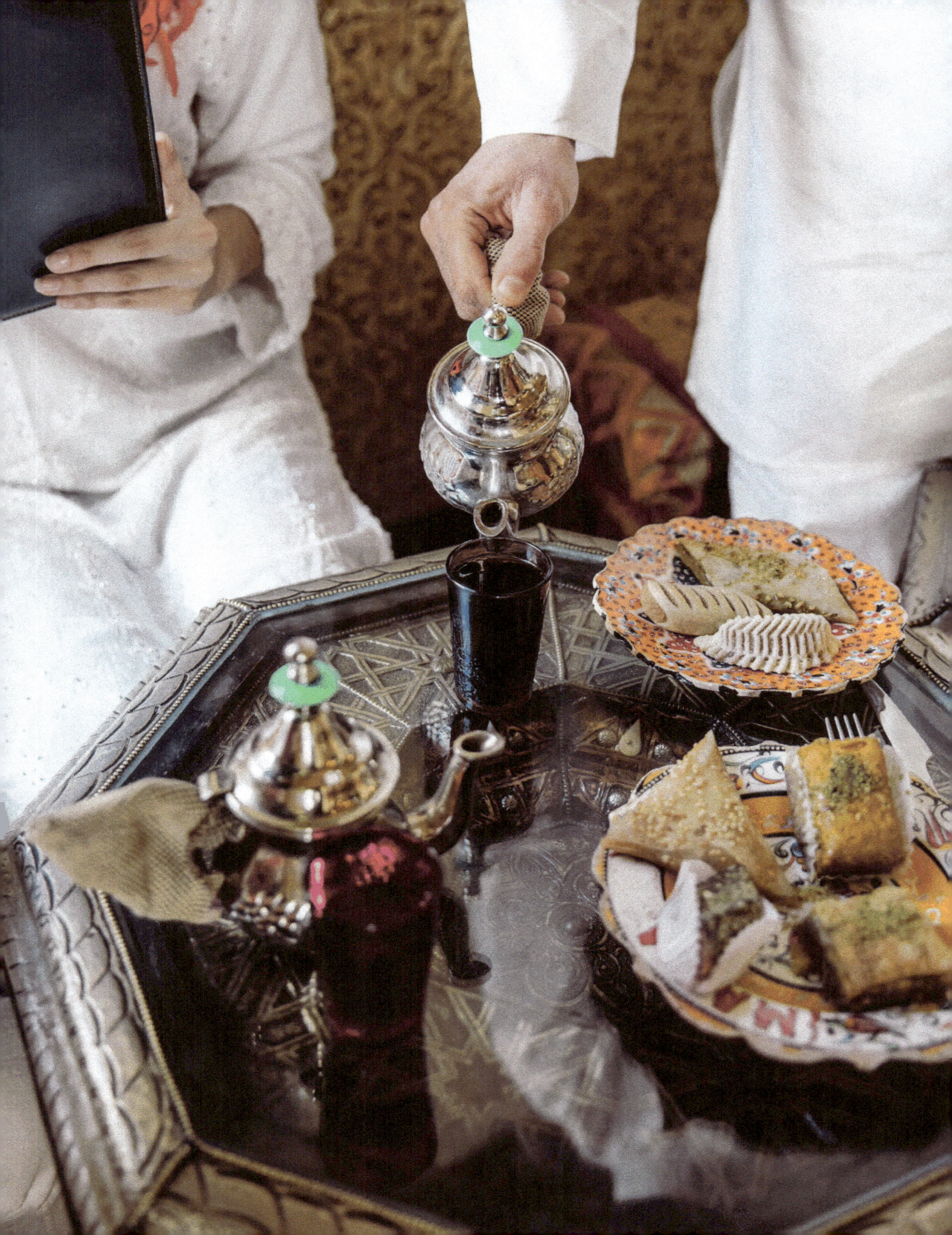

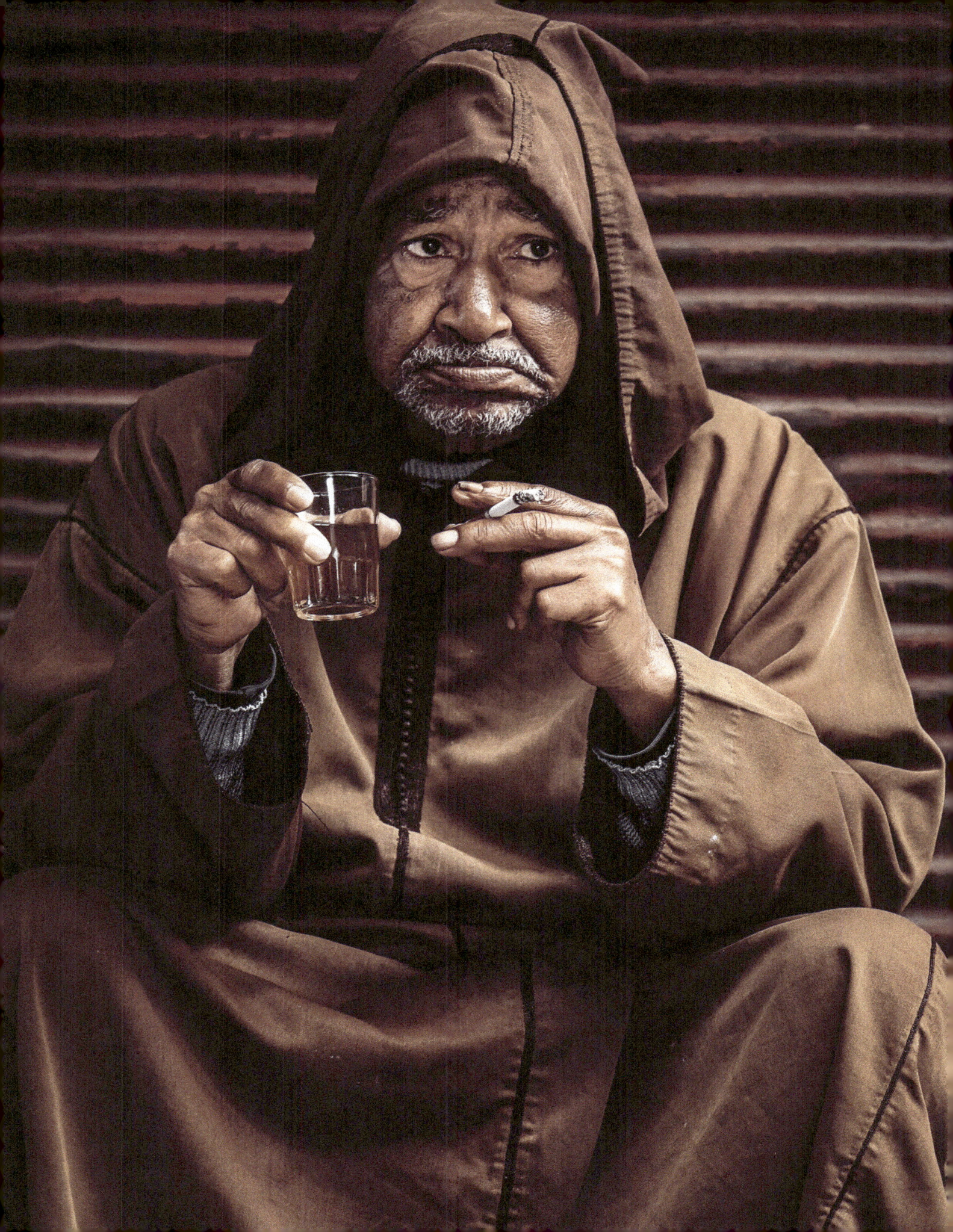

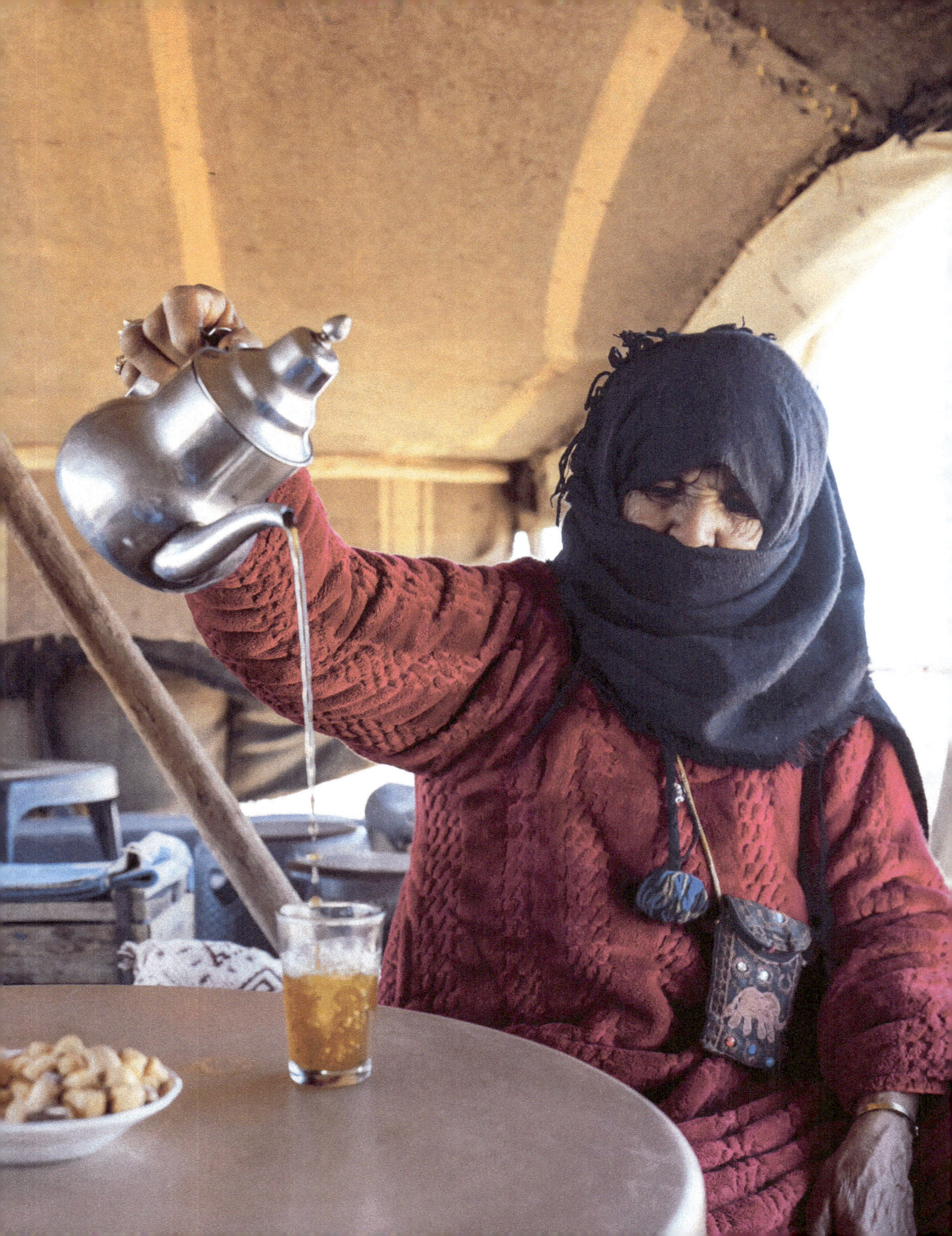

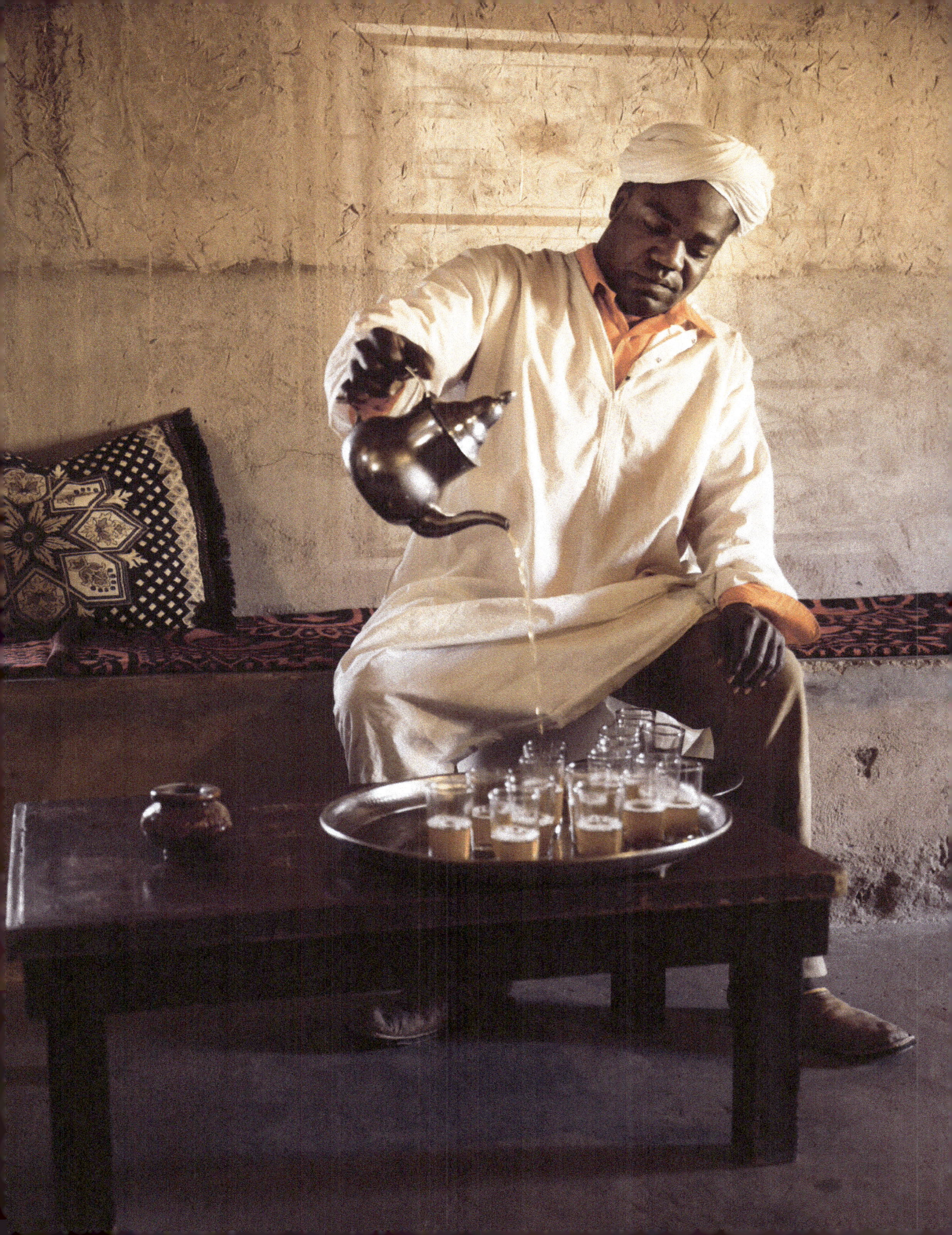

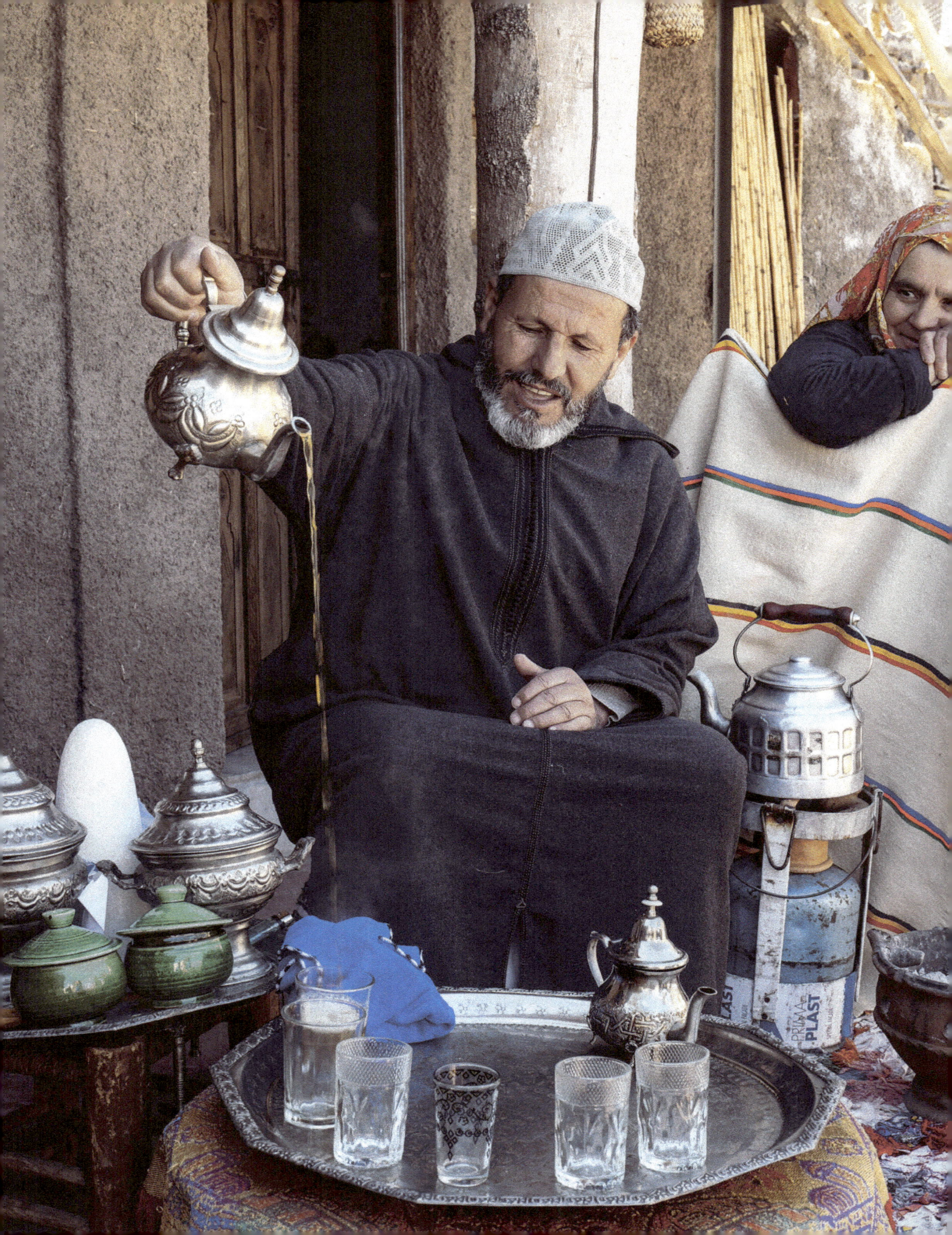

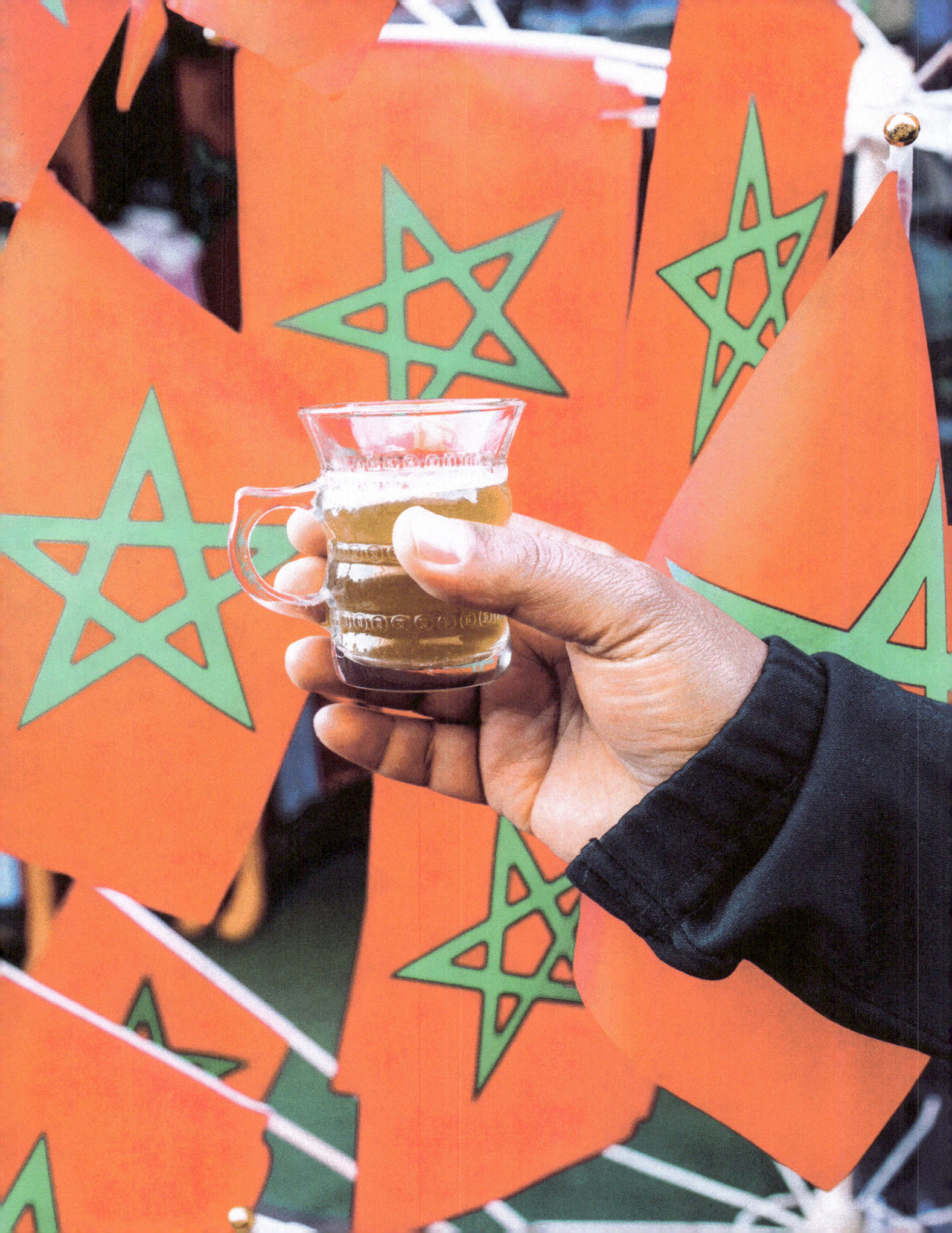

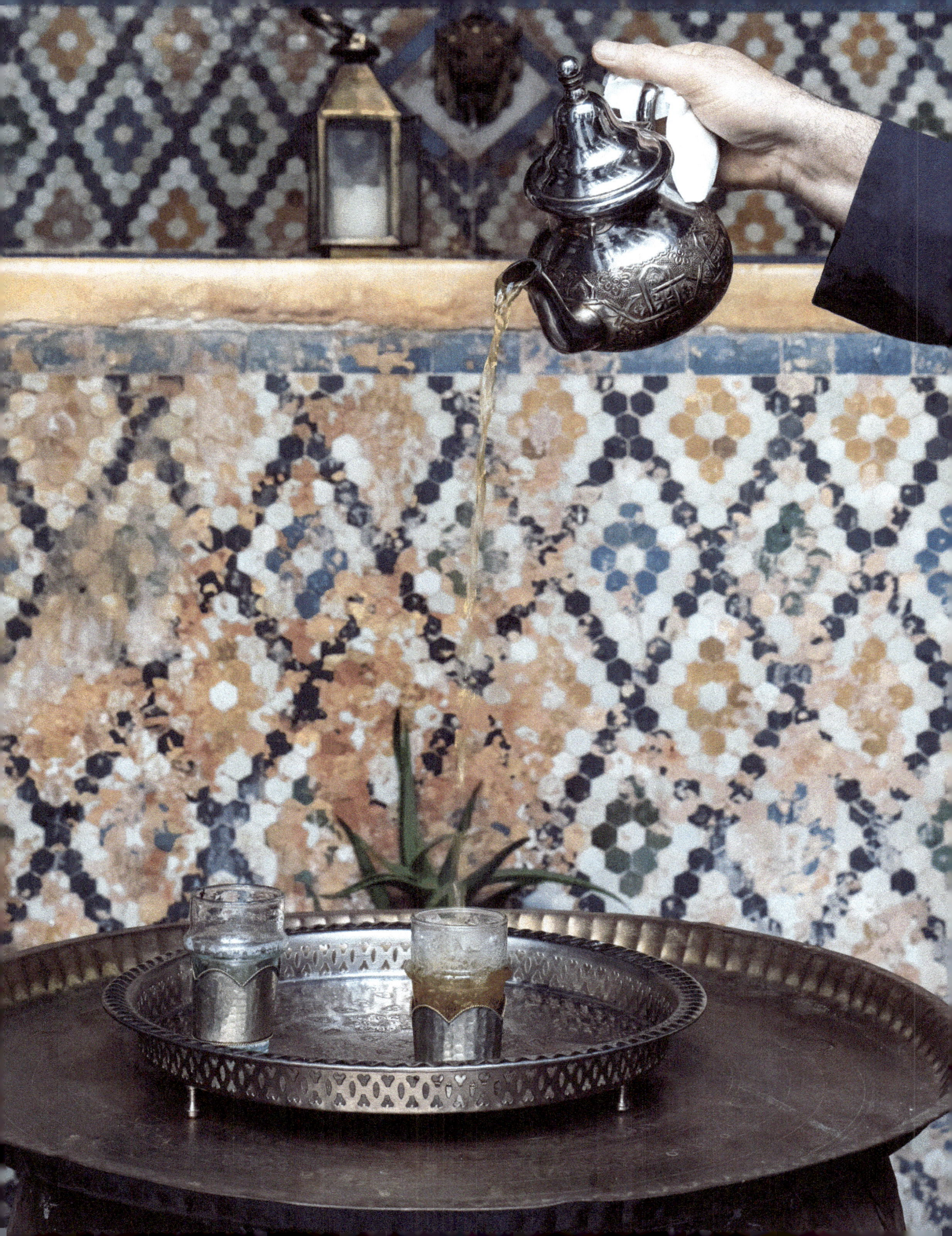

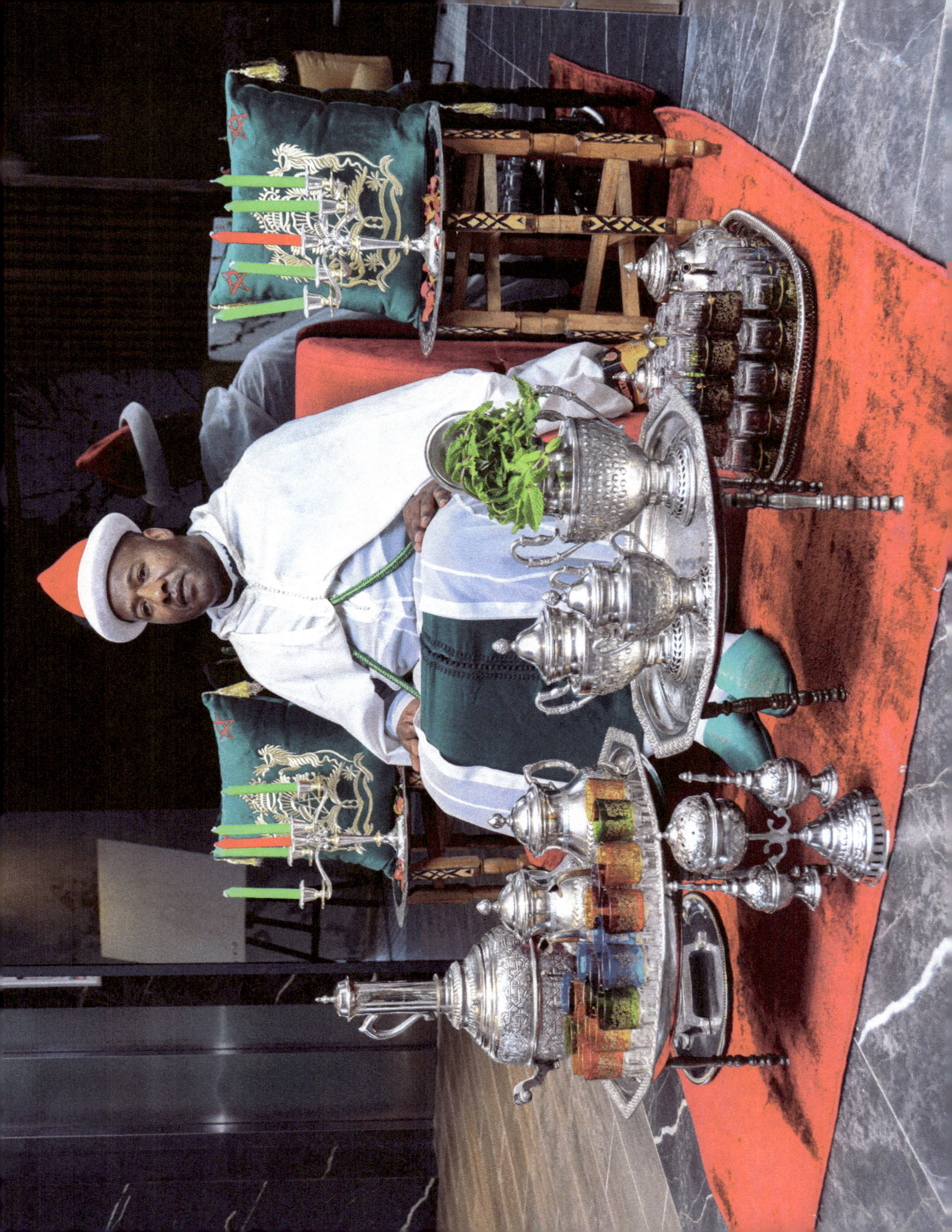

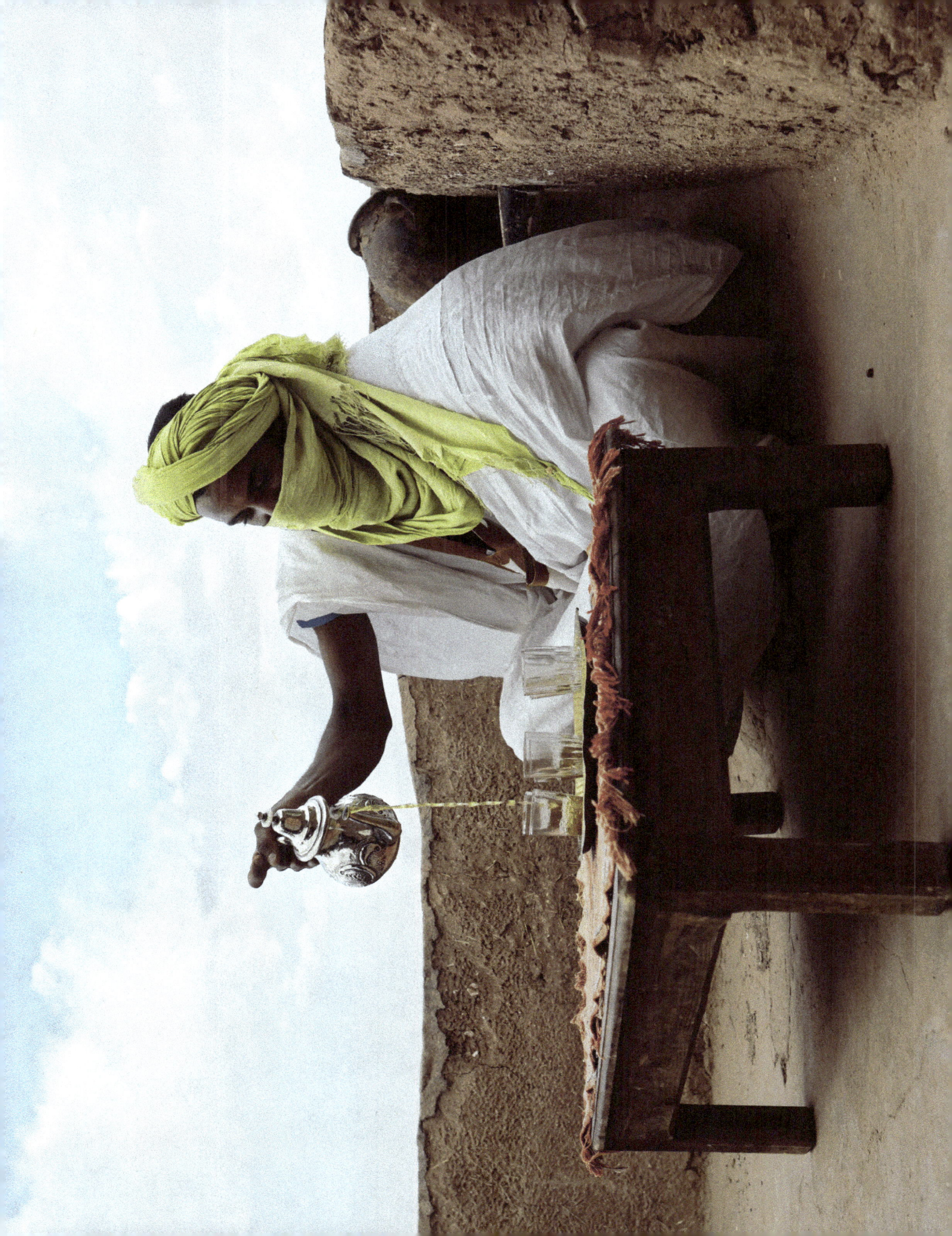

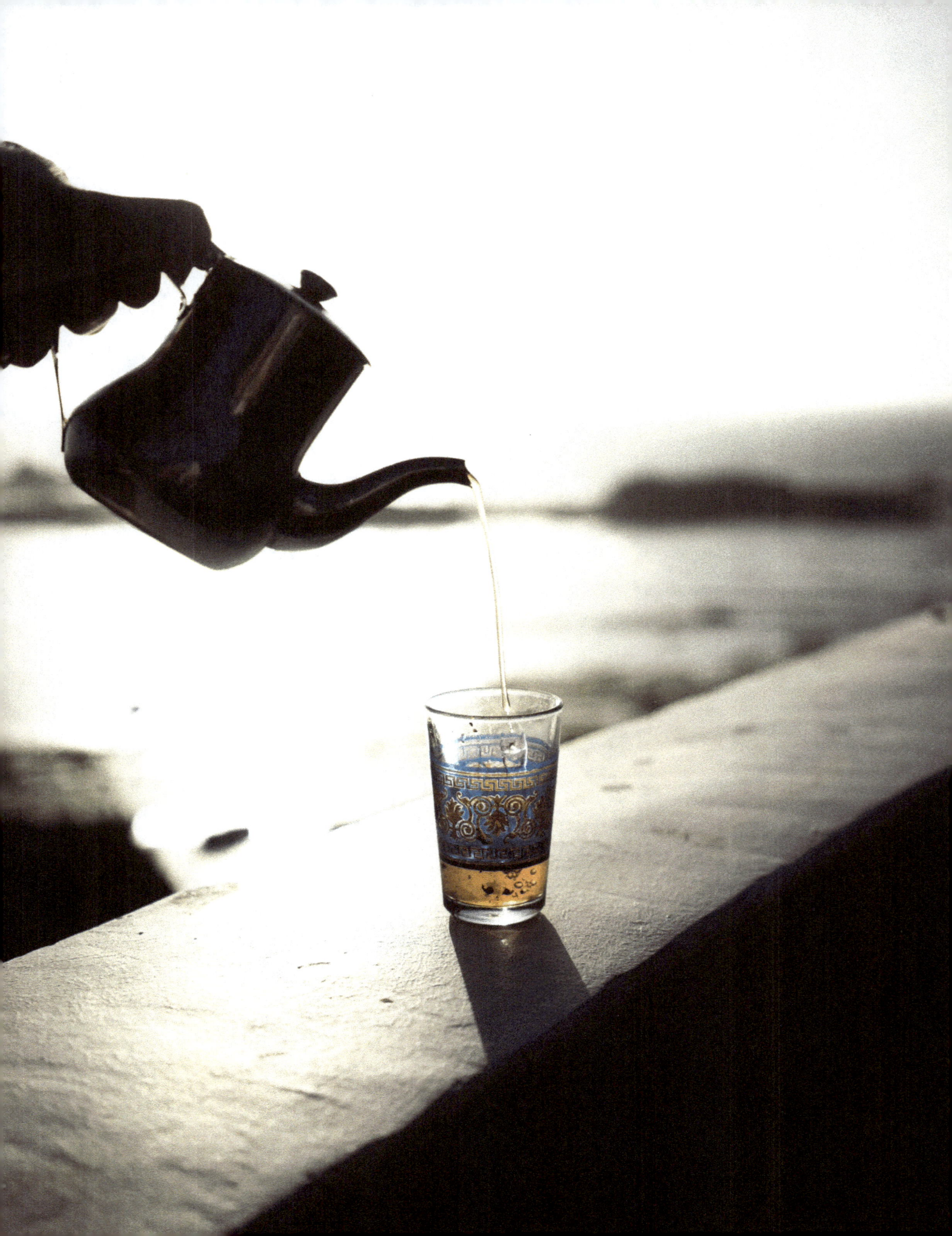

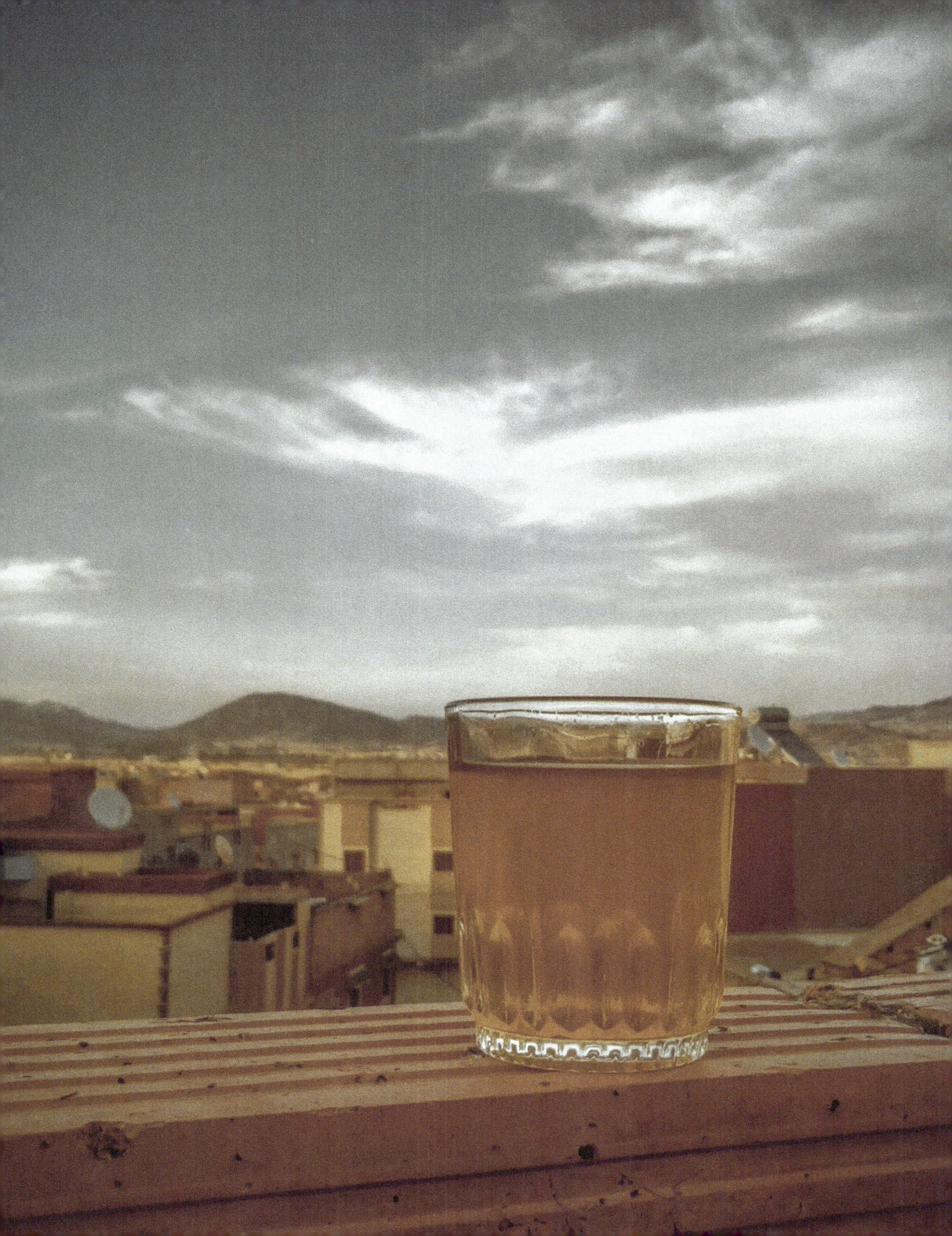

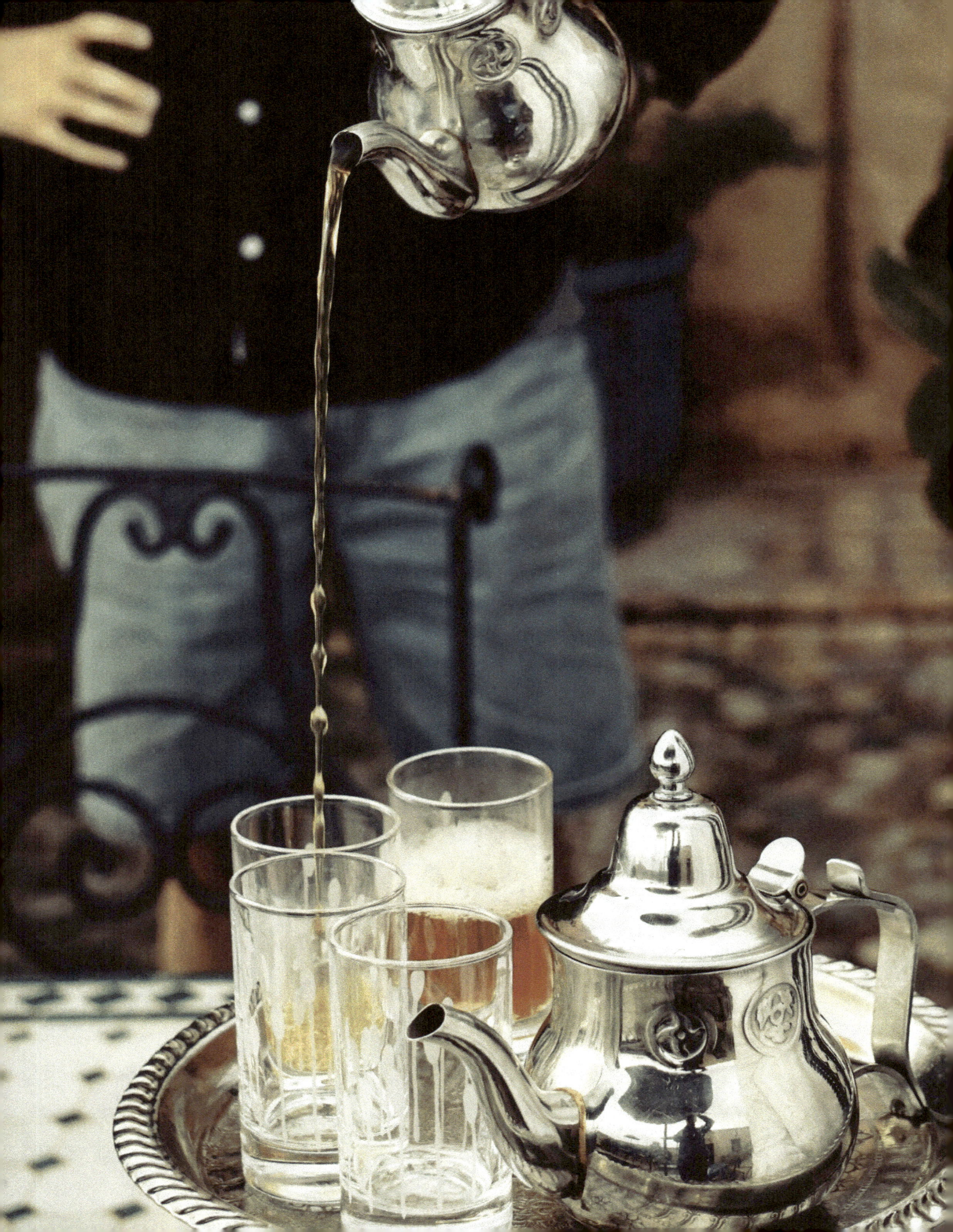

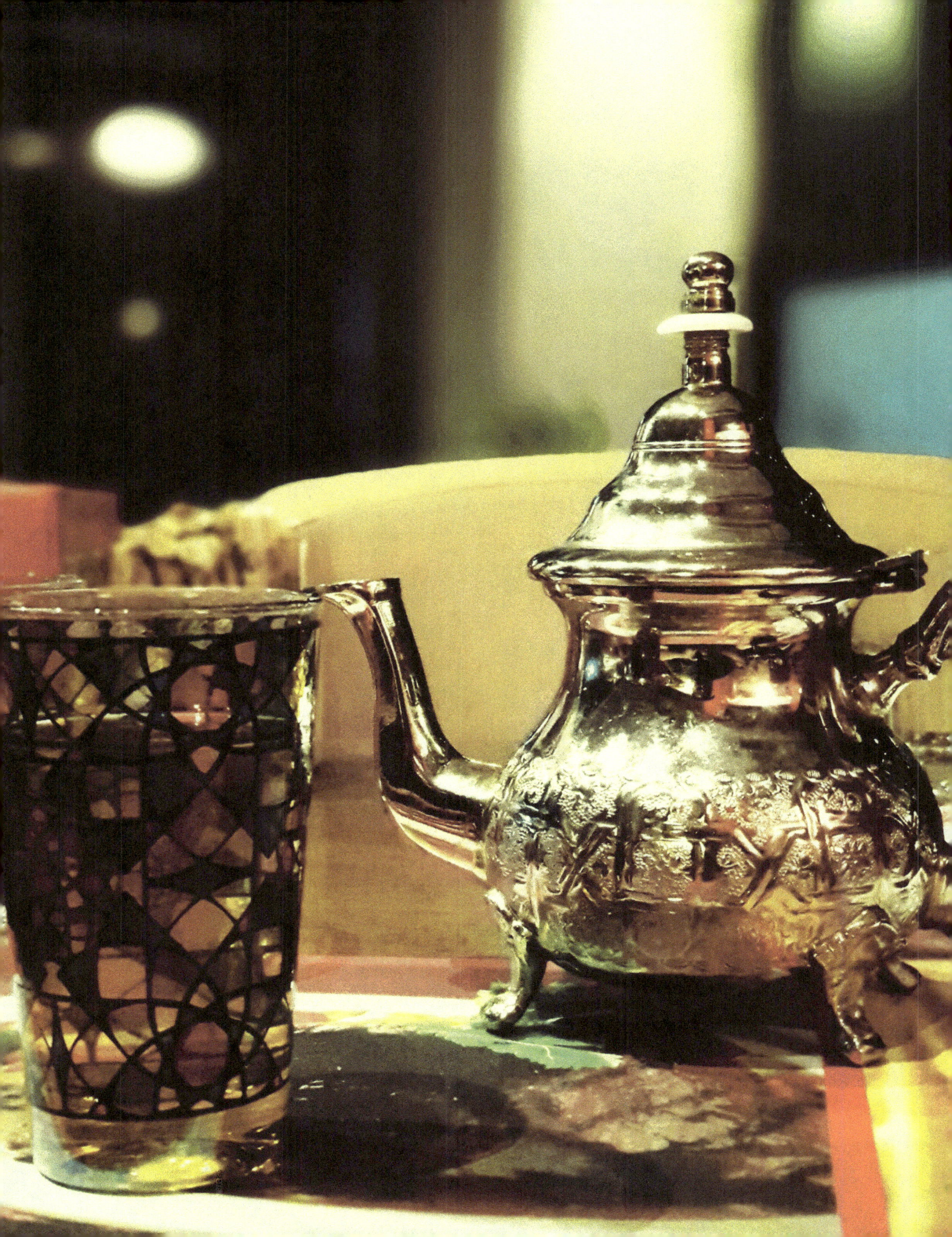

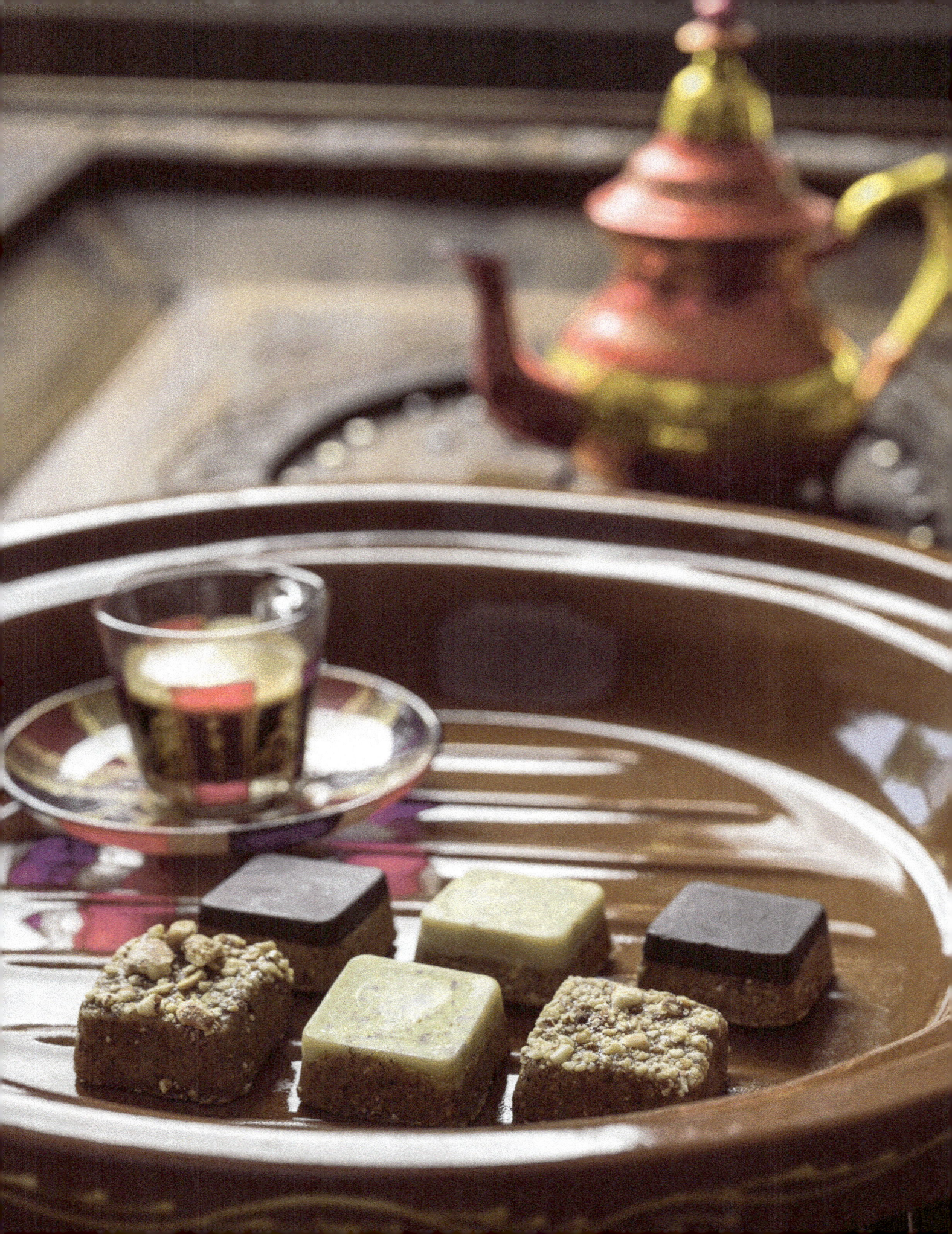

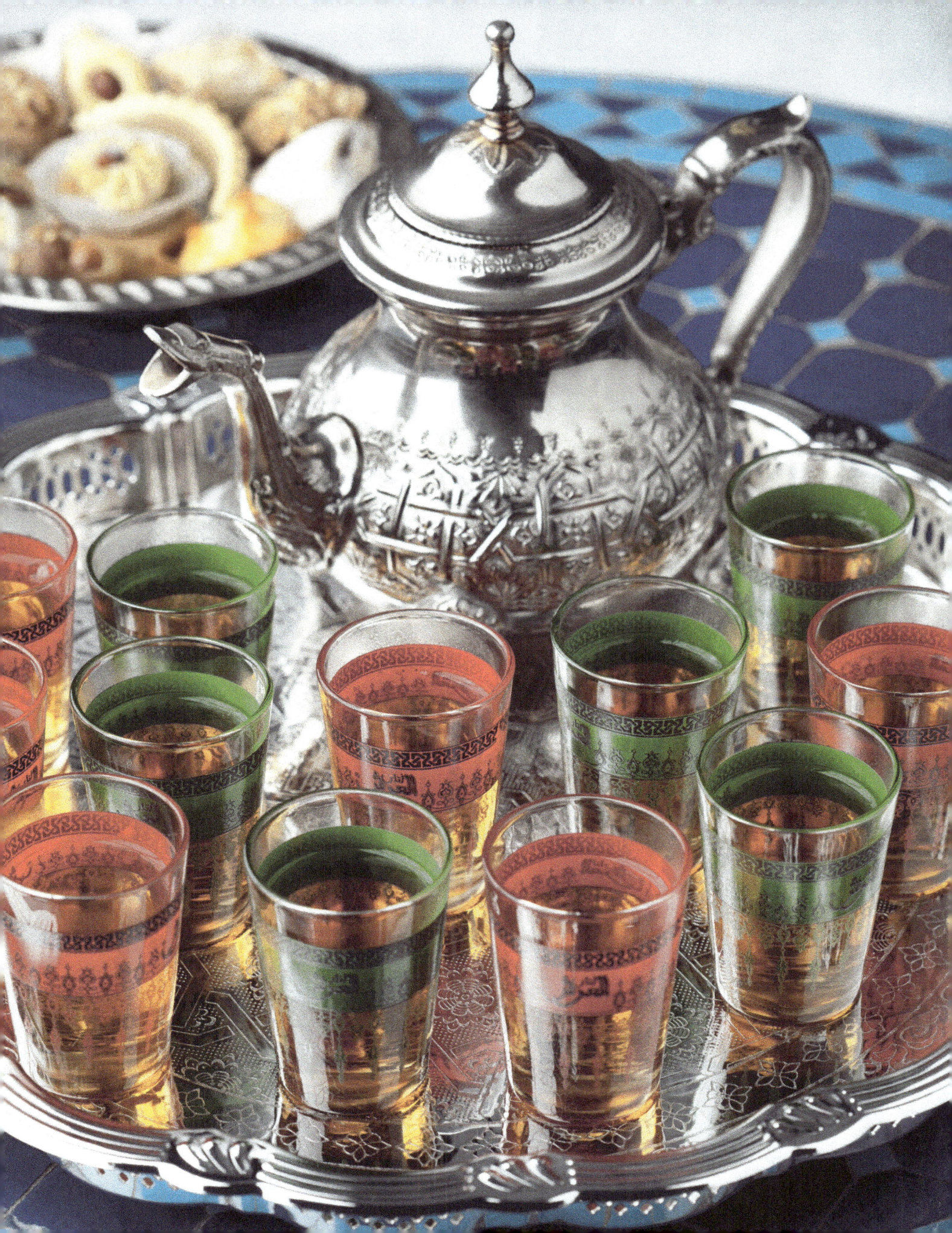

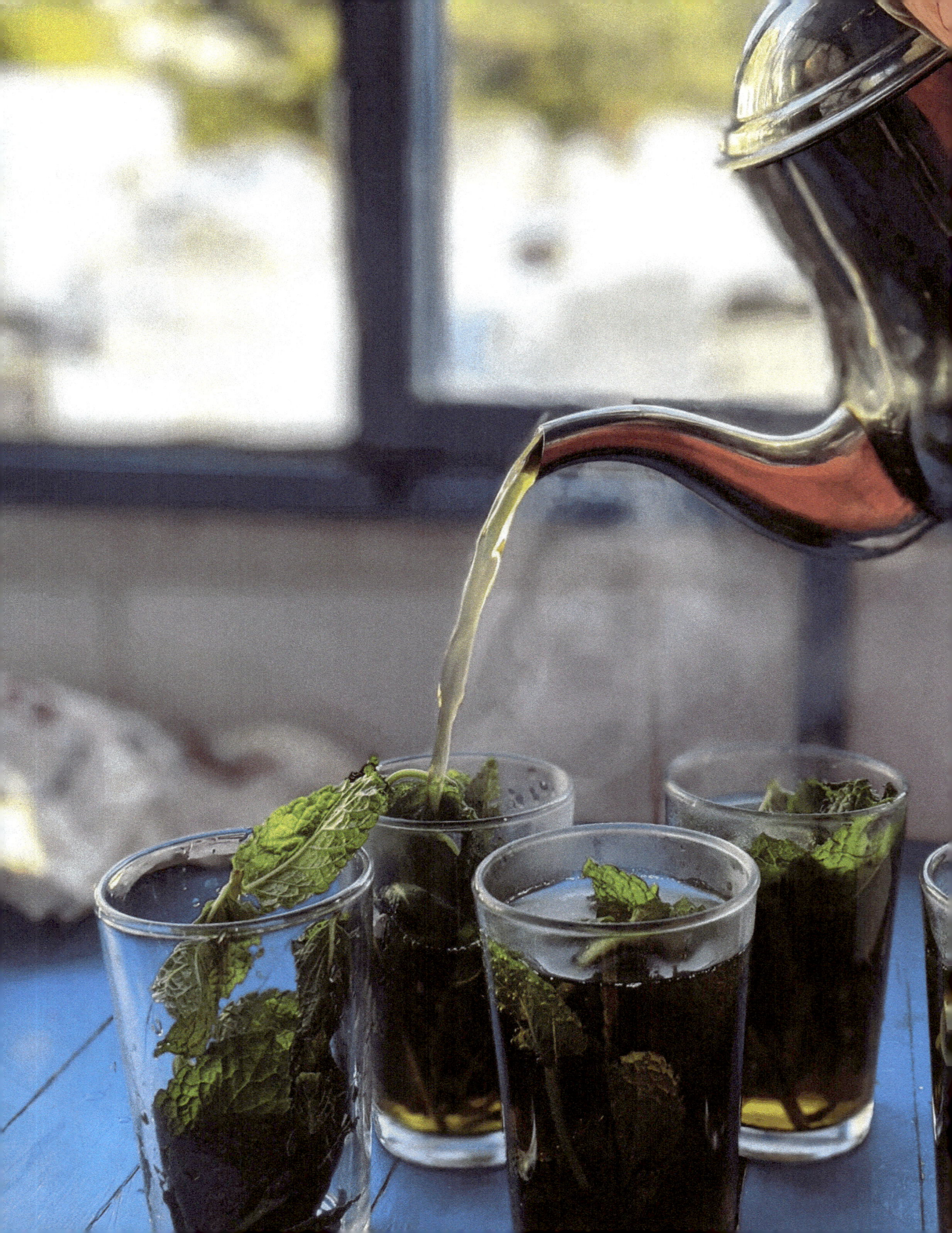

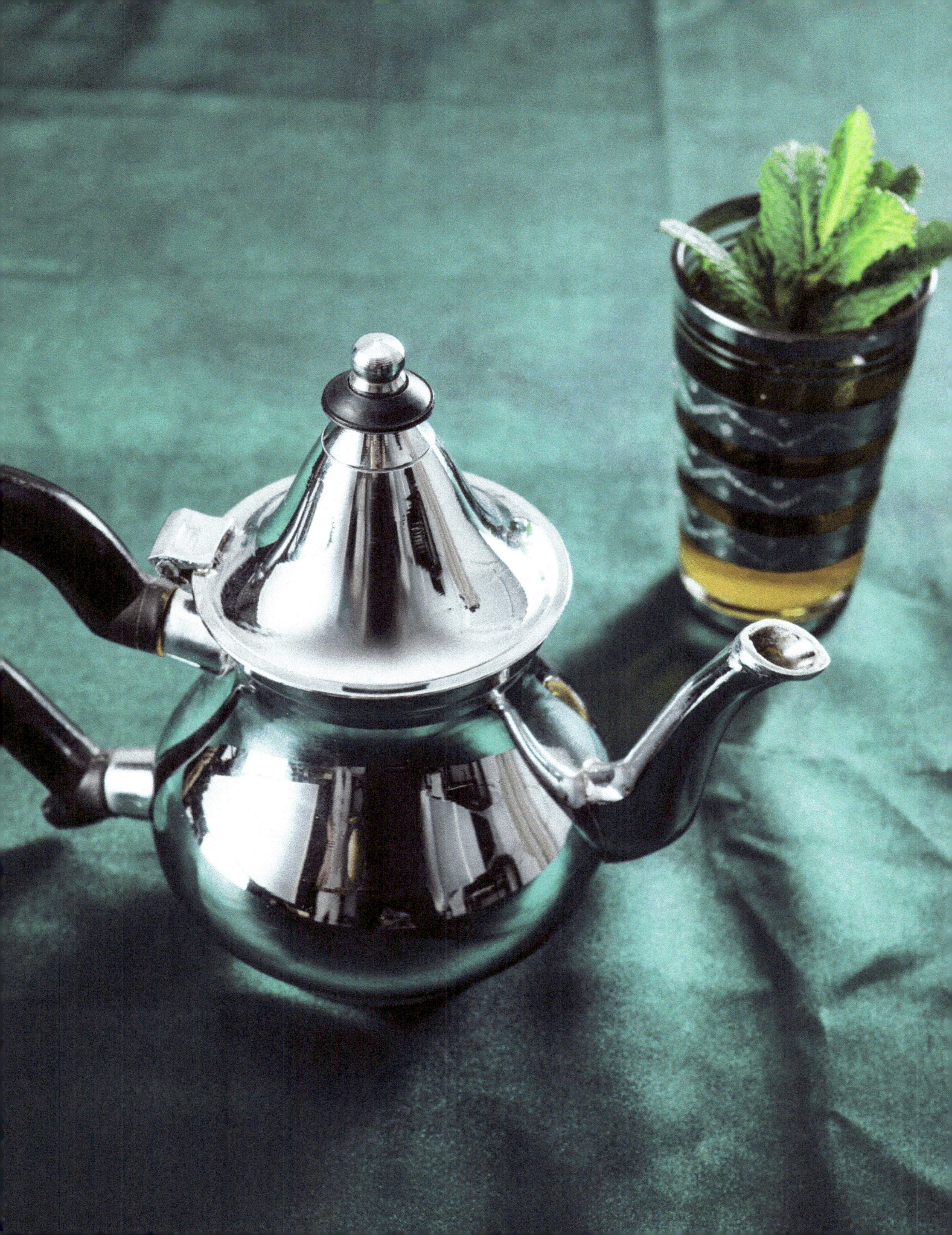

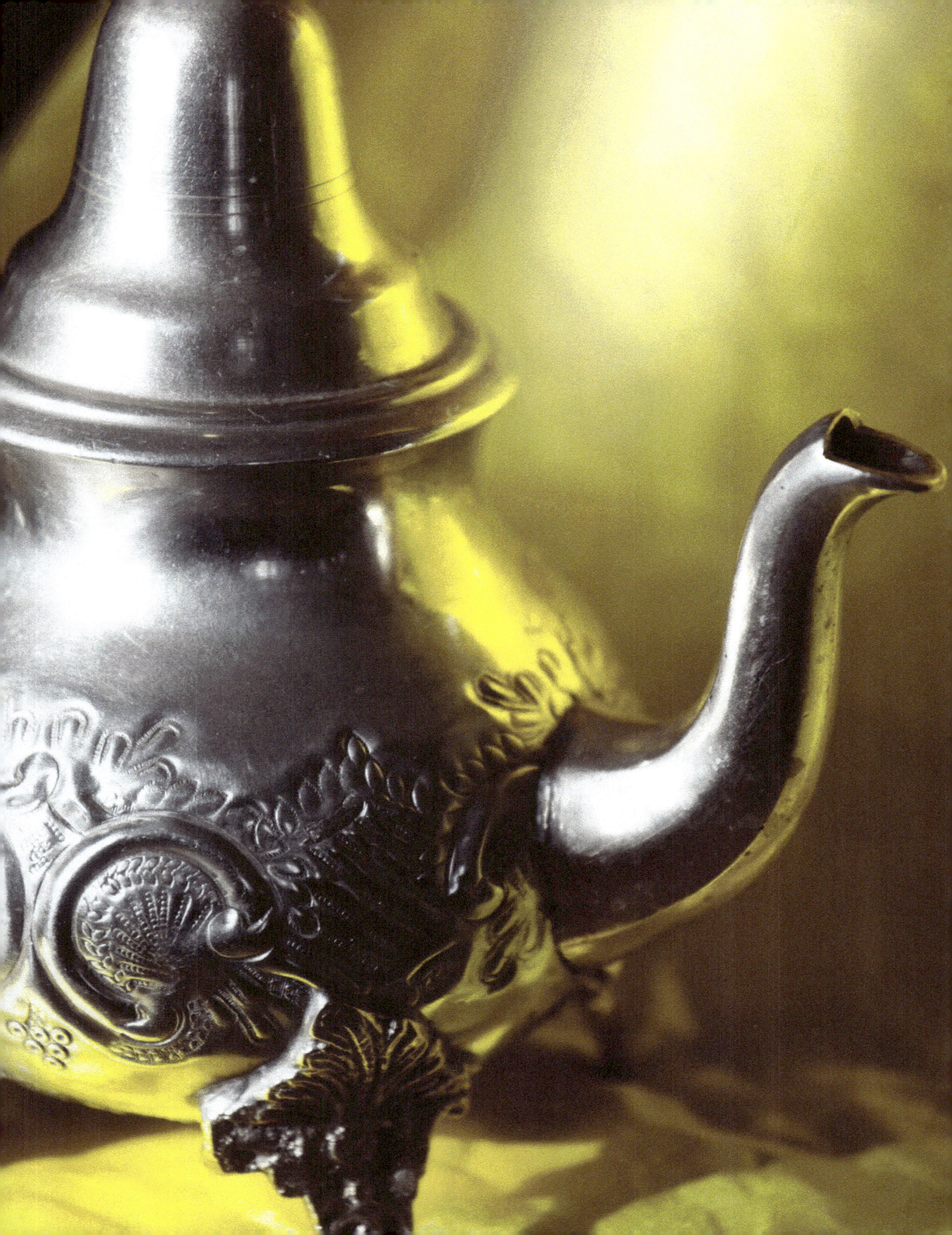

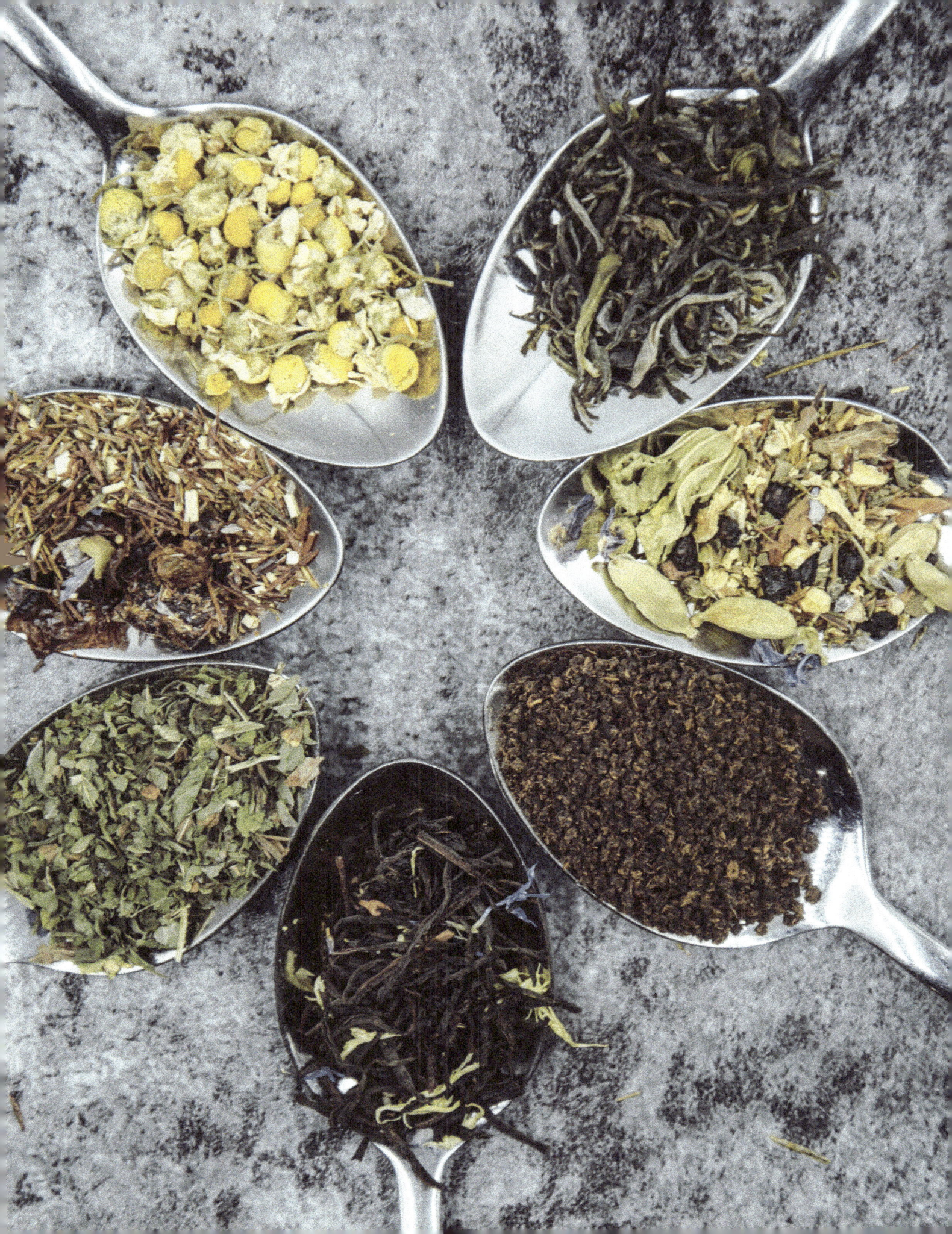

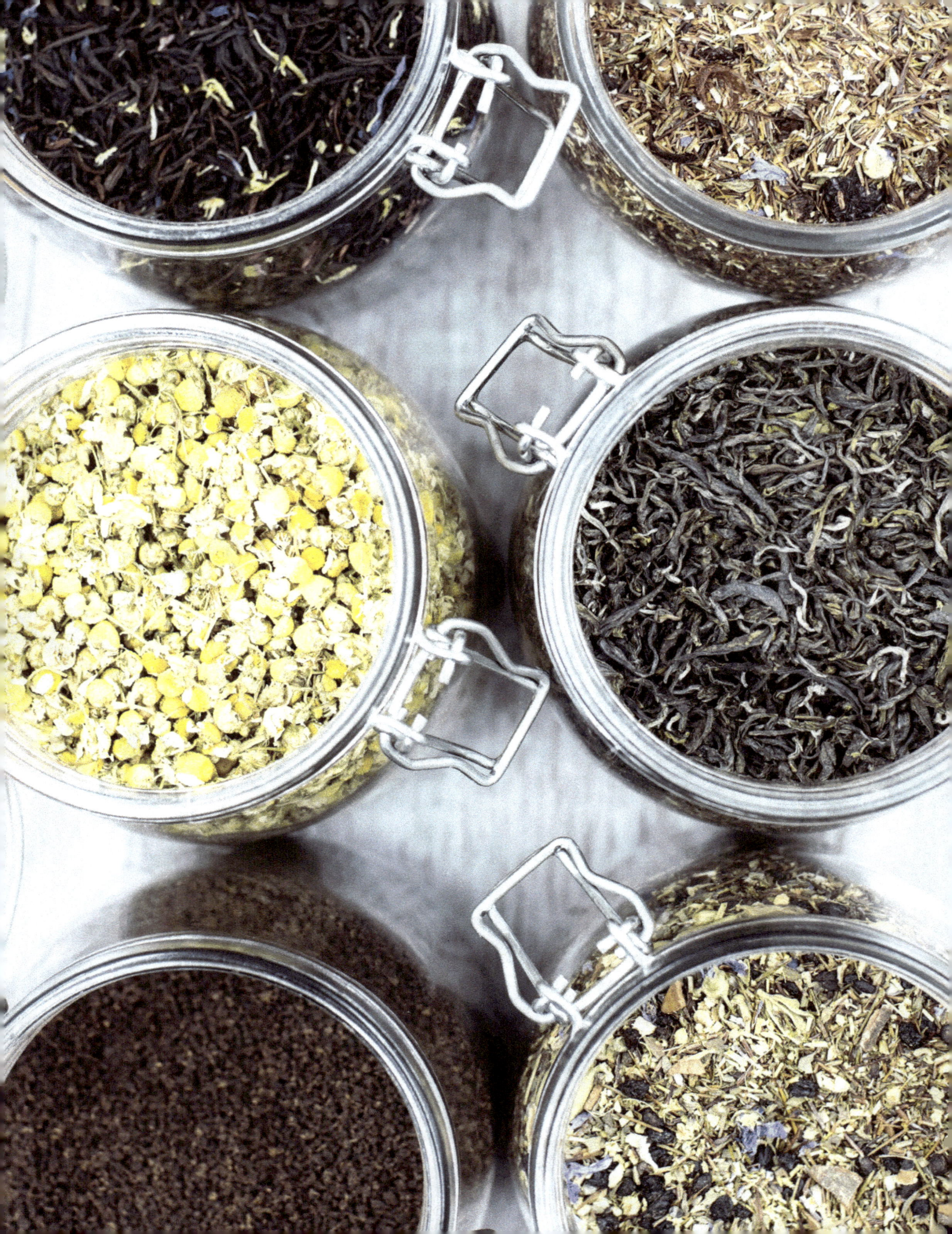

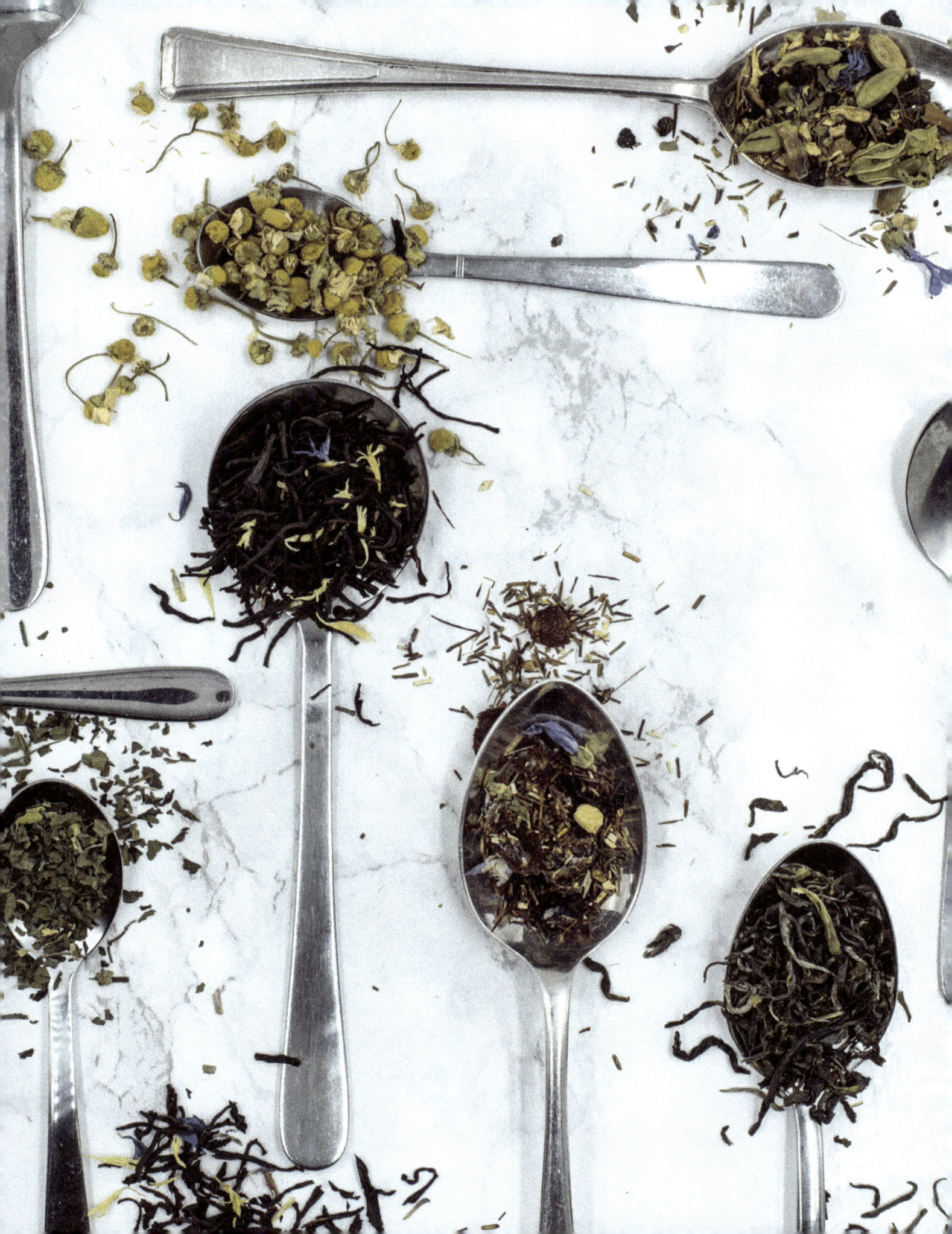

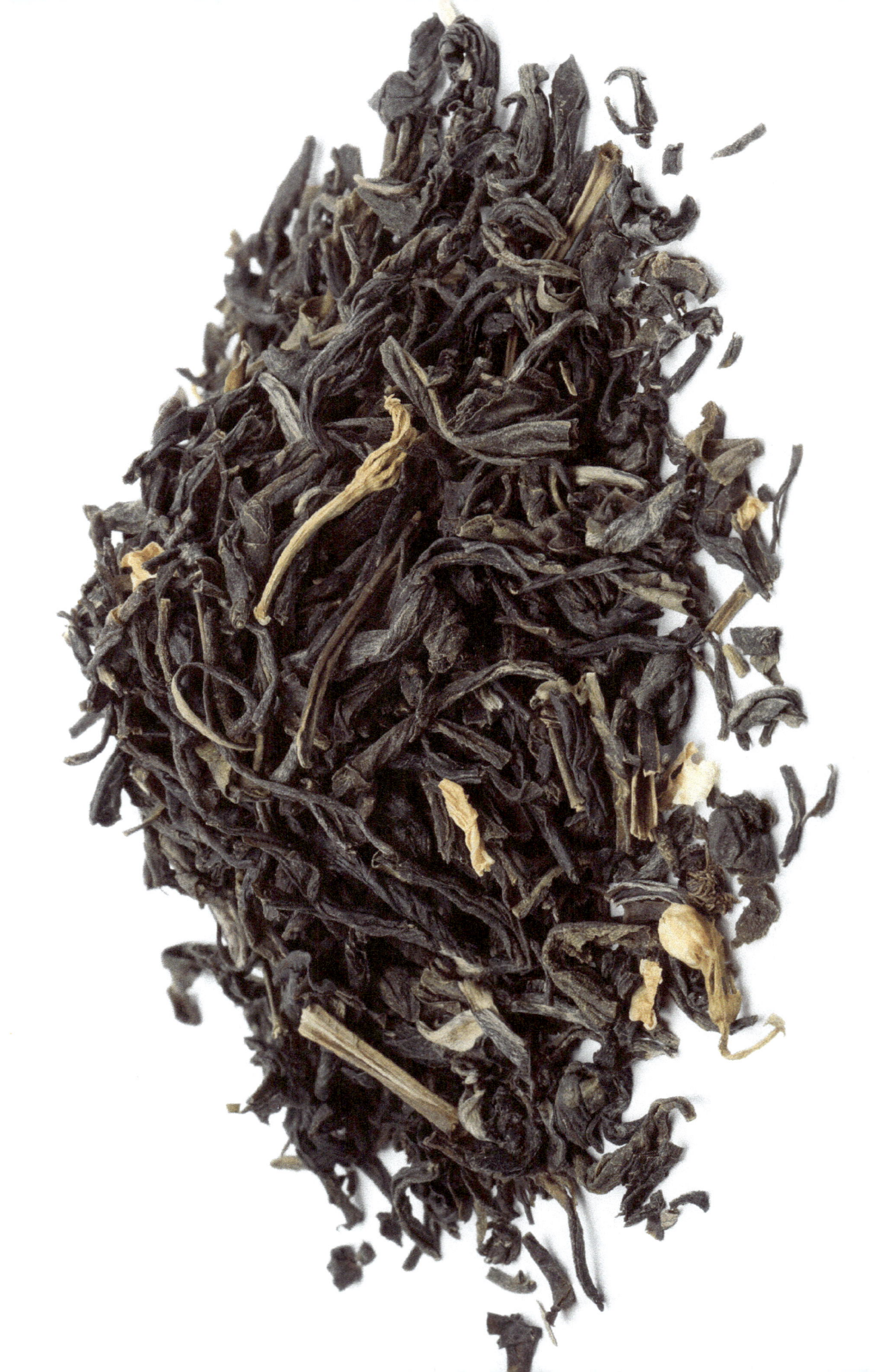

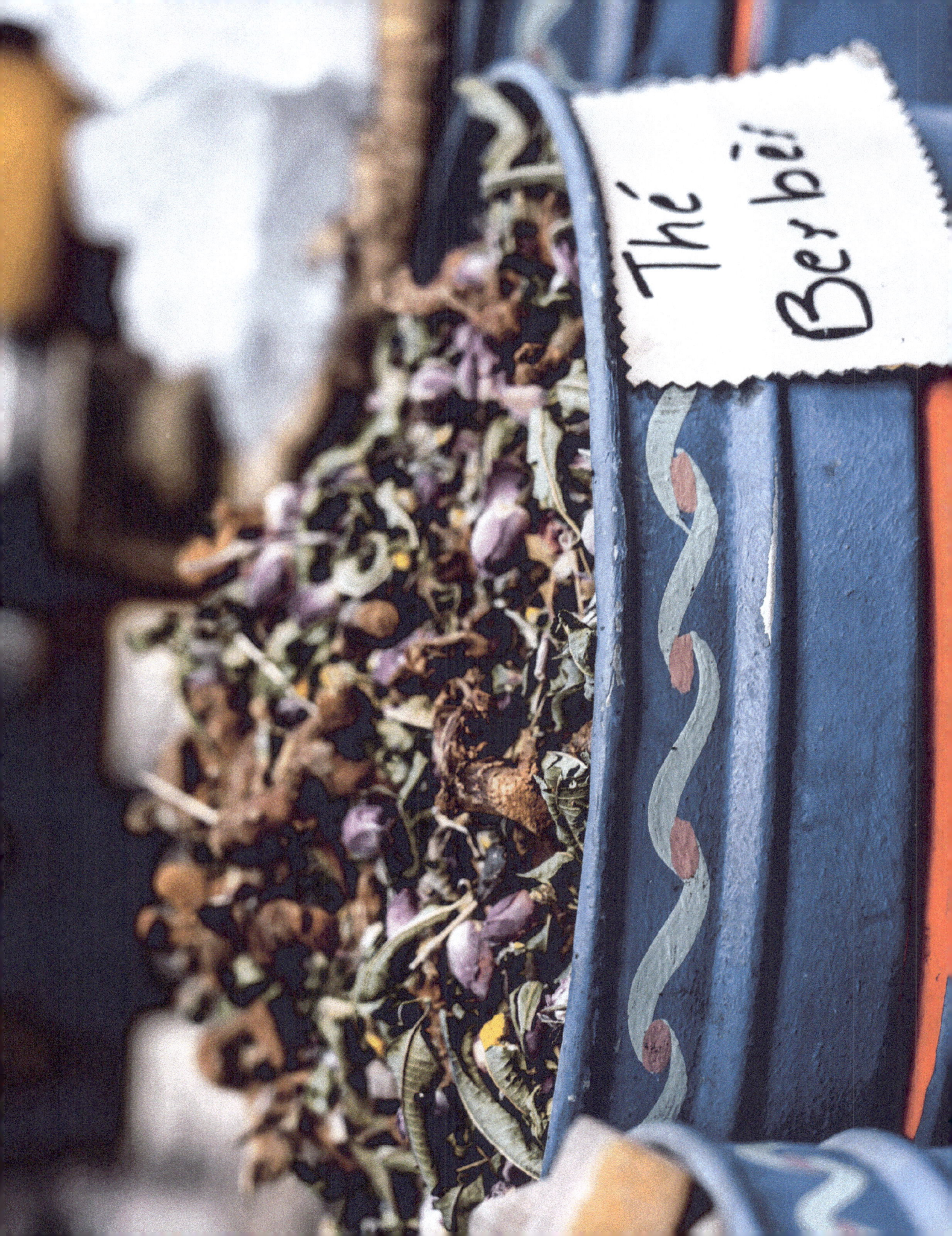

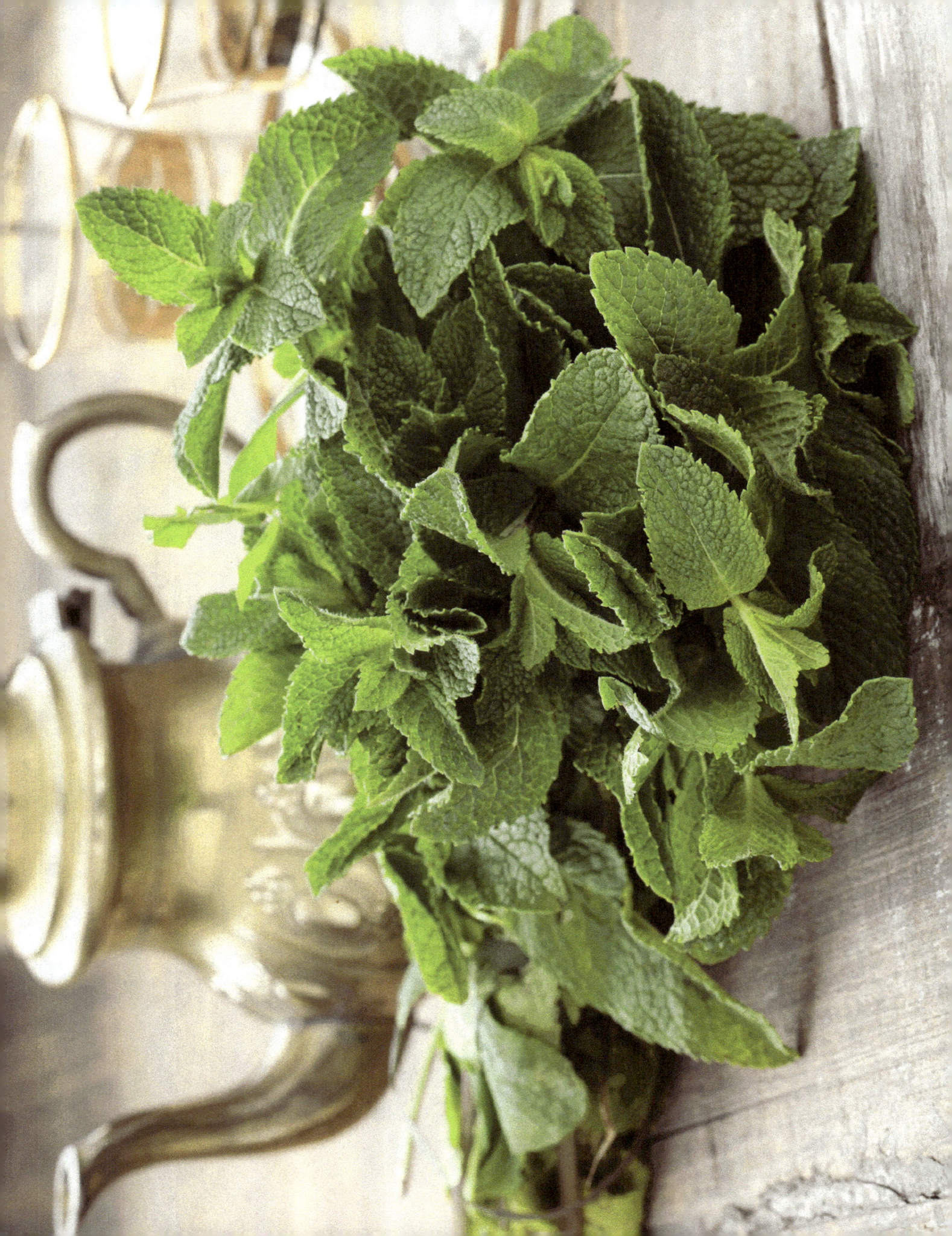

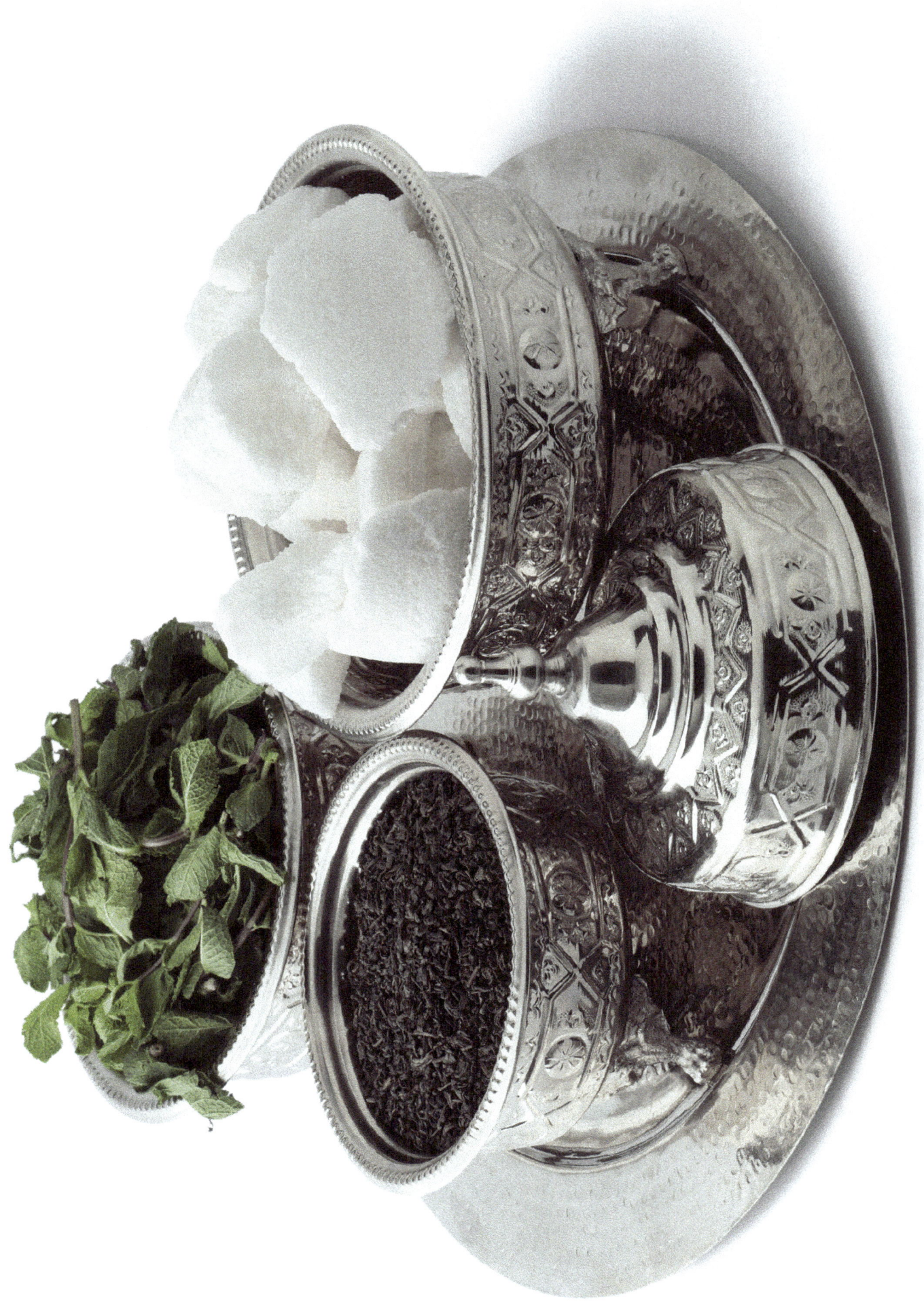

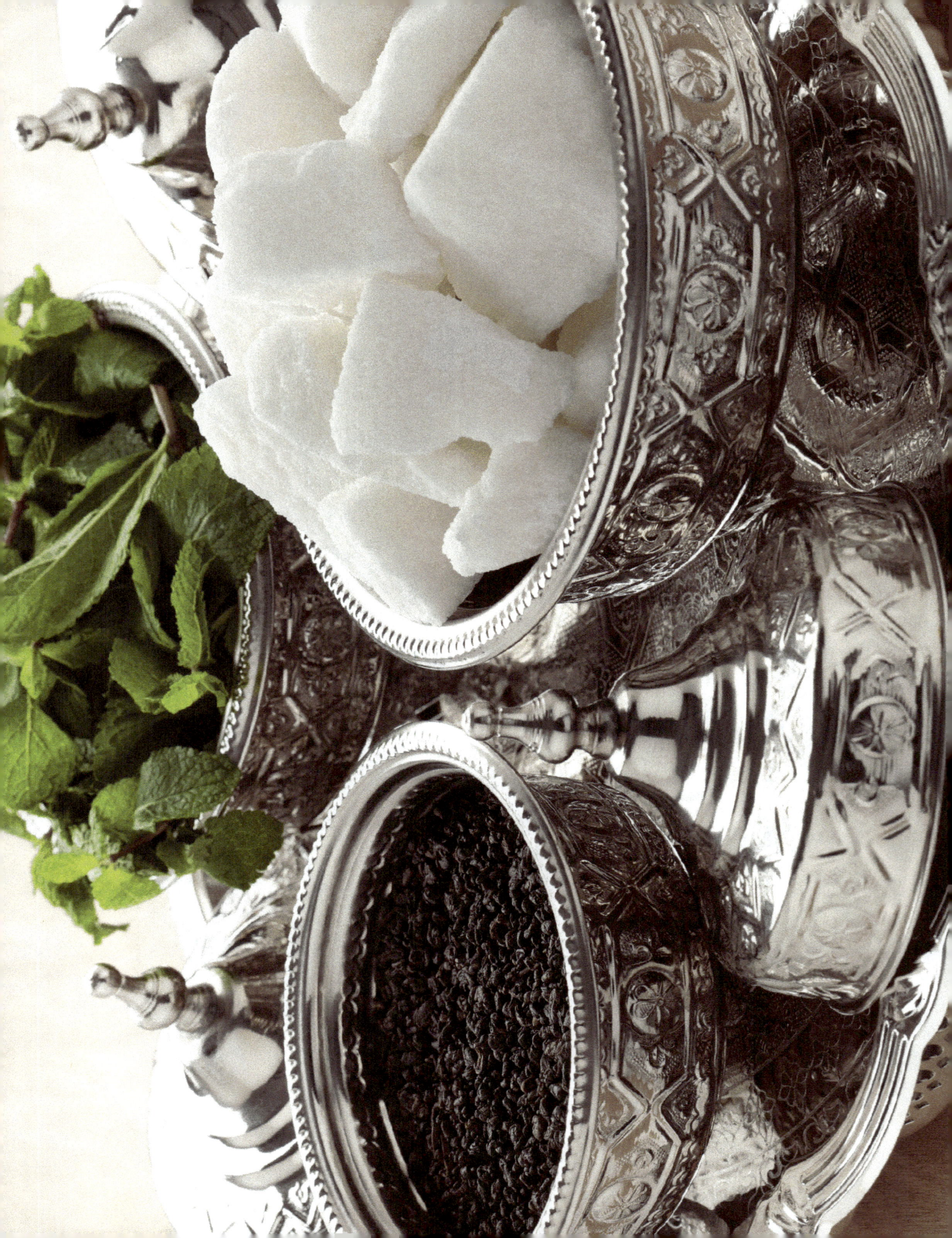

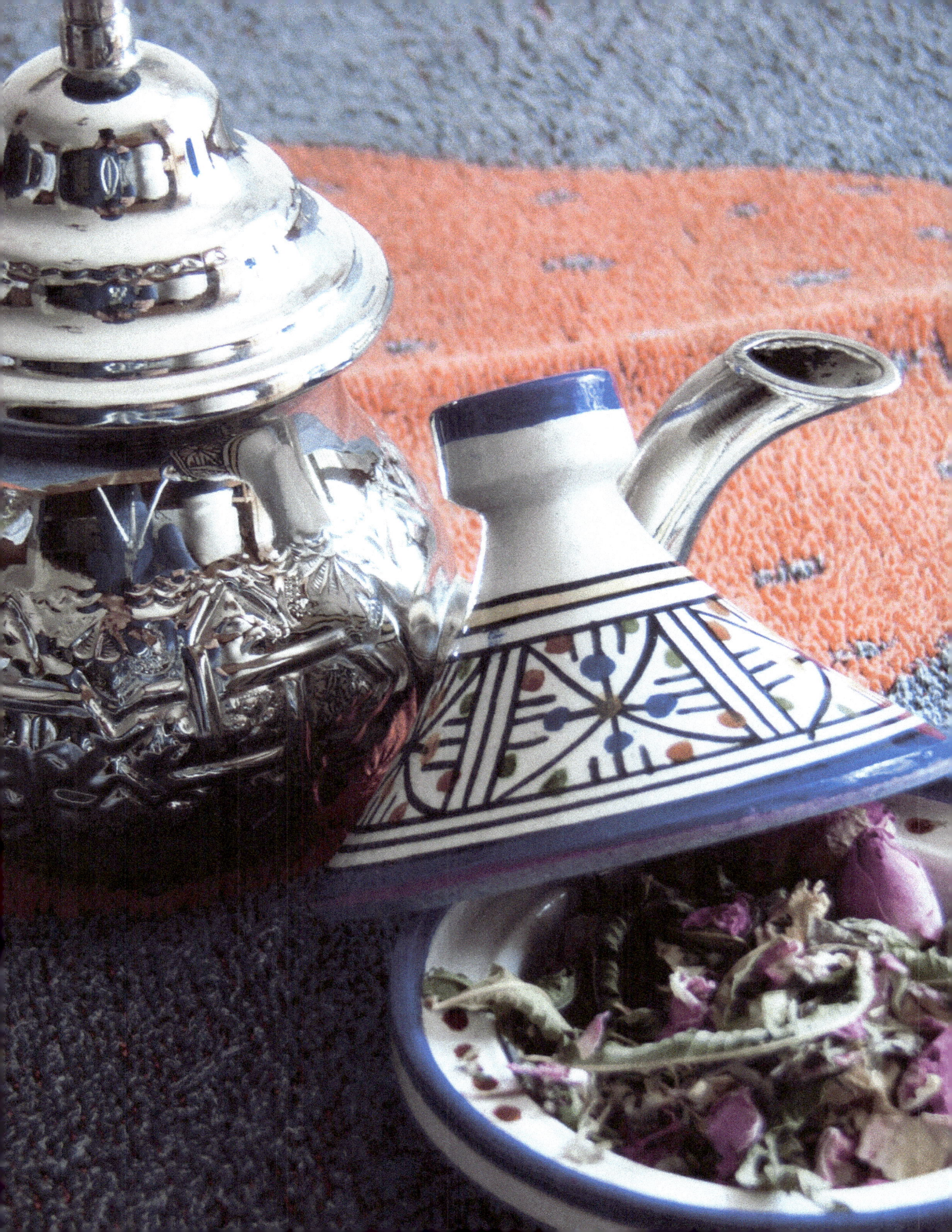

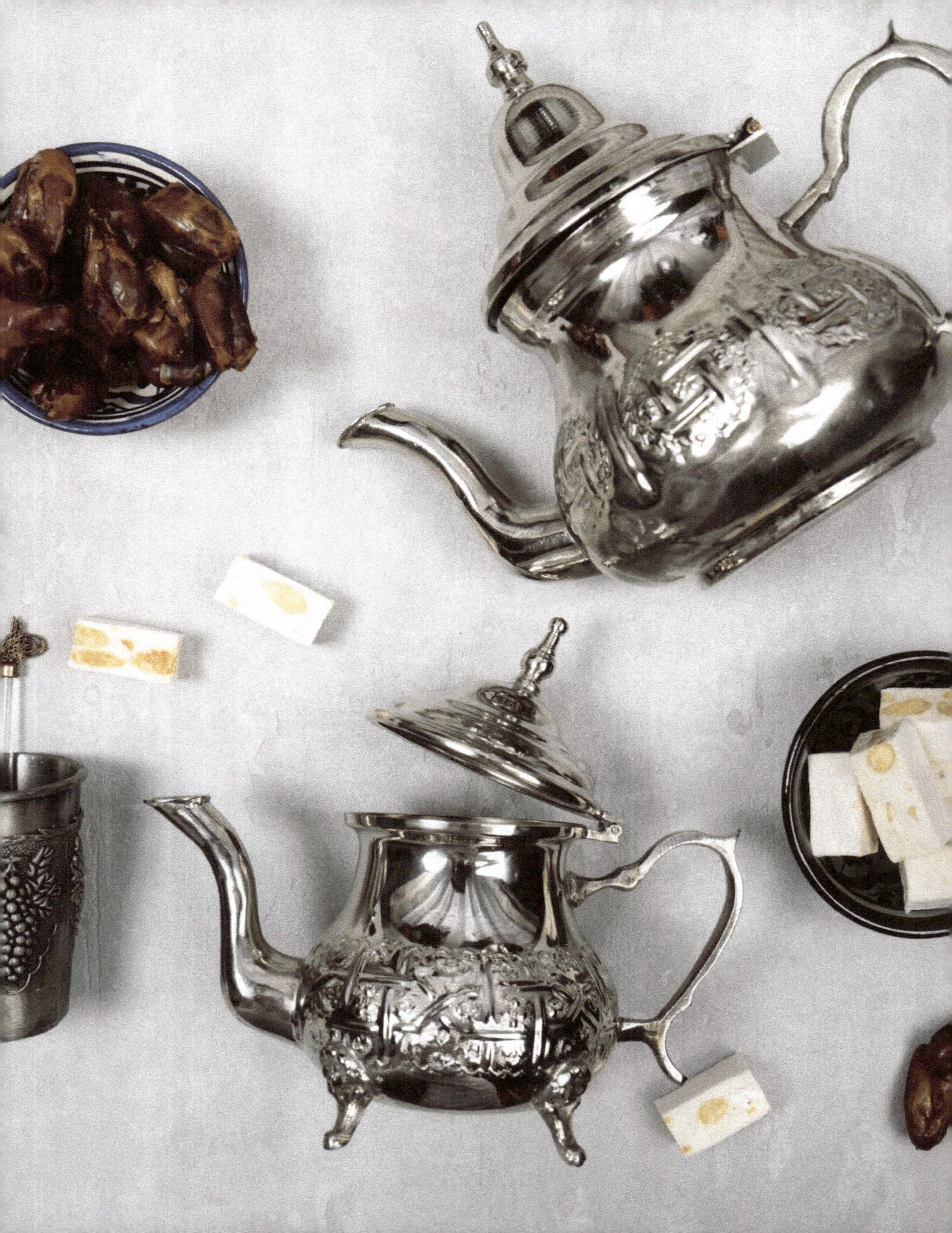

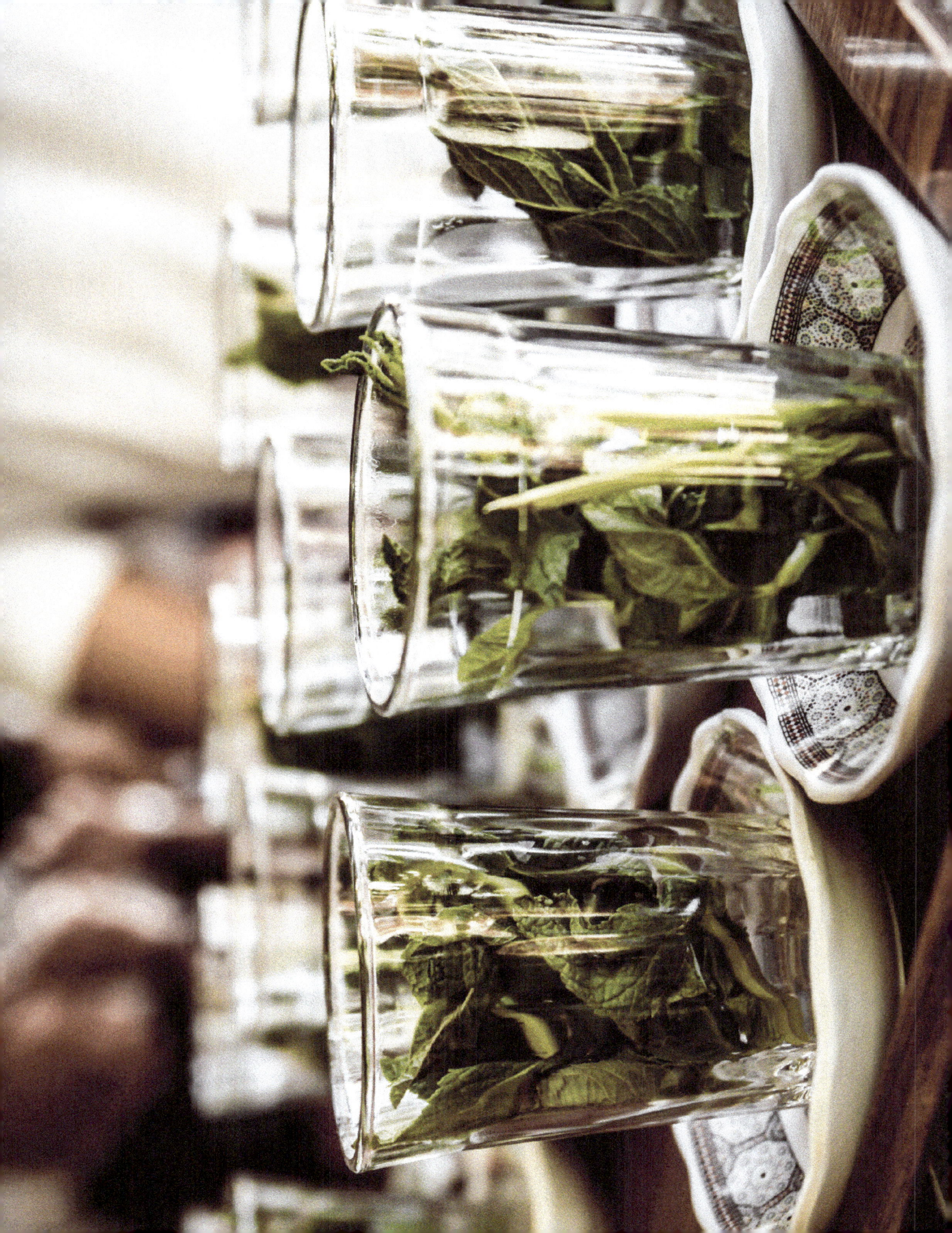

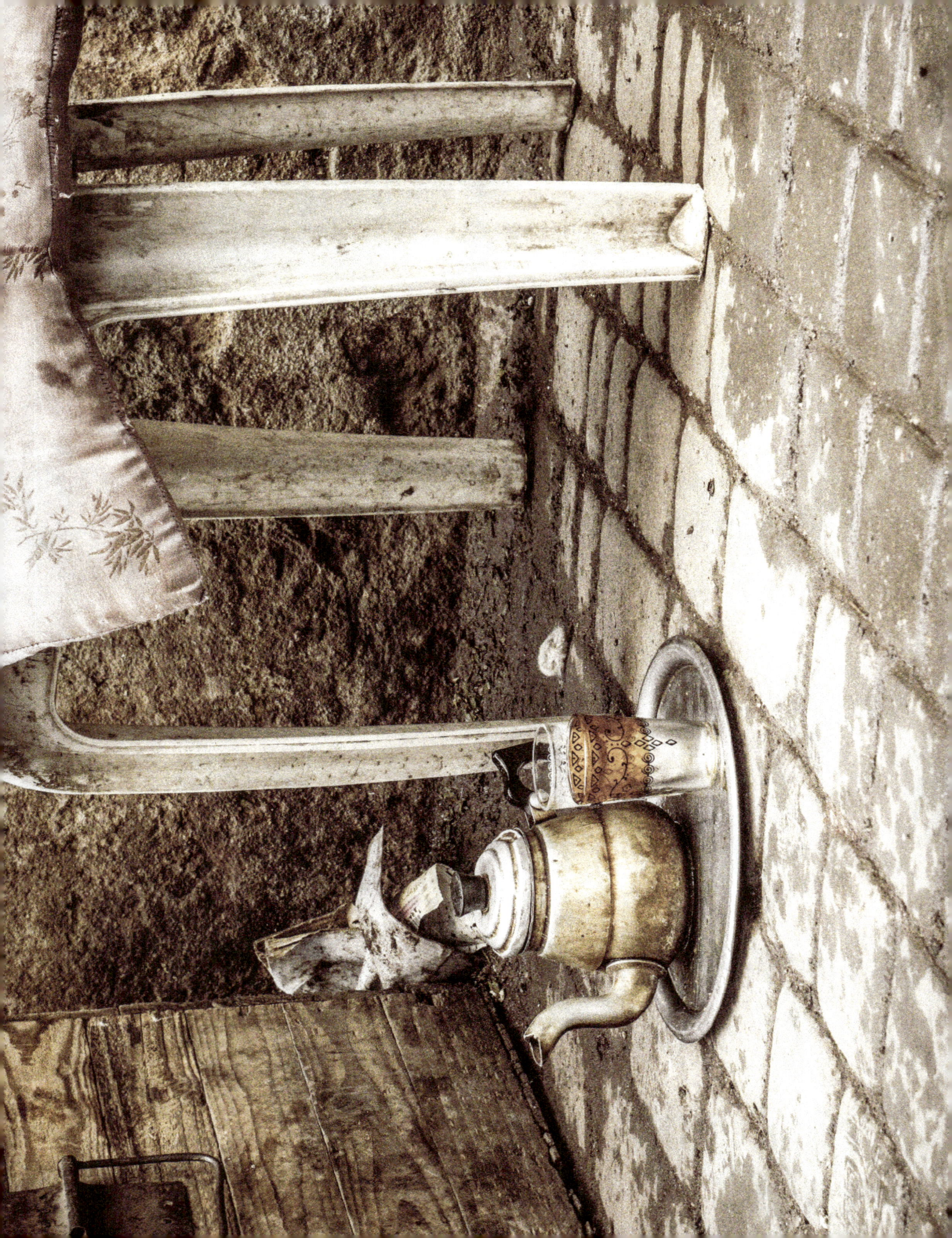

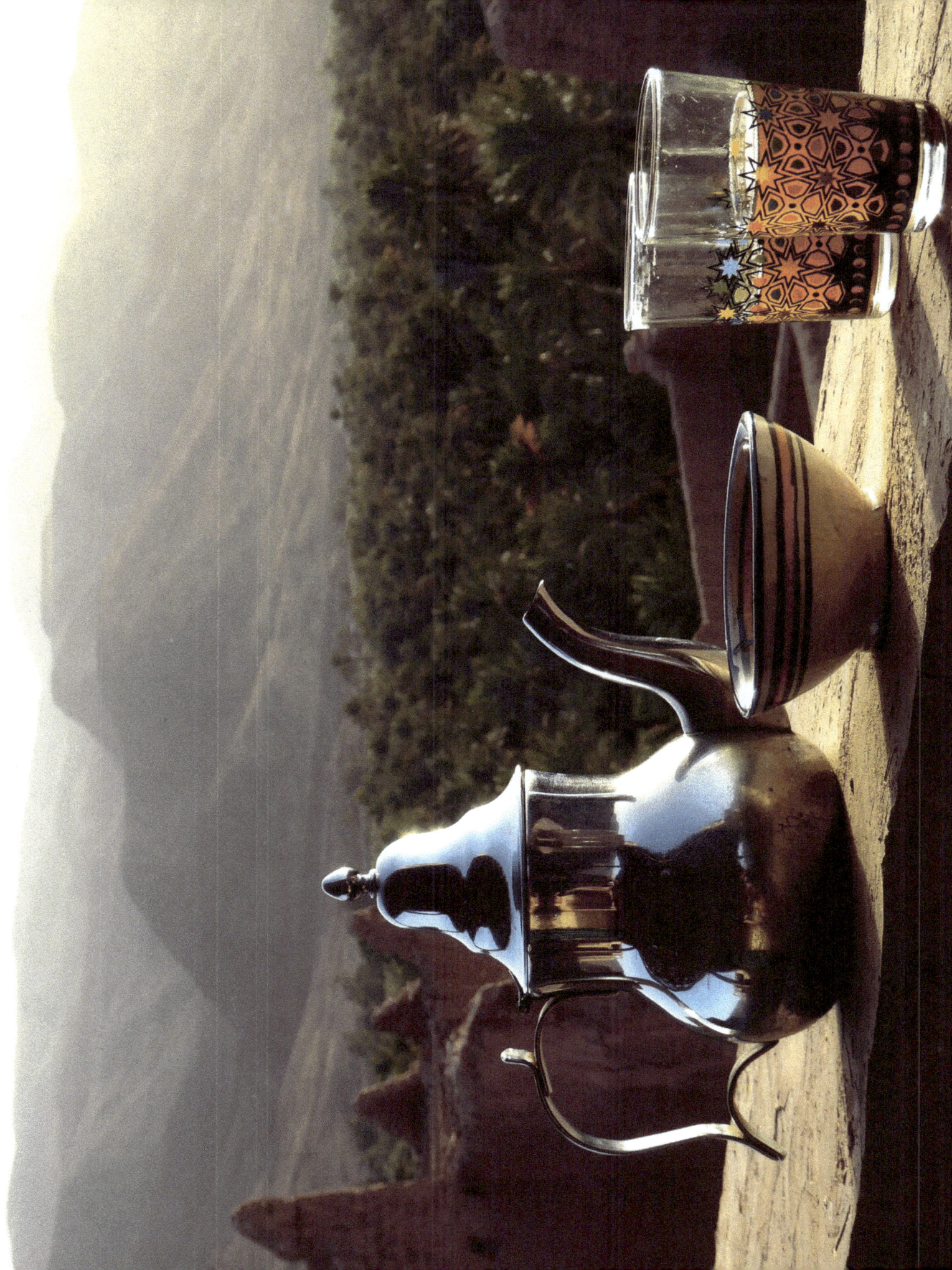

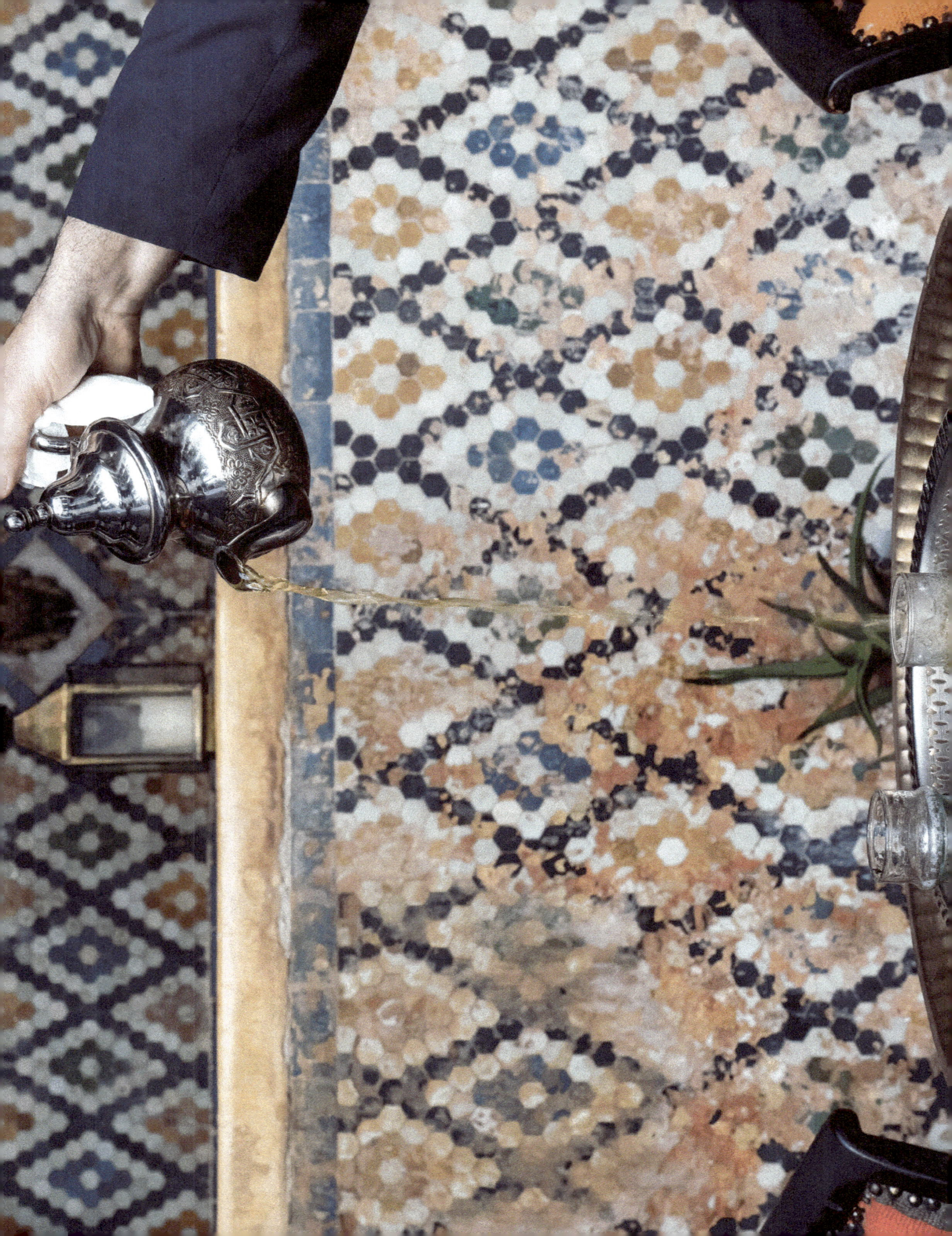

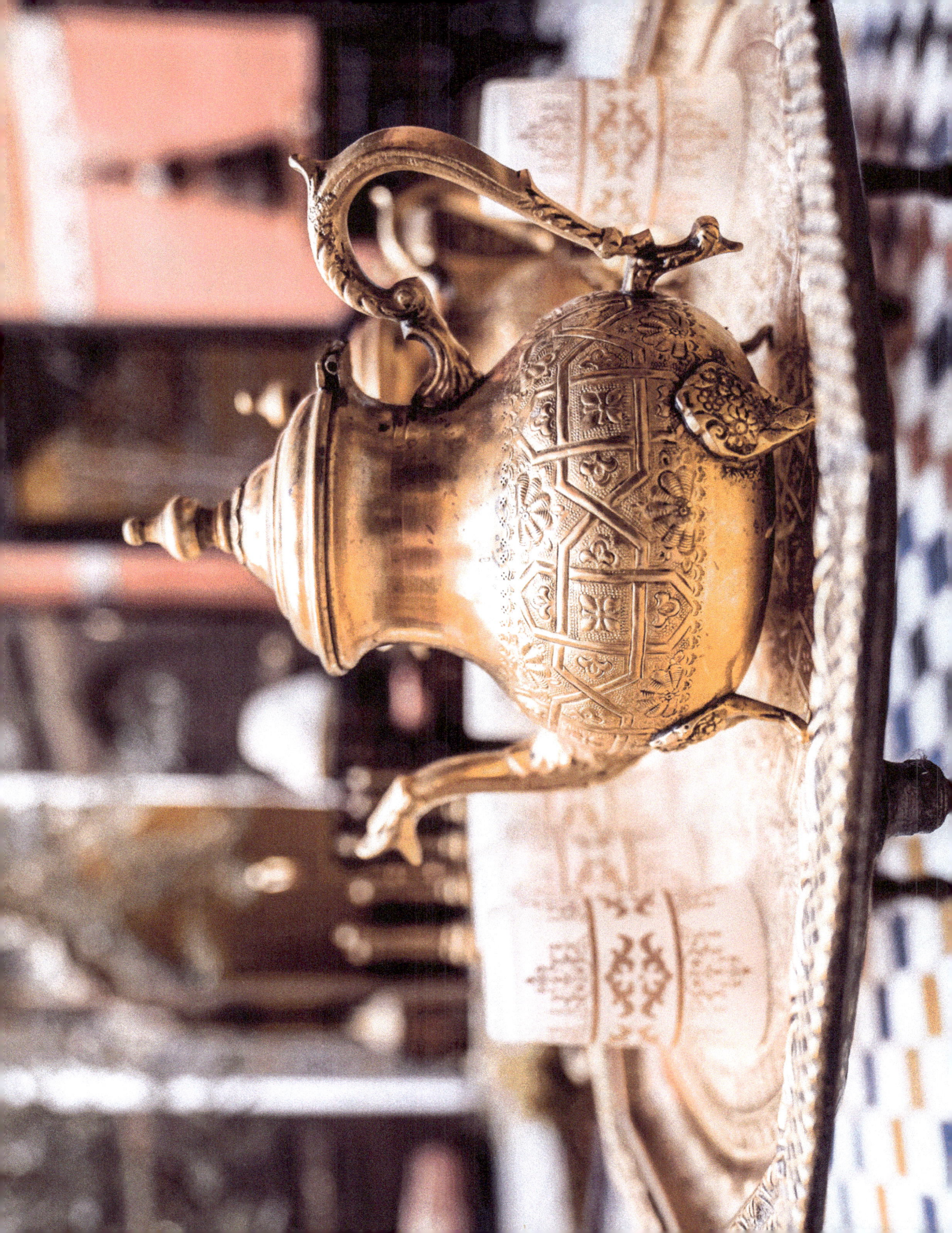

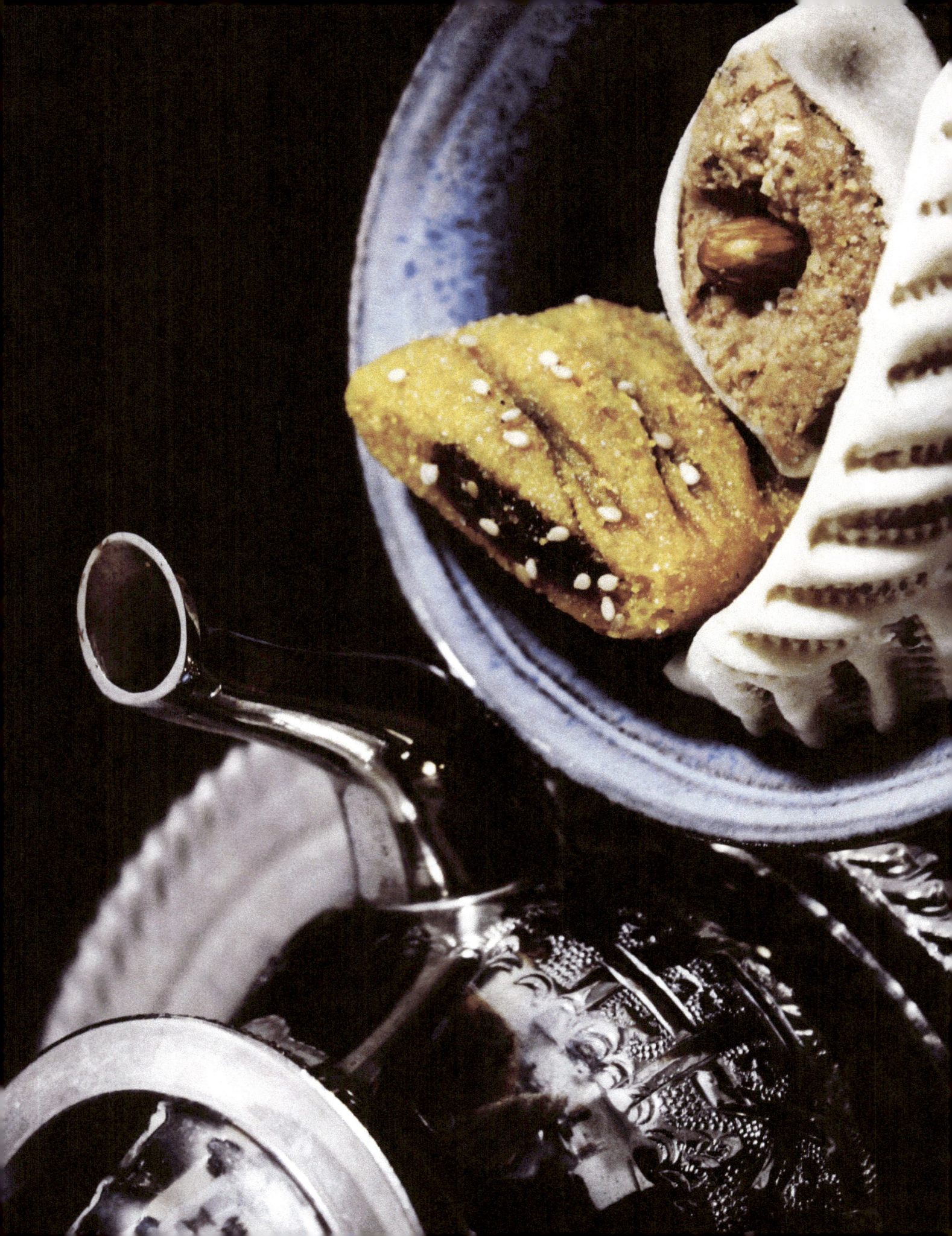

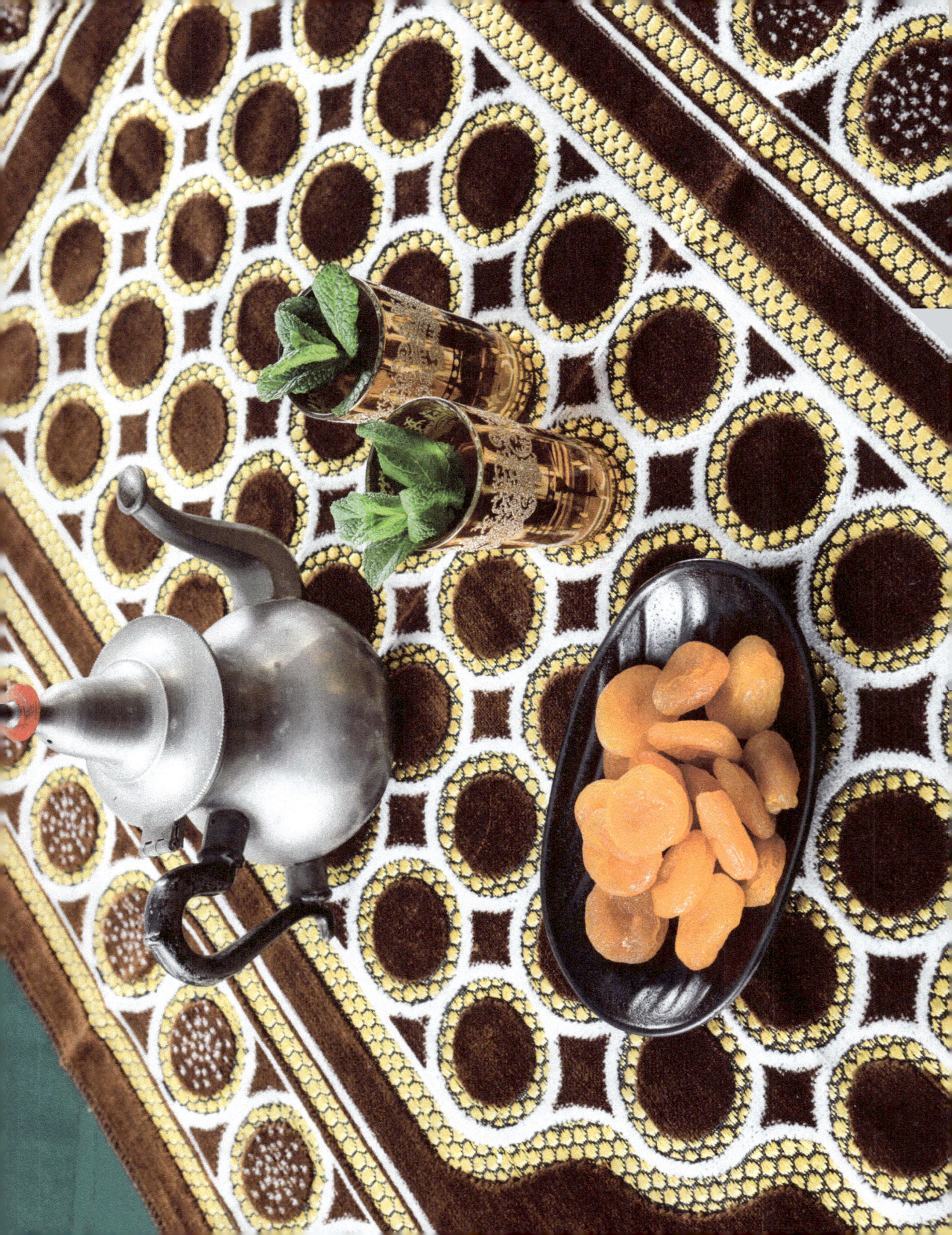

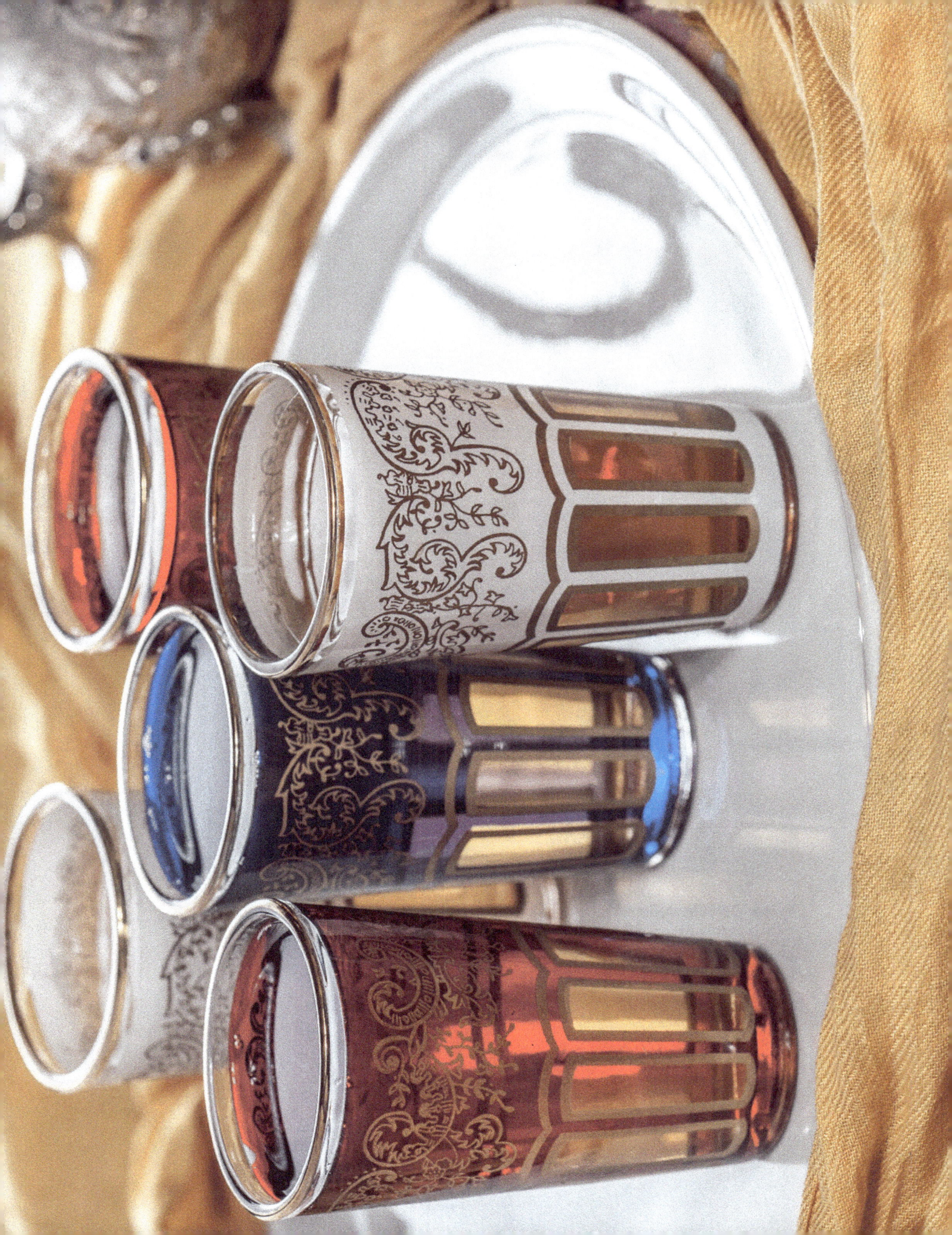

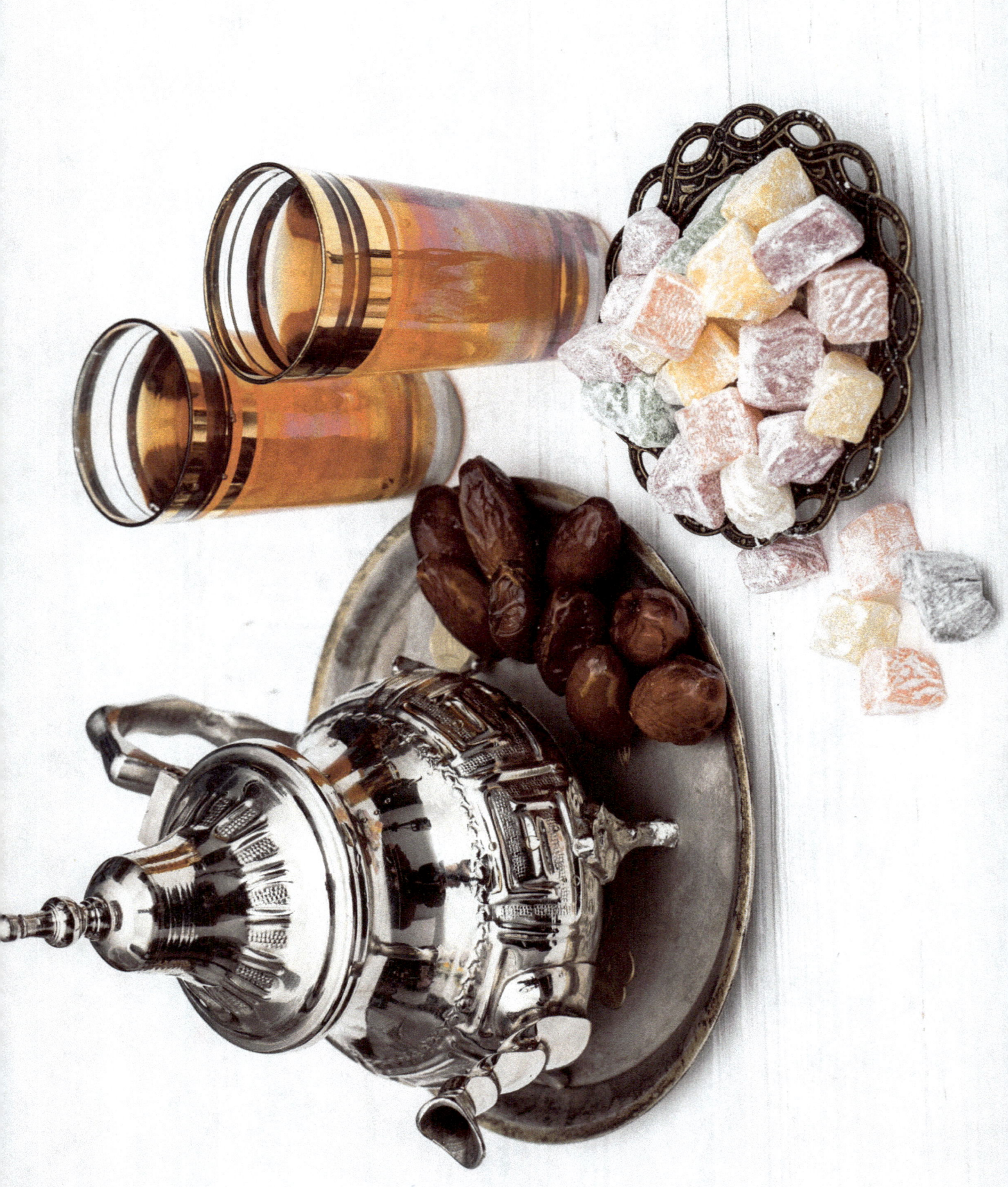

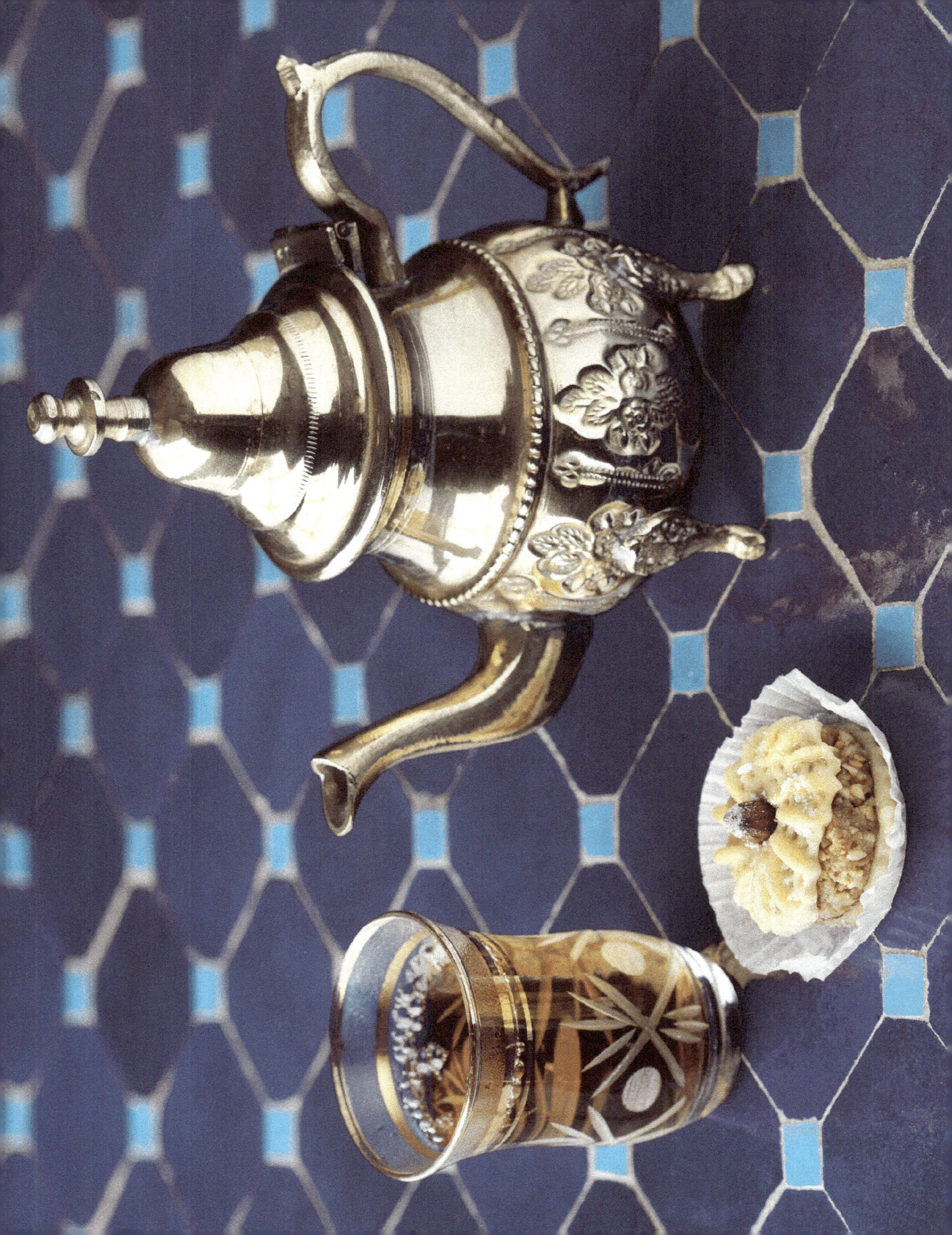

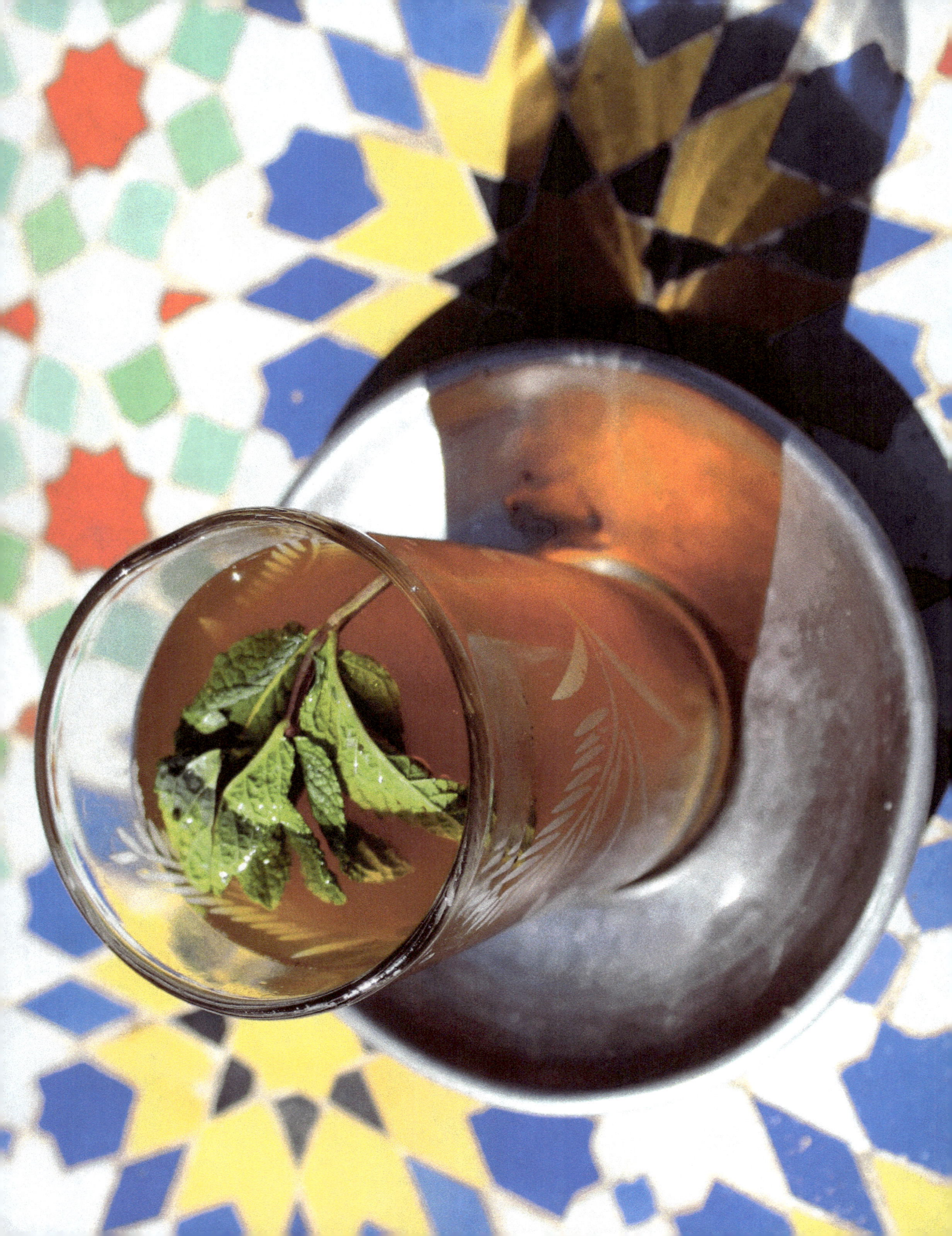

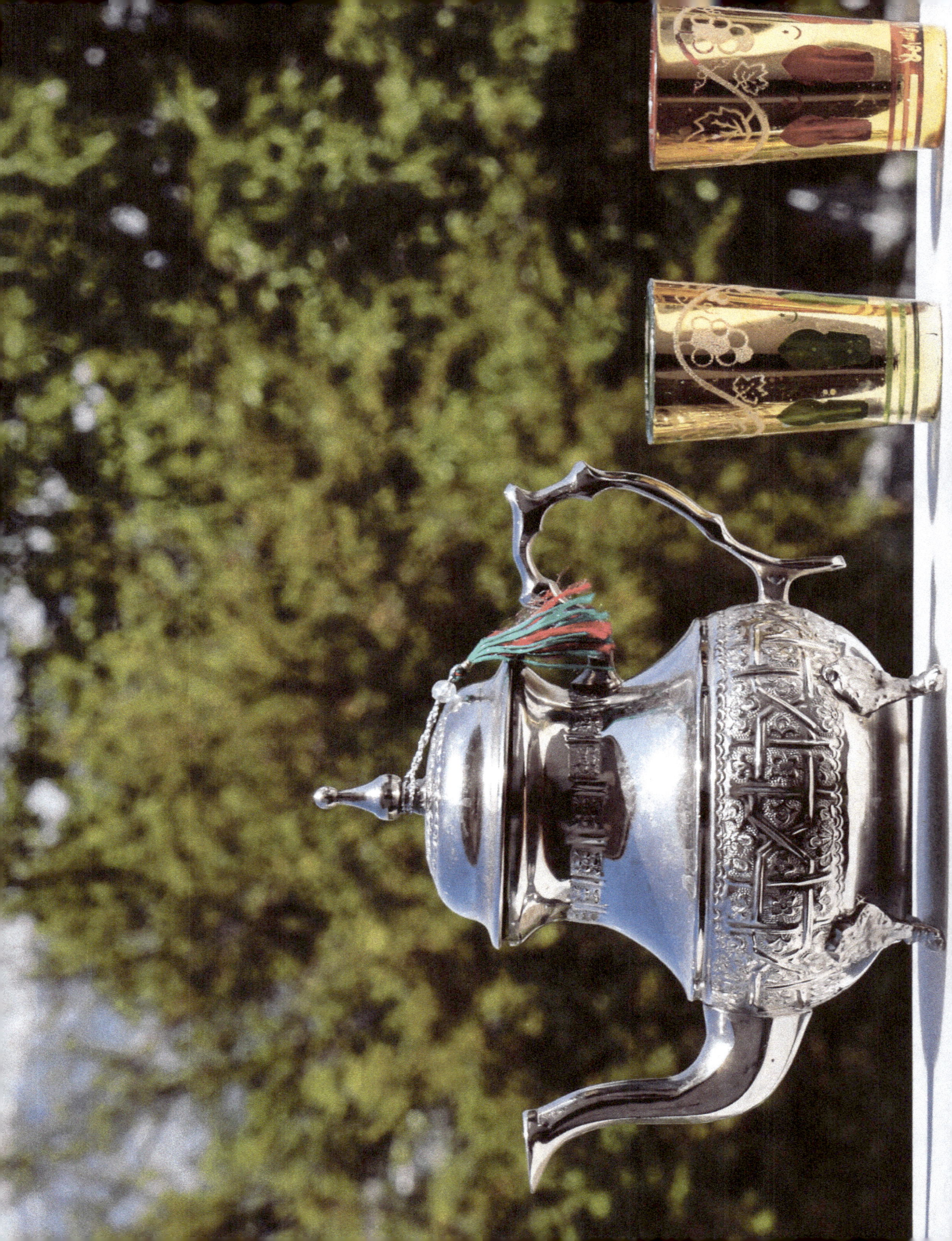

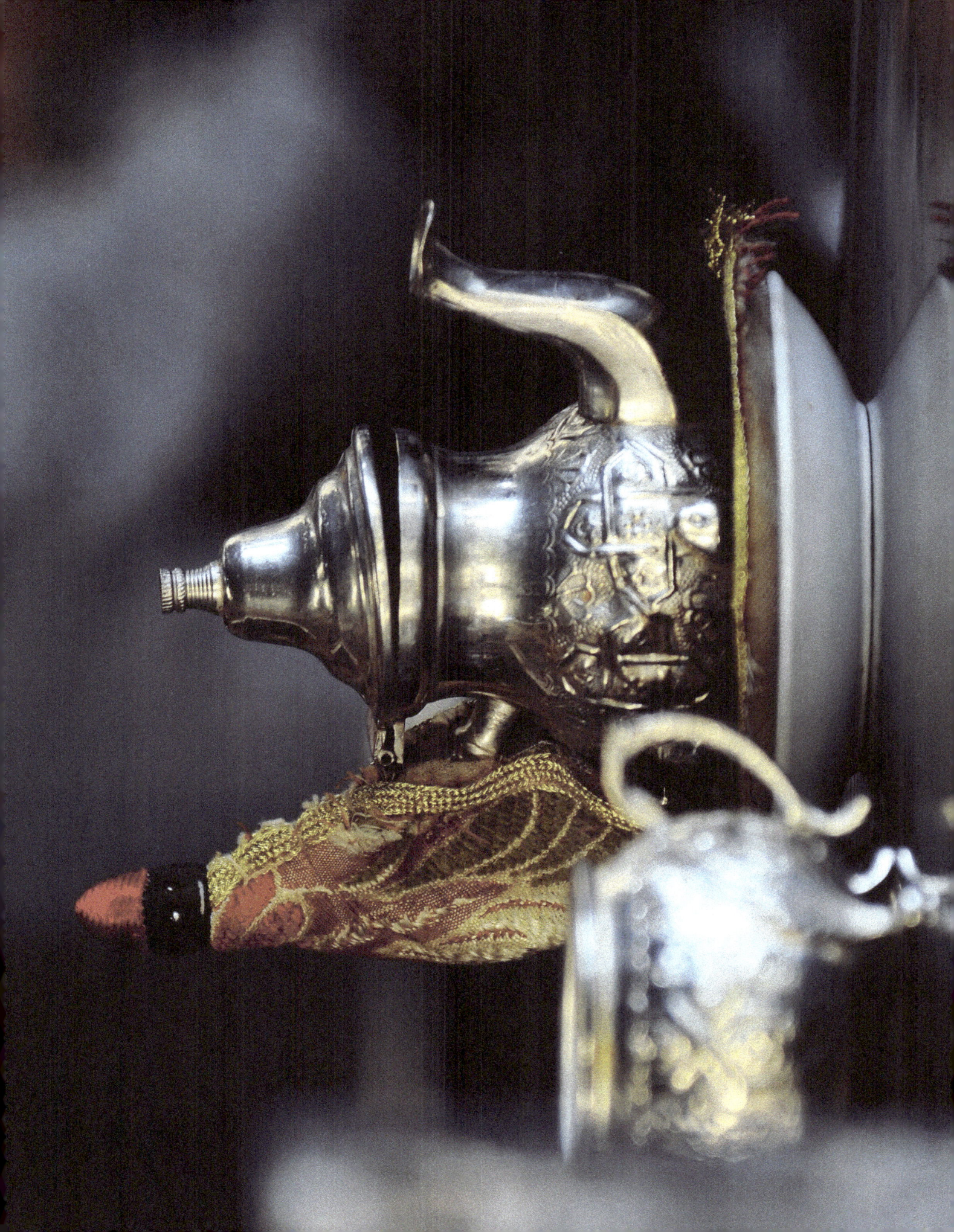

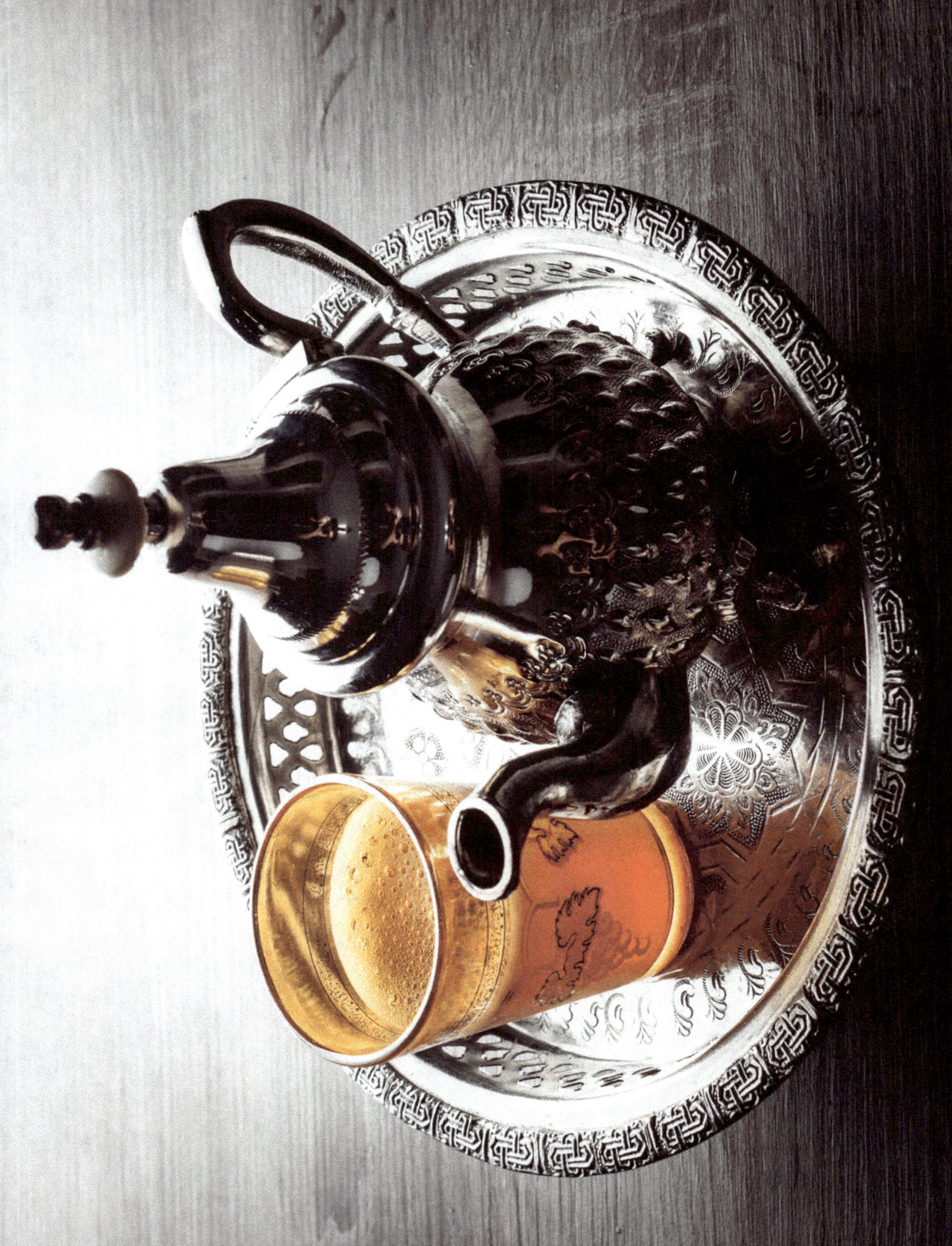

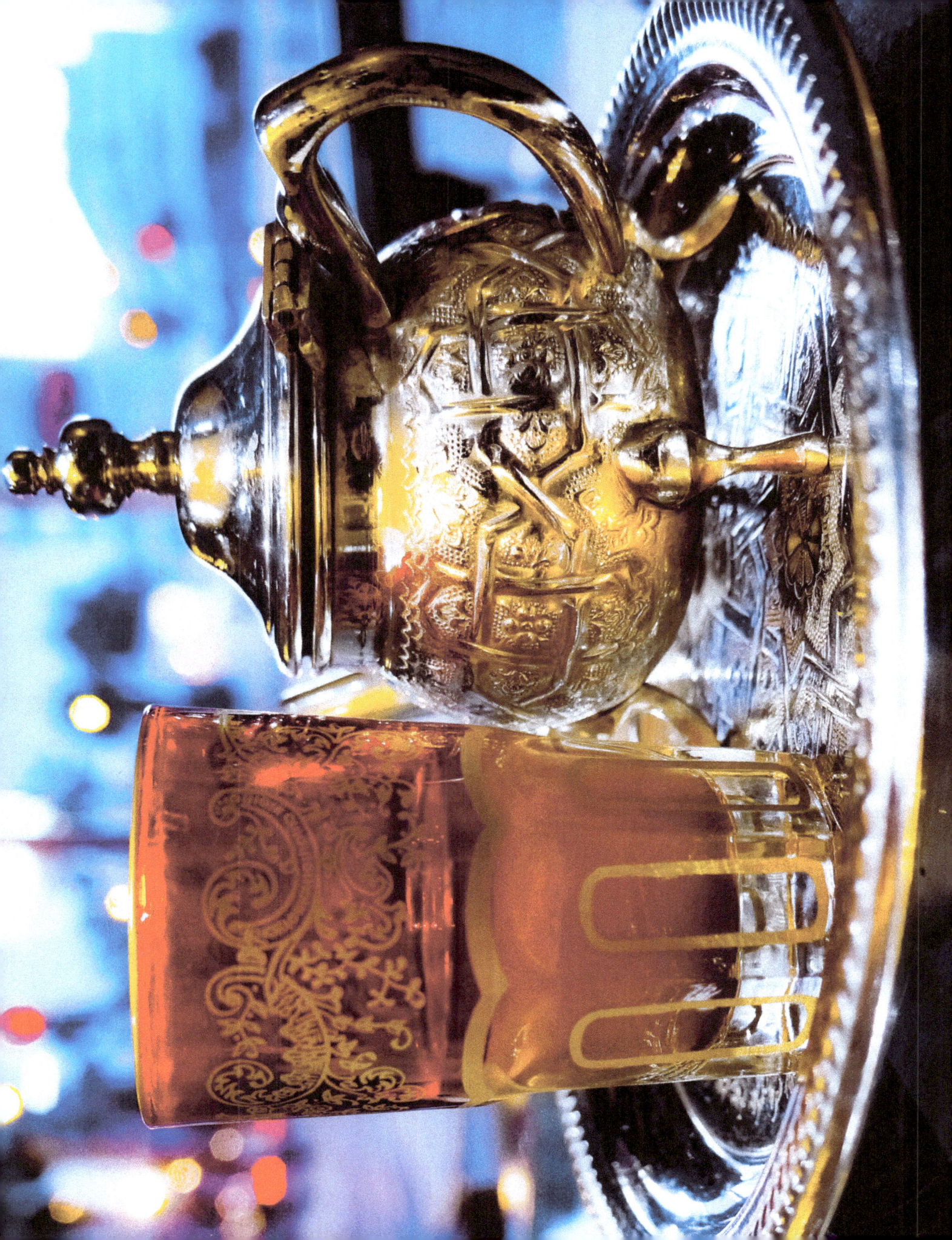

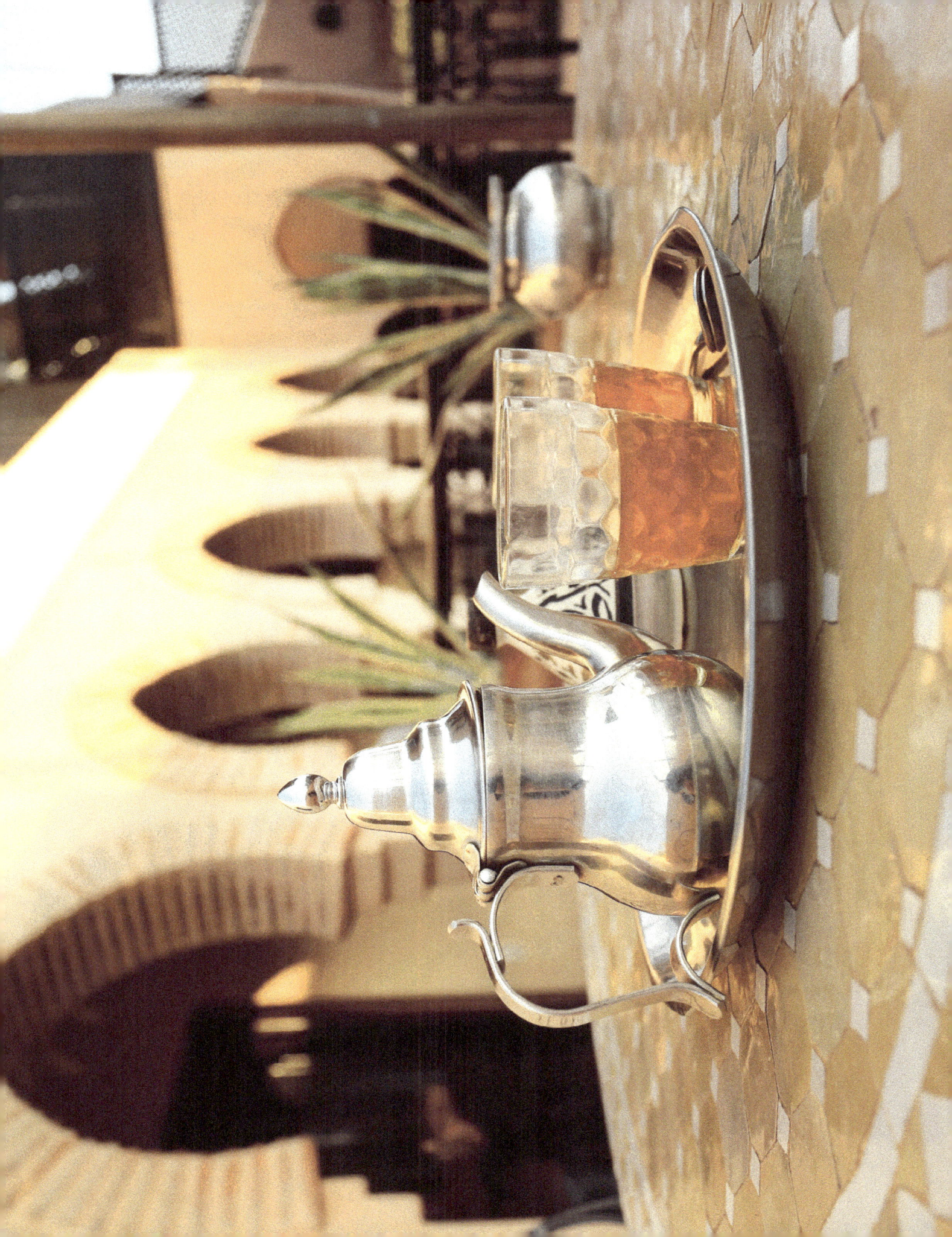

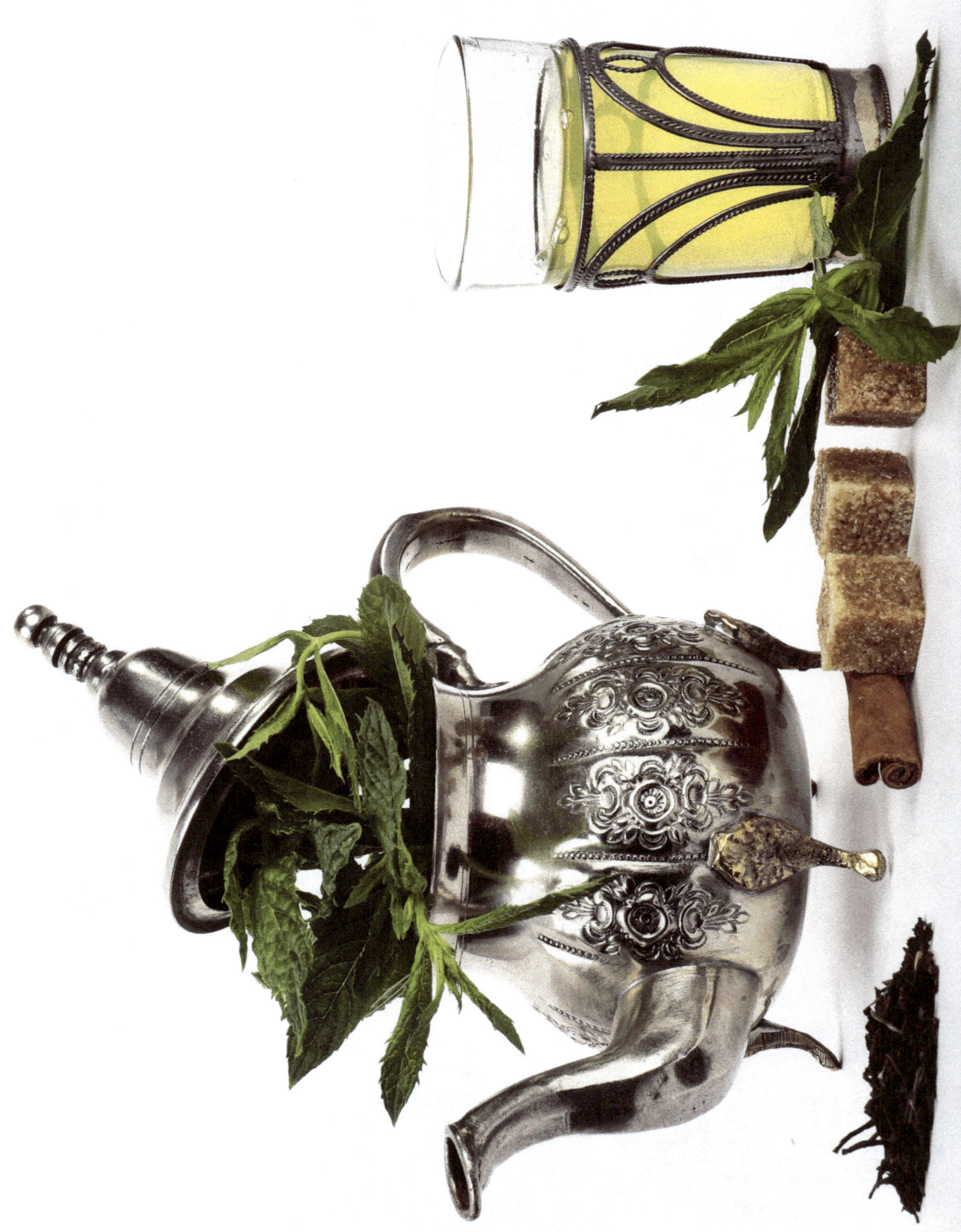

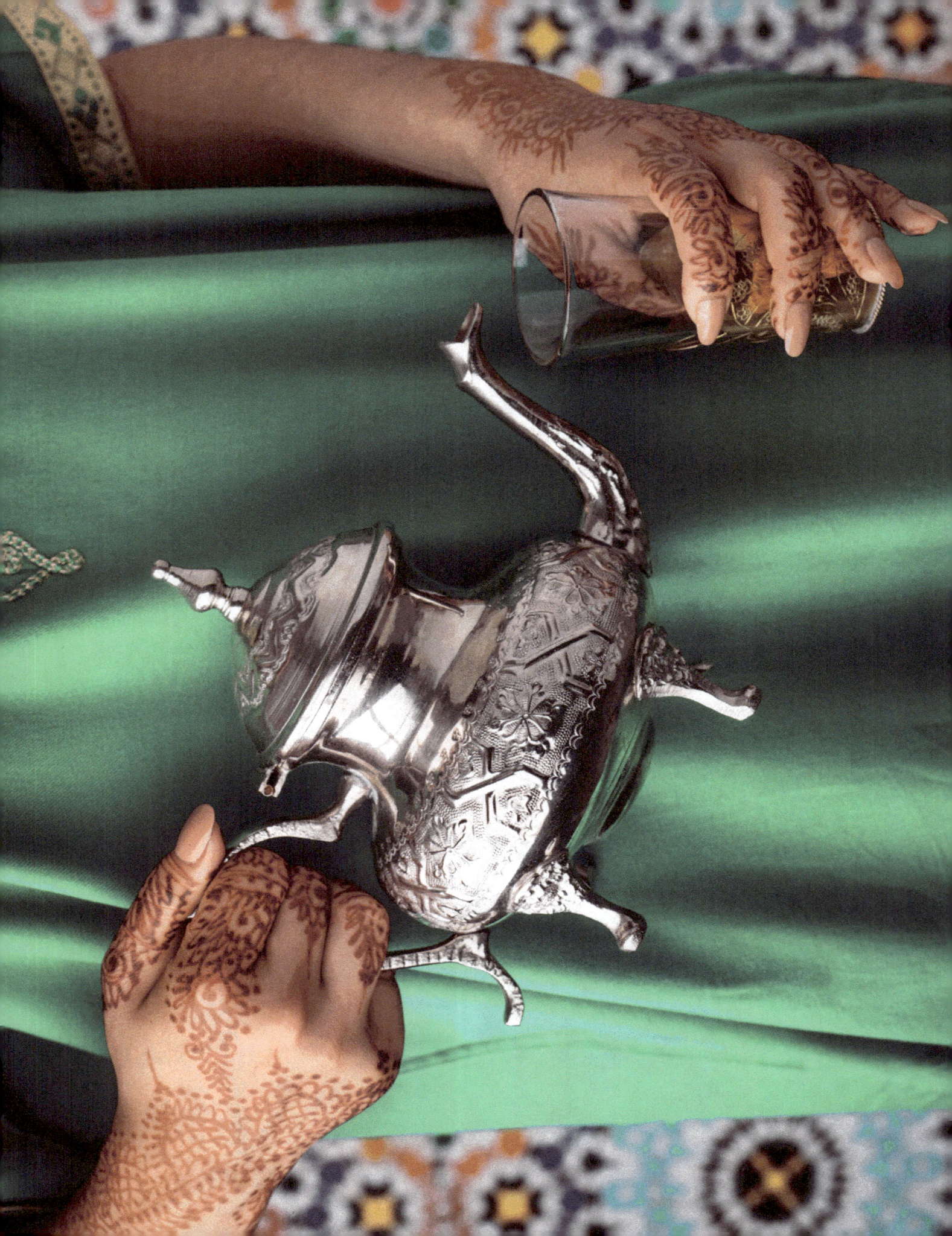

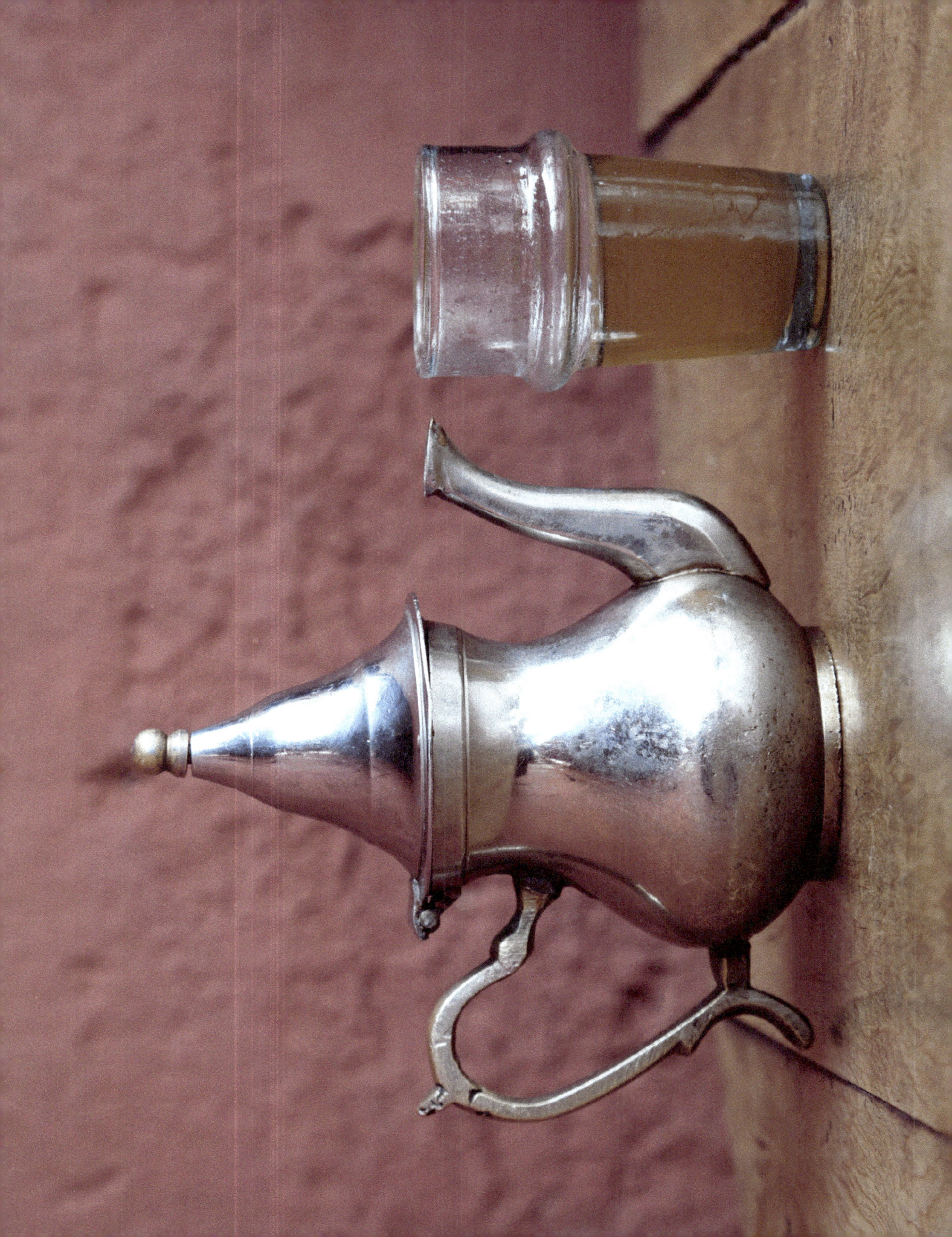

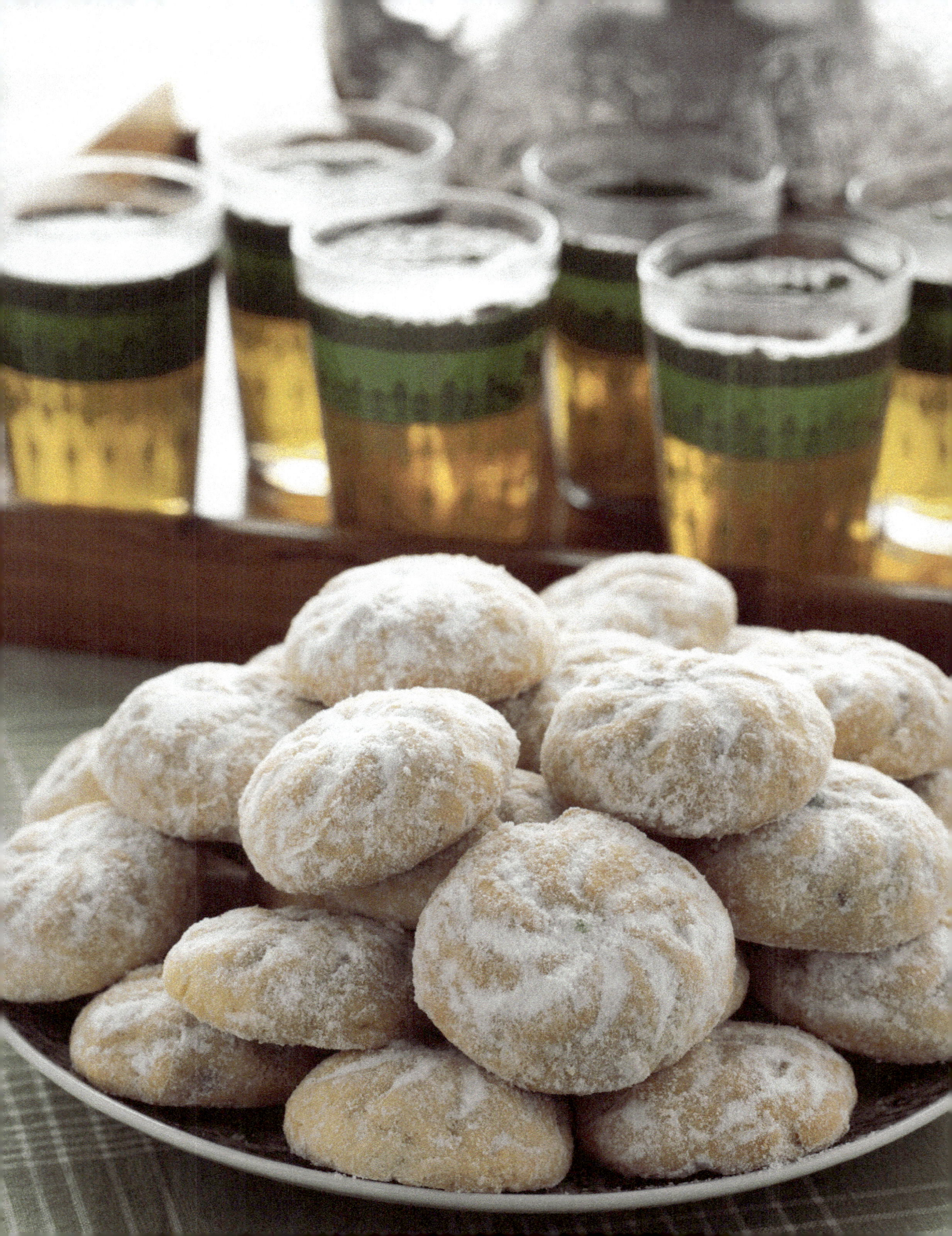

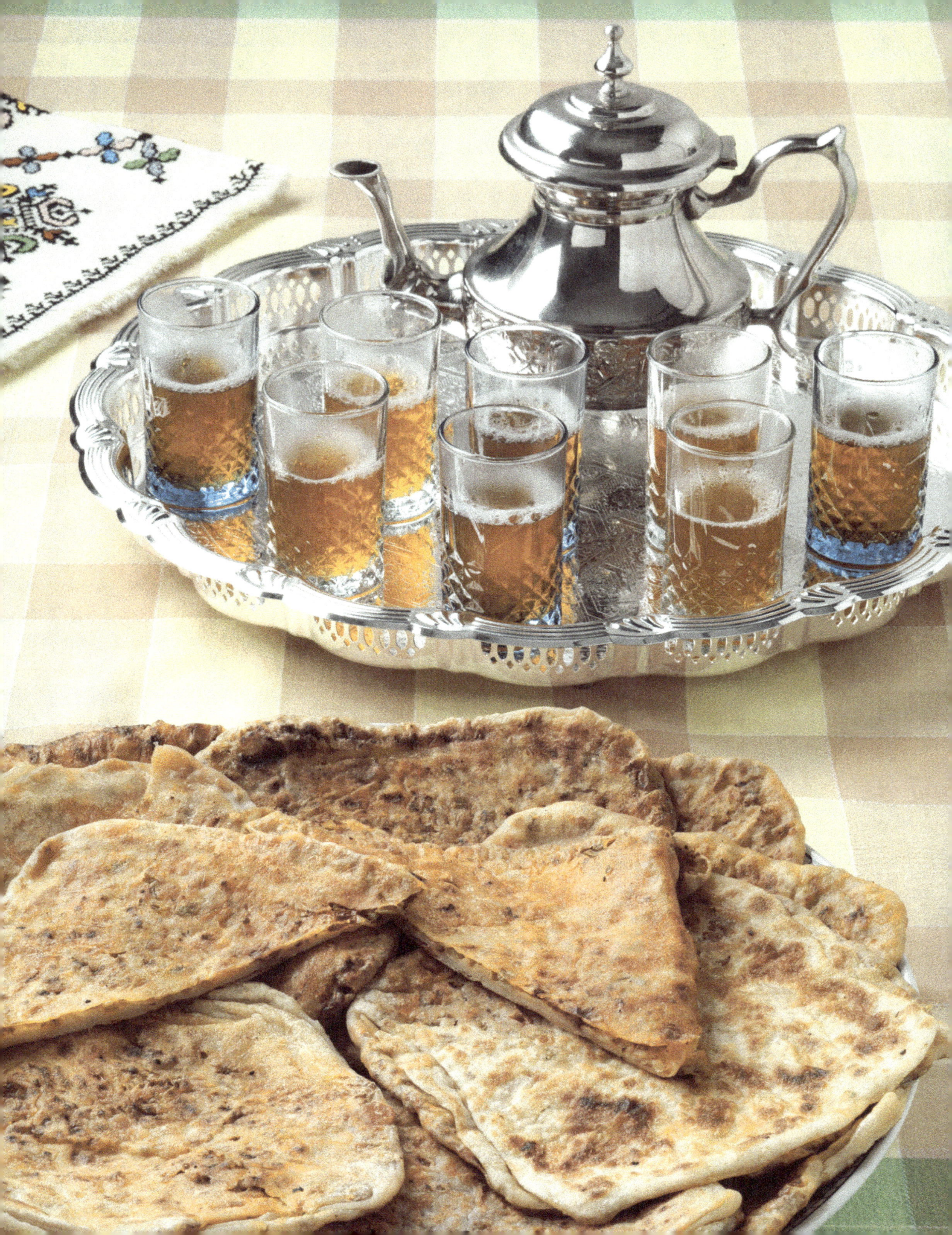

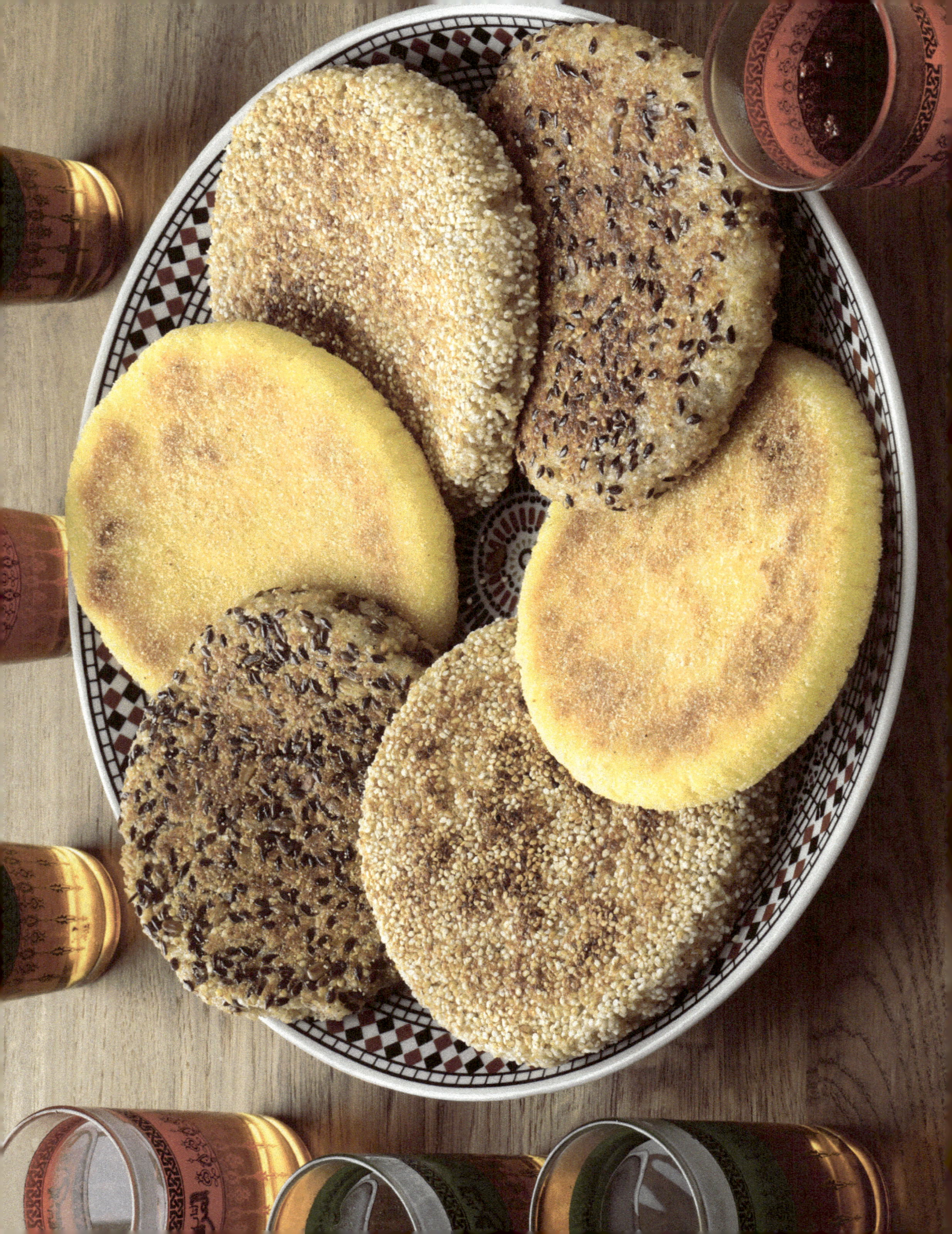

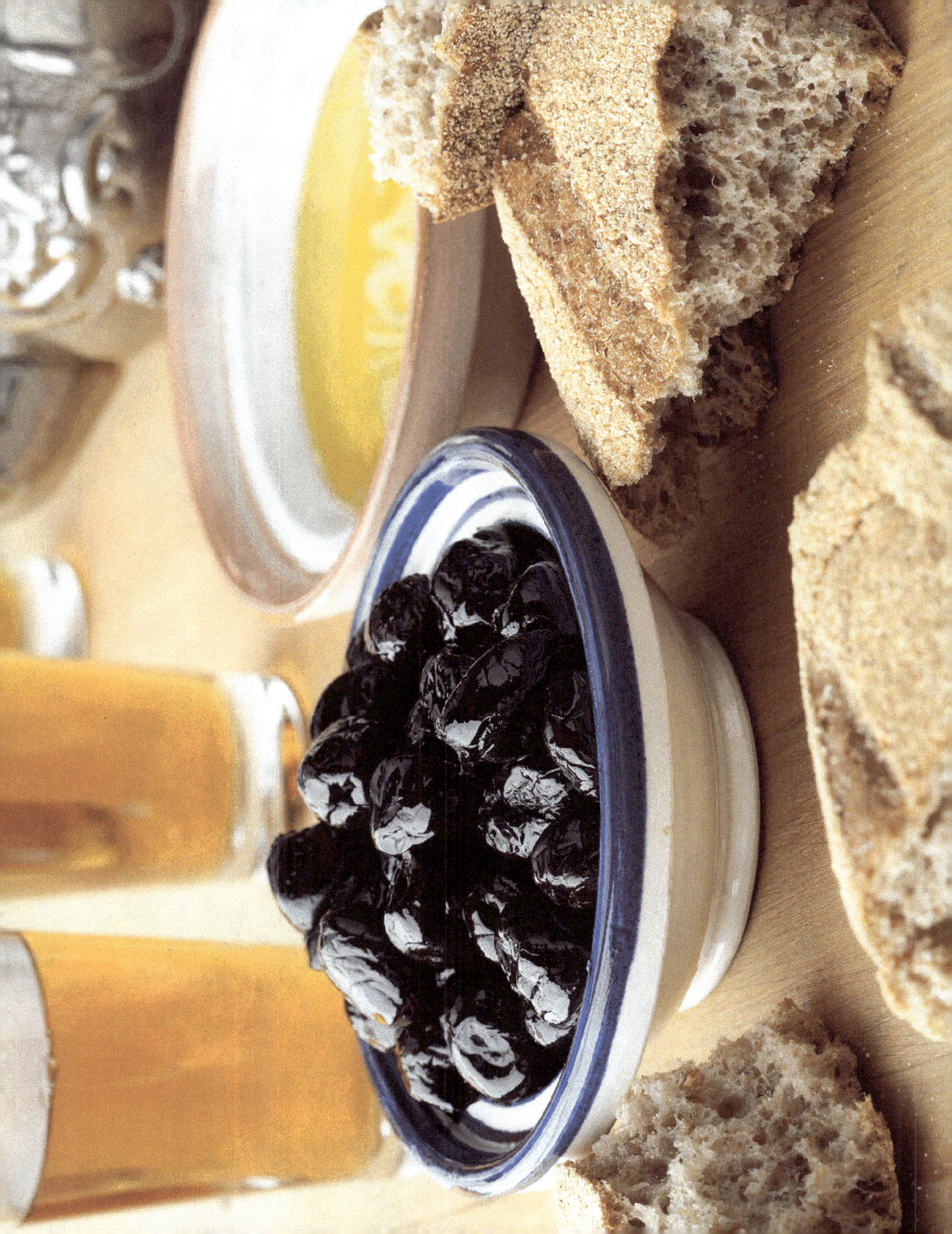

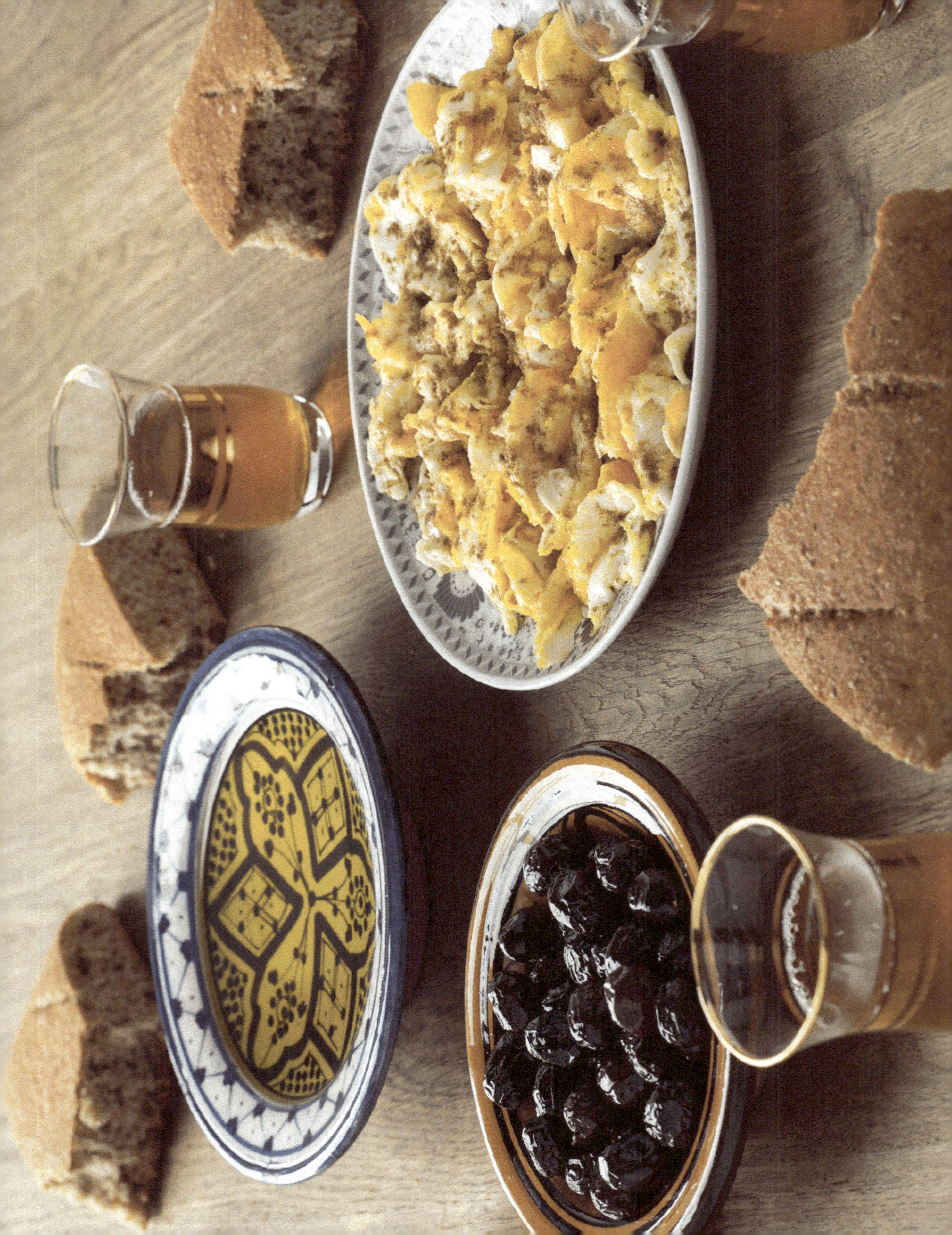

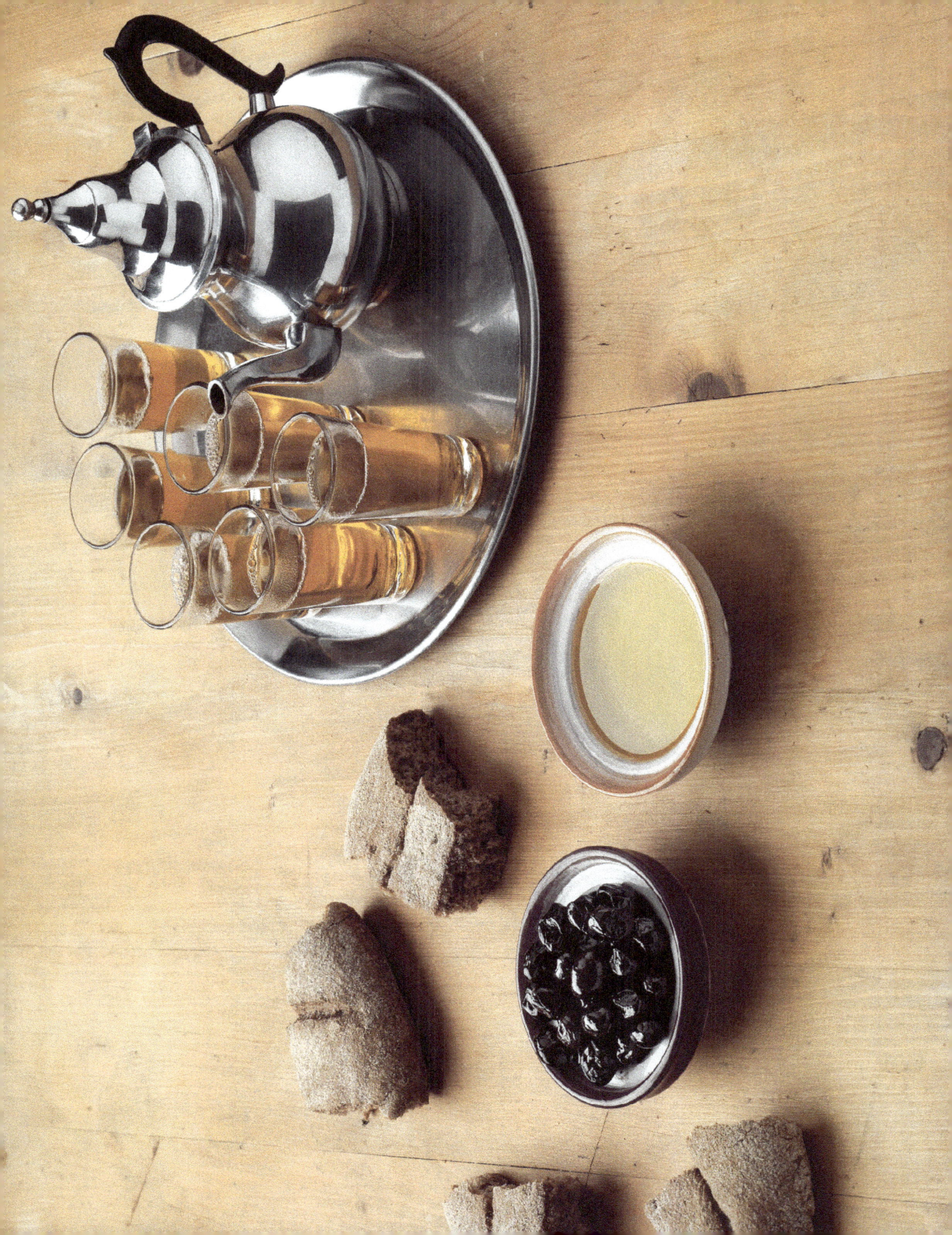

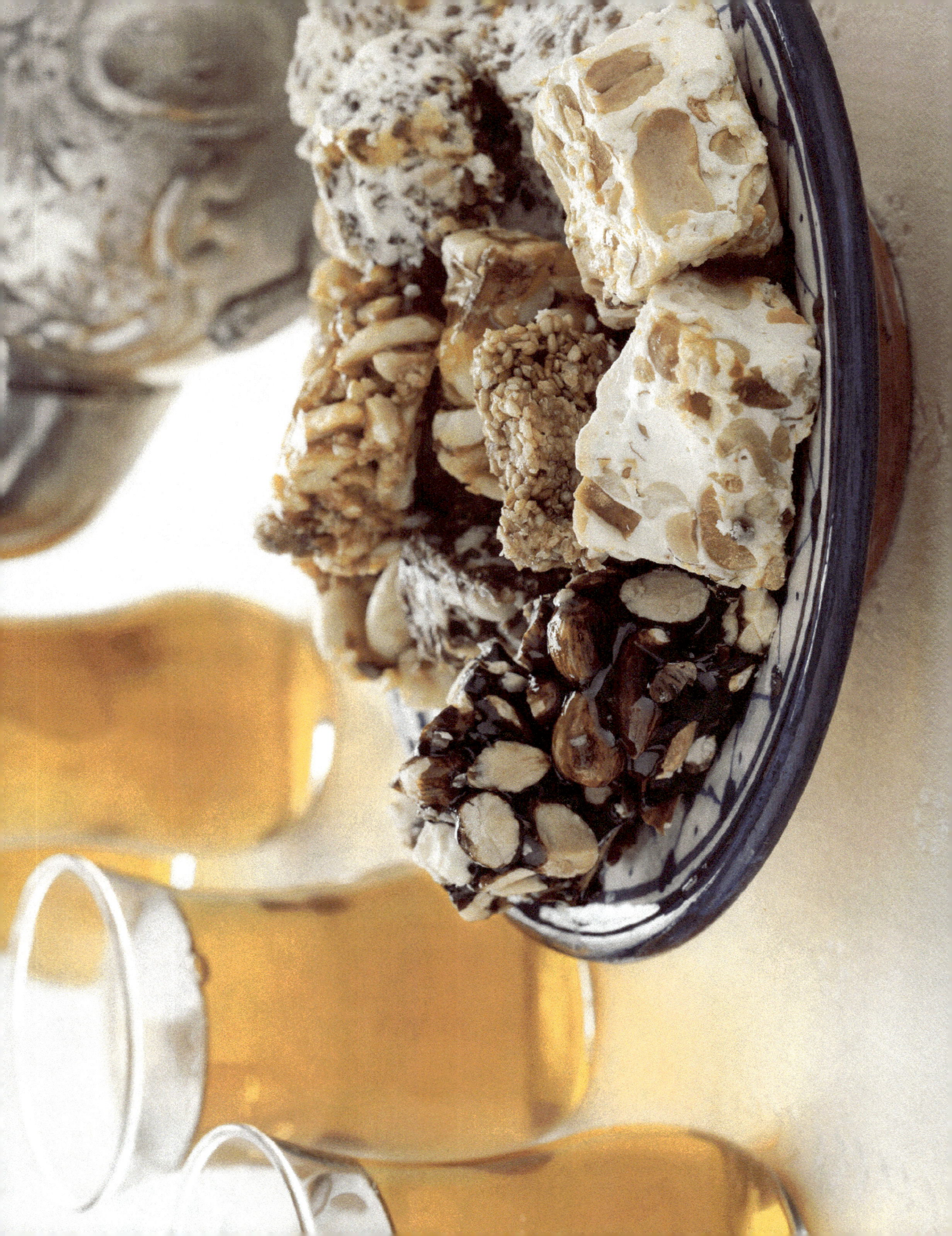

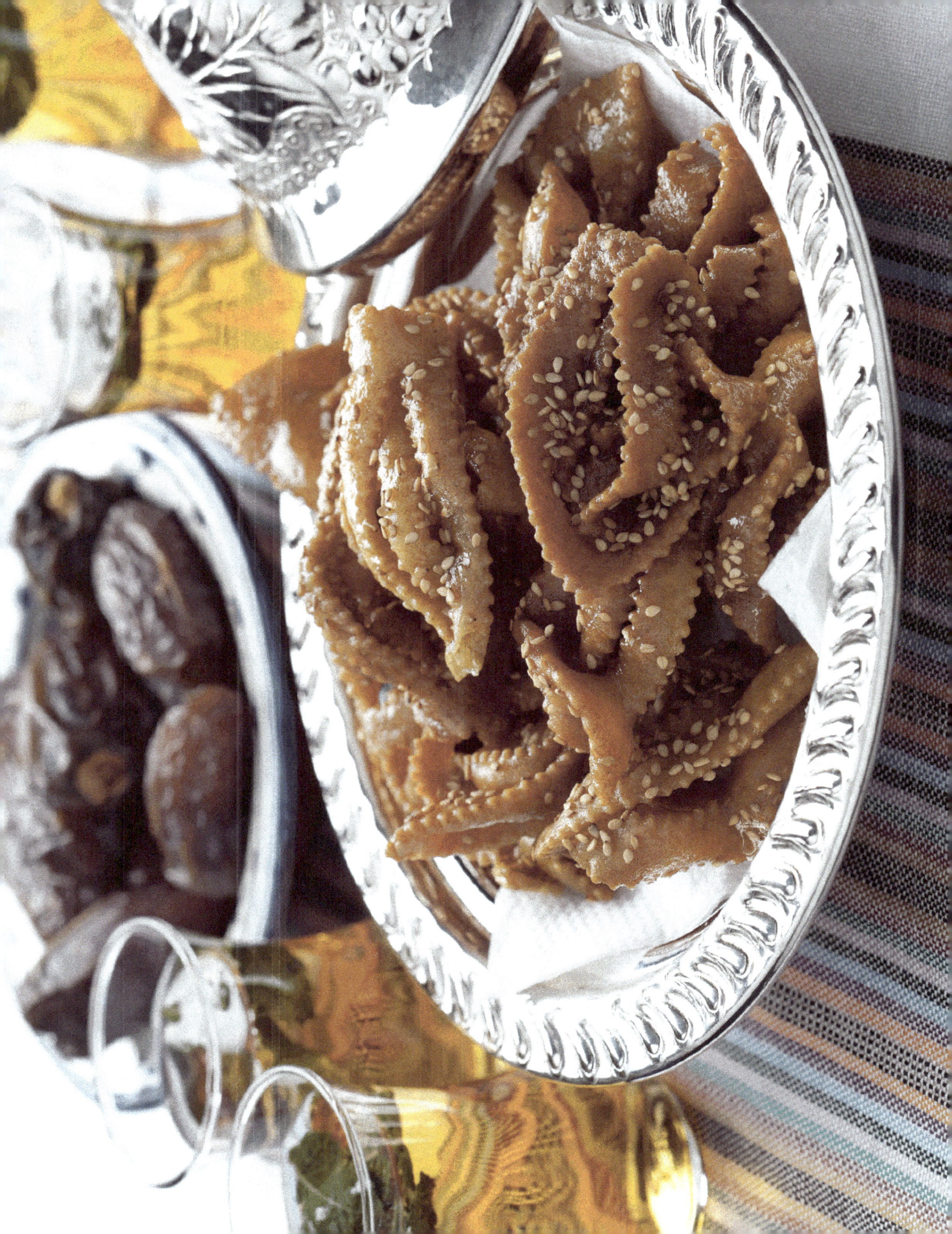

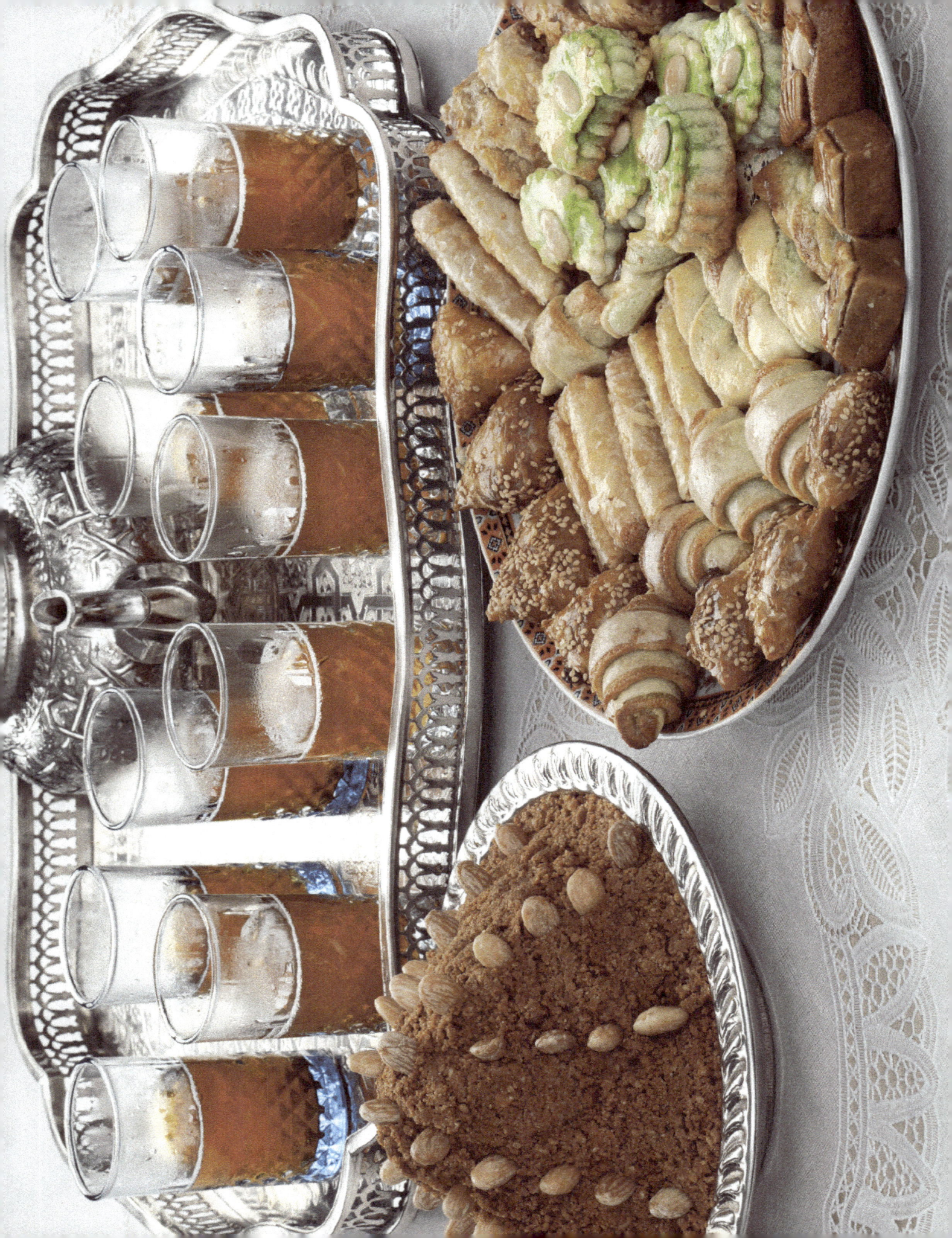

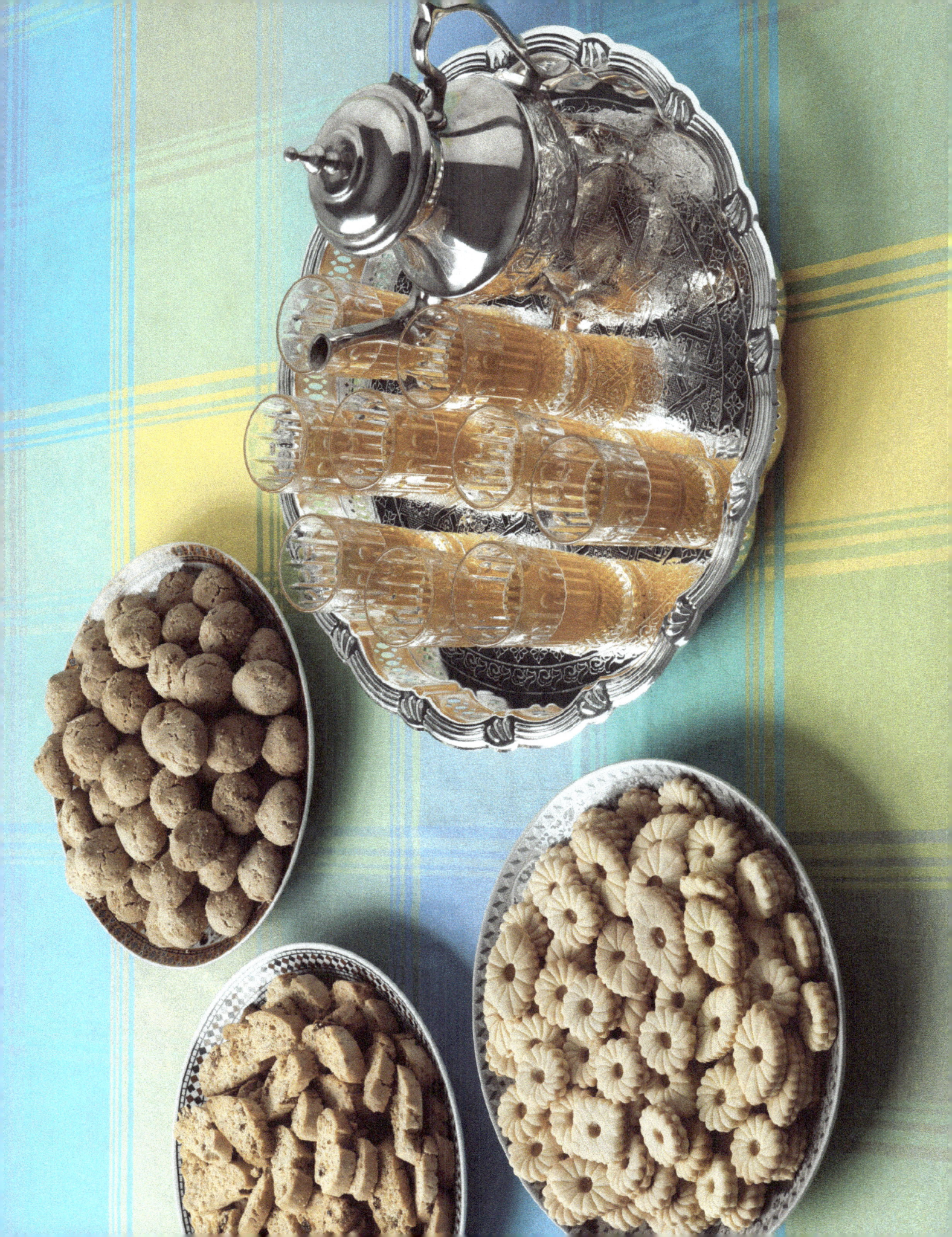

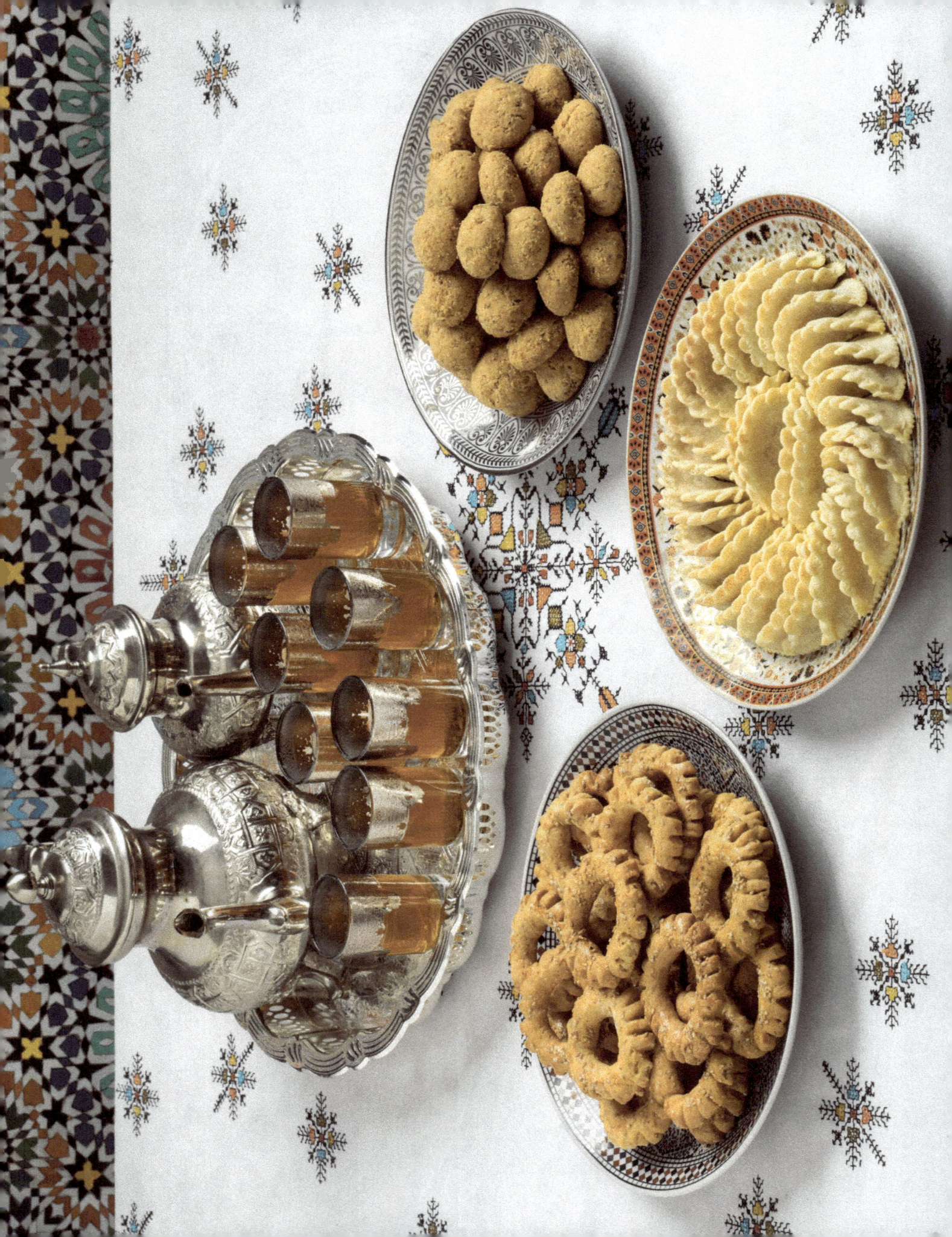

Browse our full catalogue at
MosaicTree.org

 Arabic Script & Sounds

 Arabic Vocabulary

 Arabic for Little Ones

 Arabic/Islamic Mosaic & Calligraphy

 Arabic Learning Journals

 Well-Being & Character Development

Completed with the grace of God